The Saxophone in Advertising

T0316490

Markt-Management

Herausgegeben von Prof. Dr. Axel Eggert,
Prof. Dr. Wolfgang Müller und Prof. Dr. Konrad Zerr

Band 5

PETER LANG

Frankfurt am Main · Berlin · Bern · Bruxelles · New York · Oxford · Wien

Axel Eggert/Melanie Vockeroth

The Saxophone
in Advertising

PETER LANG
Europäischer Verlag der Wissenschaften

Bibliographic Information published by Die Deutsche Bibliothek
Die Deutsche Bibliothek lists this publication in the Deutsche
Nationalbibliografie; detailed bibliographic data is available in
the internet at <http://dnb.ddb.de>.

ISSN 1432-914X
ISBN 3-631-50679-1
US-ISBN 0-8204-6412-0

© Peter Lang GmbH
Europäischer Verlag der Wissenschaften
Frankfurt am Main 2003
All rights reserved.

Printed in Germany 1 2 4 5 6 7

www.peterlang.de

Foreword

For more than thirty years, academics have researched the role of music in advertising. The influence of advertising, which has subliminal appeal, is known to have a significant effect on consumer attitudes and buying habits, although findings vary regarding the extent to which consumer preferences can be influenced. However, research has so far mostly concentrated on the sound of music, whereas the study of individual musical instruments in a visual commercial context has been much more limited. Nevertheless, particular musical instruments tend to conjure up specific images for their readership, whether that readership is one of music lovers or a consumer group. Instruments such as the guitar and saxophone have been used in printed advertising for some time, even though the reasons for this have not always been clear. The work of the Austrian researcher, Dr Bernhard Habla, has ensured that a large number of advertisements featuring a saxophone has been preserved, enabling further exploration of the use of musical instruments in printed advertising and their effects in specific advertisements.

Dr Habla's initial work, coupled with his extensive archive, has meant that a study of the saxophone's role in printed advertising could now be conducted. Melanie Vockeroth collected further new advertisements whenever they were seen or could be found. For the first time it has been possible to carry out an analysis of the iconography and an attempt to identify the reason for using a particular instrument in preference to another. The result is a state-of-the-art investigation into the use of music in commerce, its subliminal appeal, and the role of musical instruments. This analytical study of the use of a specific instrument may be seen as the first stage of an enquiry into the cultural issues which may influence the use of the saxophone, and which may offer an opportunity for initial research conclusions to find wider application.

As editors, we hope that the study will generate an increased interest in this area of academic research, which may take the form of extending the study to other musical instruments and their specific role in advertising, or of comparing the current findings with those of other cultural and commercial contexts. We hope, therefore, that readers will find this volume useful and that they will appreciate the authors' contribution towards expanding this area of research and towards inspiring other academics to continue this line of investigation.

The Editors

TABLE OF CONTENTS

Index of Tables

Index of Figures

13

1. Introduction

1.1. Statement of the Problem

Since the 1990s the saxophone has appeared in many printed advertisements. These pictures or drawings, which show a saxophone in addition to other elements, do not only advertise musical events or the instrument and its accessories, but they also advertise a wide range of other products and services.

Interesting questions remain unanswered in literature, including: Why does the saxophone appear in so many advertisements? Is the saxophone always used in the same way or is it used in different ways? How is it used? Which products or services are advertised with the saxophone? What sort of association is the saxophone supposed to transfer to the products and services advertised? Who are the target groups for these advertisements? Is the saxophone shown on its own or together with people/players or other instruments?

Very little research has been done into the use of the image of musical instruments in general in advertising or the image of the saxophone in particular. The only research that has been done on the saxophone in advertising in German-speaking countries is a collection of advertisements involving saxophones, compiled by the Austrian Bernhard Habla and edited so, that it can be used as an entertaining slide show. The content of the slide show has also been published as a work report of the *University of Graz*.[1] Thus there is still a lot of room for further investigation. This study tries to establish a state-of-the-art examination on a topic that has so far been left out of research.

1.2. Objectives and Delimitation of the Subject

The main objective of this study is to find out what role the saxophone plays in advertising. In order to answer this question, the image of the saxophone and theory about images in advertising will be examined. In order to prepare an understanding for the whole topic, music as a topic will be looked at more closely. Aspects, such as emotion in music and also in advertising, semiotics, and further advertising background and a deeper understanding of the effects of music will be discussed.

It is necessary to delimit the topic to a particular culture, as the saxophone symbolises similar, but not identical characteristics in different cultures. In this

[1] Habla (2001), pp. 153-188

15

study German-speaking countries will be examined. The main focus will be on Germany, but Austria and Switzerland will also be considered via examples. There will be a detailed examination of advertisements featuring the saxophone since 1990 with illustrated examples, in order to show how advertisers have made use of the saxophone in advertising. A further delimitation has been established regarding the media examined: The investigation focuses on visual aspects and, within visual advertising, the medium print is the main object of this examination. Although the saxophone's use will only be discussed in print media, there will be a discussion of the sound of music and the use of music in advertising, as well. In order to see how diversely the saxophone has been used, the focus of this investigation is on advertising design rather than an examination of the publications in which the advertisements were printed.

It is important to understand that this study is written from a marketing point of view and not from the point of view of a musicologist. One could definitely enlarge upon some aspects from a musical point of view, but this will not be part of this examination, which is trying to find answers to the above questions.

1.3. Structure of the Paper

As little to no research has previously been done on the topic of the saxophone in advertising, there is no literature available which covers both the saxophone **and** advertising at the same time.[2] Firstly, therefore, certain relevant elements of advertising theory will be dealt with. As a second step, the actual state of affairs regarding the topic of music in connection with emotions, meaning, advertising, its effects on consumer behaviour and cultural aspects in research will be discussed. Then, in order to be able to appreciate the examination of how the saxophone has been used in advertising, the saxophone will be explained as a musical instrument, in order to familiarise the reader with the most important dates and circumstances of its history and developments. These are necessary in order to understand the image that the saxophone has gained over the years. The main part of this paper will consist of a detailed examination, illustrated by examples, of how the saxophone has been used in advertising since 1990. As this examination, linked with the theory outlined before, can give only a limited

[2] The only time a saxophone seems to be mentioned in advertising literature is by Messaris (1997), p. 62 and p. 68 in the context of an American advertisement in which the saxophone is used as a sexual symbol. Furthermore, there was evidence of a French study by Françoise Carret, *Représentation du saxophone dans l'annonce publicitaire,* Université d'Aix-Marseille (1995). Unfortunately the paper was unobtainable, even though email contact and exchange with Françoise Carret could be established.

explanation, qualitative research becomes necessary. Through interviews with advertising agencies and companies who have already used the saxophone in advertising, this study will identify objectives and target groups, as well as reasons and methods behind past use of the image of the saxophone in advertising.

Through the examination of the theoretical use of images in advertising in general, through the consideration of examples of past use of the saxophone in advertising, and through interviews with those advertising agencies and companies that have already used the image of the saxophone in advertising, conclusions can be drawn and recommendations for the future will be given.

2. Advertising Background

In the following paragraphs some important aspects regarding advertising theory will be outlined. In order to understand the saxophone's role in advertising, topics such as the communications process, need to be clarified. It is also essential to have a common background on the effects of sociocultural influences, the use of images in advertising, how they work, and how visual persuasion works. These aspects will be identified by means of a topic-oriented examination.

2.1. Terminology

Advertising can be defined as any paid form of non-personal promotion transmitted through a mass medium.[3] This means that through advertising the communication with large numbers of people through paid media channels becomes possible. In other words, advertising is mass-market communication. Advertising can be put into two basic categories: it can either be product-orientated or institutional. Product-orientated advertising focuses on the product or service being offered, whereas institutional advertising (also called image advertising) aims at building a sound reputation and good image of an entity such as a range of products or services, a company, a brand, or an institution.[4]

George Lois looks at advertising from a less conventional point of view, which is useful when considering the saxophone in advertising. He states that advertising, after all, is a form of art. For him, the most important aspect of advertising is *the Big Idea*. Any advertisement needs a highly original idea which influences and remains in the audiences' minds. Only then can an advertisement achieve something.[5] Given the strictly scientific basis of the conventional definition of advertising, Lois's rather unorthodox view is beneficial, if one is going to think about creativity in advertising. Furthermore, Lois points out that advertising can provide a product with extra value, in a world in which most products are equivalent, but only if the advertisement is vivid and unforgettable. The only difference between these generally similar products is based on the perception of the consumer. And it is advertising that influences this perception.[6]

[3] Brassington & Pettitt (1997), p. 604
[4] cf. ibid., p. 604
[5] cf. Lois (1993), pp. 26 and 255
[6] cf. ibid., p. 137

Before developing an advertising campaign it is important to define and specify objectives. These objectives have to be consistent with the general marketing objectives, as advertising should be part of an integrated marketing approach and thus part of the communication and general objectives of an enterprise.[7]

Advertising objectives can be put into two groups: economic and communicative objectives. Economic objectives can be classified in financial terms, like turnover, profit, costs, etc., whereas communicative or psychological objectives are more difficult to measure.[8] One has to be aware that it is not always easy or possible to unite economic effectiveness and stylistic satisfaction.[9] Possible communicative objectives are shown below in Table 1:

Possible advertising objectives	
To inform	
- Telling the market about a new product.	- Describing available services.
- Suggesting new uses for a product.	- Correcting false impressions.
- Informing the market of a price change.	- Reducing buyers' fears.
- Explaining how the product works.	- Building a company image.
To persuade	
- Building brand preference.	- Persuading buyers to purchase now.
- Encouraging switching to your brand.	- Persuading buyers to receive a sales call.
- Changing buyer perceptions of product attributes.	
To remind	
- Reminding buyers that the product may be needed in the near future.	- Keeping the product in buyers' minds during off seasons.
- Reminding buyers where to buy the product.	- Maintaining top-of-mind product awareness.

Table 1: Possible Advertising Objectives[10]

Three communicative objectives should always be considered: an advertisement should arouse attention, it should communicate a message and it should initiate changes in attitude and behaviour.[11] Opinions about which objectives should prevail differ widely between the US, Britain, France, and Germany. Chisnall

[7] cf. Meffert (2000), p. 27
[8] cf. ibid., pp. 678-680
[9] cf. Wöhe (2000), p. 582 and Ogilvy (1984), p. 24
[10] Kotler et al. (1999), p. 795
[11] cf. Rehorn (1988), p. 1

points out, "Of West German agencies, 92 per cent said that sales should not be the criterion for judging the success of an advertising campaign."[12] This statement was made a few years ago, but nevertheless indicates the importance of communicative objectives in Germany.

2.2. The Communication Process

The communication process is a very complex psychological phenomenon, which many scientists have tried to analyse. This section is not intended to give a detailed analysis about all economic behavioural aspects, but it is a specific exploration of a few important ideas, which will help to understand the saxophone's role in advertising. The five basic elements of communication are the source (communicator), the message, the medium,[13] the recipient and the objective, i.e. the intended effect on the recipient.[14] When the recipient (or consumer) receives the message, internal psychological processes take place. Among these processes are motivation, perception and attitude formation, which are all cognitive processes, which influence the decision-making process of the consumer. Cognitive attitudes relate to the beliefs or disbeliefs of the customer. These elements have been studied and defined in different ways; the phenomenon of 'attitude' alone has some five hundred definitions.[15] In this study attitude shall be defined as "A person's consistently favourable or unfavourable evaluations, feelings and tendencies towards an object or idea".[16] Apart from being cognitive, attitudes can also be affective, which relates to the feelings or emotions evoked by something. Or they can be conative, which describes the link between the attitude and the behaviour that is likely to result from an attitude.[17]

The next aspect that needs defining within this study is the word 'perception'. Perception is to be understood as "The process by which people select, organize and interpret information to form a meaningful picture of the world".[18] Or following the definition of Brassington, which gives some extra information: "Perception represents the way in which individuals analyse, interpret, and make sense of incoming information, and is affected by personality, experience and

[12] Chisnall (1997), p. 274
[13] cf. Haley et al. (1984), p. 14 where they investigated the contribution of music and its effects as a non-verbal type of communication specifically in TV advertising.
[14] cf. Koeppler (2000), p. 14
[15] cf. ibid., p. 4
[16] Kotler et al. (1999), p. 998
[17] cf. Brassington & Pettitt (1997), pp. 107-108
[18] Kotler et al. (1999), p. 1006

mood." [19] These two aspects – attitudes and perceptions – play an important role when trying to understand the saxophone's role in advertising and in the context of involvement.

Involvement, a concept that was first raised by Krugman in 1965, is an important aspect which influences the way consumers perceive an advertisement, a product or a service. It is to be understood as the degree of motivation stimulating an individual's interest in an object or activity. The highly involved consumer is usually looking for information. He or she compares many alternatives and very carefully chooses one of several options. On the other hand there is the low involved individual. Somebody with low involvement realises information casually and without looking for it. Only a small amount of information is grasped and remembered. [20]

For this investigation the concept of involvement is important, as the consumer can be helped to realise and remember an advertisement better through the use of stimuli that carry activating potentials. These can be associations (like positive characteristics the consumer links with the stimulus) or symbols (e.g. words) and signs (such as iconographic images). Different people react differently to the same stimulus. [21] Somebody who is interested in the saxophone will show more interest in the advertisement and thus towards the product or service advertised because the image of the saxophone in the advertisement creates higher involvement. The saxophone is an element towards which that person directs his or her selective attention. Selective attention is therefore to be understood as "the tendency of people to screen out most of the information to which they are exposed". [22] While this may be effective with some people or target groups, others may need other stimuli to experience the same effect.

This is especially important when low-involvement products are advertised. These make up the biggest share of all advertisements and are directed towards passive, mainly indifferent people. It is thought that the use of pictures and images is an effective method of advertising, as information shown in pictures can be digested more easily and quickly than text. Low-involvement products are bought not because of better product quality but because they appear to be more attractive. [23]

[19] Brassington & Pettitt (1997), p. 102
[20] cf. Schwaiger (1997), pp. 27-29
[21] cf. Belch & Belch (2001), p. 114
[22] Kotler et al. (1999), p. 247
[23] cf. Koeppler (2000), p. 81

2.3. Sociocultural Influences

Whether an advertisement or campaign is received and understood depends on many factors. In addition to personal preferences and intellectual ability, social and interpersonal factors (such as cultures and subcultures, groups, reference groups, social class, and family or friends by whom the recipient of an advertisement is surrounded and on whom he or she is dependent) are important.[24]

In this context, the following definition of culture, after Kroeber & Kluckhohn, provides a good basis for the following discussion:

"Culture consists of patterns, explicit and implicit, of and for behavior acquired and transmitted by symbols, constituting the distinctive achievement of human groups, including their embodiments in artifacts; the essential core of culture consists of traditional (i.e., historically derived and selected) ideas and especially their attached values; culture systems may, on the one hand, be considered as products of action, on the other as conditioning elements of further action." [25]

This definition emphasises the importance of symbols[26] within a culture.[27] Symbols represent certain ideas. Objects and events become meaningful in a symbolic way based on history and developments of which the advertiser has to be aware. This is because the various meanings associated with a symbol influence the way in which the consumer perceives the symbol, and therefore influences his or her behaviour. A symbol in advertising has to be used in a certain way that matches the way consumers understand the symbol.[28] Transferred to the saxophone, this means that advertisers should be aware of the saxophone's background within the cultural frame, as they have to understand the visual imagery of the saxophone within the context of a certain (here: the German, Austrian, Swiss) culture. The saxophone might otherwise be used in a way, which does not carry the intended meanings.

[24] cf. Brassington & Pettitt (1997), pp. 109 et seq.

[25] Dieterle (1992), p. 45

[26] 'Symbol' is here understood in a very broad sense. This definition of a symbol incorporates the meanings of icons and indices as well. A more detailed view will be given in section 2.4.1., where the generic term 'image' is broken down into icons, indices and symbols.

[27] For the discussion of language as another strong influence of culture and its relevance specifically in advertising, cf. Cross (1996), pp. 4-6. Examples are given for the 'linguistic vandalism' that advertisers use to create its spurious surface of language games, appropriating words for the use in realm somewhere between truth and falsehood, p. 2

[28] cf. Dieterle (1992), p. 47

Within every culture there are subcultures based on religion, nationality, racial grouping, language or geographic region.[29] Furthermore, every individual belongs to various groups, which influence a person's behaviour. First of all there is almost always a degree of social class structure. Other reference groups can be either formal, such as professional bodies or hobby-orientated groups, or informal, such as lifestyle groups. There are various lifestyle models, which take into consideration dimensions like activities, interests, opinions, and demographics, as all these factors also influence the consumer's behaviour. In addition, family, and a person's role within it, have an important impact on buyer behaviour.[30] These sociocultural factors and their various influences build a very complex system, which makes it almost impossible to predict the effects on a consumer regarding a single element in advertising. Nevertheless, they have to be taken into consideration as an advertisement is always directed at specific target groups with specific values and ideas. Applied to the saxophone this means that the advertiser should know that among people, who are orientated towards classical music, for example – thus belonging to an informal group – the majority will probably not be attracted by the saxophone, as in classical music the saxophone is still not a fully accepted instrument.[31]

Another very important aspect in this context is that there is an overflow of information in our cultures nowadays. The daily presence of gripping optical and acoustical forces strongly influences our aesthetic feelings, and our lives in general, more quickly and strongly than this has been possible for many centuries. Advertising for services and products reflects our everyday culture.[32] Translated to advertising with a saxophone this means that the saxophone must play some important role in our daily lives, as the saxophone appears in quite a few advertisements, which will be analysed later on.

One more aspect to be mentioned regarding culture is that in this study the advertisements of three countries will be considered. The German, Austrian and Swiss cultures all belong to the same cluster of countries, as described by Ronen.[33] Even though one must always be careful not to generalise, this implies that they are similar enough to be investigated at the same time. It should be noted, however, that Germany and Austria differ from Switzerland, owing to the Third Reich and its consequences for the saxophone and its music in being

[29] cf. Kotler et al. (1999), p. 231 and Brassington & Pettitt (1997), p. 112
[30] cf. Brassington & Pettitt (1997), pp. 109-116 and pp. 177-180
[31] The saxophone's history and its current perception will be analysed in Chapter 4.5.
[32] cf. Ciolina & Ciolina (1993): „Die alltägliche Gegenwart der eindringlichen optischen und akustischen Kraft der Werbung prägt unser ästhetisches Empfinden, unser Leben ganz allgemein, rascher und mehr, als dies über Jahrhunderte möglich war. Werbung für Dienstleistungen und Produkte ist das Spiegelbild unserer Alltagskultur.", p. 9
[33] cf. Ronen et al. (1985), pp. 435-454

regarded as 'degenerate'.[34] Otherwise, differences are insignificant and can be ignored.

Advertising creativity also assumes an important role within this context. The elements of creativity consist of the broad categories format, tone, style and visuals used in an advertisement. The way in which the advertisement is presented is based on the creativity used to develop it. The idea behind an advertisement is vitally important and very often is taken from aspects and situations out of popular culture.[35]

However, advertising creativity is also very often in the line of fire, as some advertisements have already won advertising awards but failed to fulfil their main objective. So when is an advertisement creative? Some would say that an advertisement is creative when it fulfils its primary objectives to increase sales or enhance the image of the product advertised. Others define creativity from an artistic point of view, completely ignoring the principle ideas or objectives of advertising. Others base their opinions somewhere in-between.[36] So even if the design of an advertisement very often determines whether an advertisement is noticed at all and with the knowledge that effectiveness and liking of an advertisement are not always easy to reconcile, it should always be remembered that "entertainment value should not override the purpose of informing consumers about the object of the message".[37] The danger of advertising creativity is that consumers might not recognise the link between the advertisement and the product or service that is advertised. They might remember the advertisement, but not even realise what it is advertising or miss the connection between the advertisement and the intended meaning and thus misinterpret or misunderstand the advertisement's message. Such an advertisement would be useless in regard to its desired objectives.

The word image has an ambiguous meaning. On the one hand, an image is an optical appearance, a picture of something. On the other hand, an image is something intangible, invisible. It is the reputation of something. When the word 'image' is used, its meaning depends on the context, although sometimes its ambiguity will be consciously exploited. Furthermore, a distinction should be made between an image in advertising, which refers to pictures used in advertising, and image advertising, which is the same as institutional advertising.

[34] see Chapter 4.3. for the background of the saxophone's history in Germany
[35] cf. Lois (1993), p. 16
[36] cf. Belch & Belch (2001), p. 245
[37] Oller & Giardetti (1999), p. 179

The following sections will take a closer look at signs and images in advertising. Therefore the construct of semiotics will be explained, as that will help to understand how images can be used in advertising and how they work.

2.4. Images in Advertising

Semiotics is the study of signs and signifying practices.[38] There are two main scientists who have dedicated their work to semiotics. The one who is more practical regarding visual art, and thus more appropriate to consider in relation to the investigation of the saxophone in advertising, is the American philosopher Charles Peirce (1839-1914). His ideas and definitions will be explained in more detail in the following section. The ideas of Ferdinand de Saussure, the other main scientist who dedicated his work to semiotics, will not be discussed here.

It has to be mentioned that some marketing specialists do not believe in the relevance of semiotics and the interpretation of signs and symbols, but as there is evidence that consumers behave according to the meanings they attach to signs and symbols, marketing professionals should be aware of those meanings and interpretations.[39] Or as Oller & Giardetti put it: "...because societies are formed only through the powers of signs which provide our only means of access to the material objects and events that constitute societies. Therefore, it is clear that the production and understanding of signs themselves is the essential issue." [40]

2.4.1. An Introduction to General Sign Theory

The science of semiotics uses semantic properties to classify the relationships between signs and their meanings. A semantically oriented description focuses on how the elements of a particular mode (images, words, musical tone, or whatever) are related to their meanings.[41] This is one method by which communication can be described.

Peirce developed a semiotic system, which consists of three categories: icon, index and symbol. His concept can best be understood by studying an example.

[38] Belton (2001), in: http://www.arts.ouc.bc.ca/fiar/glossary/s_list.html#semiotics, 13 September 2001
[39] cf. Belch & Belch (2001), pp. 142-143
[40] Oller & Giardetti (1999), p. 180
[41] Messaris (1997), p. viii

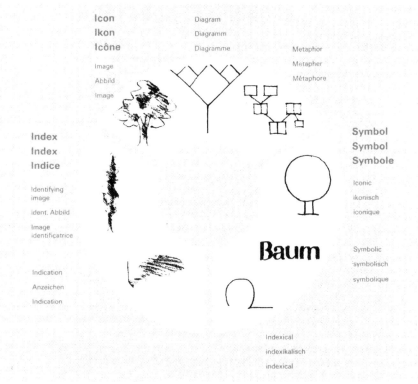

Figure 1: Semiotic Representation of a Tree[42]

The figure above illustrates the three semiotic categories, using a tree (translates into German as 'Baum'). Icons are characterised by some kind of similarity between the sign and its object, as an icon can never incorporate all qualities of its object. Indexical signs are to be understood as links between objects or shown by means of a definite characteristic. Symbols are based on conventions or tradition. They are neither similar to nor caused by the physical characteristics of an object, but they need associations with the object to give them material content.[43] The use of them is based on convention and is arbitrary. Symbolic signs are often found when they serve to simply and understandably point to a rather complex and abstract area or issue.

[42] Schmittel (1978), p. 61
[43] cf. Schmittel (1978), pp. 60-61, Oller & Giardetti (1999), pp. 20 et seq. and Messaris (1997), p. viii, and Scott (1994), pp. 264-268, who speaks of (advertising) images as a discursive form, like writing, capable of subtle nuances in communication or, like numbers, capable of facilitating abstraction and analysis.

Other authors who dedicated their studies to the field of semiotics contributed additional elements. Eco,[44] for example, added the category of codes. Codes are the basis for the classification of signs according to the described phenomena. They are rules by convention, with which signs can be transformed into another modality, such as feelings or actions. It is mandatory for enabling communication that the sender and the receiver of a message possess common codes.[45] A code can also be defined as the "establishment of a conventional rule-following relation in a symbol, represented as a deterministic, functional relation between two sets of entities".[46]

2.4.2. How Images Work

The concept of semiotics is important because it explains how images work. As it will be shown in Chapter 5, the image of the saxophone has been used in various ways and semiotic theory can help to explain why this is the case. An advertisement can only achieve its objectives if the audience understands what the advertiser intends to say. The message needs to be in the language of the people addressed, in a medium which they hold in common, and in images, gestures and words that they understand.[47] Therefore, it is very important to define and understand the right target group for a given advertisement and to select the images used in advertising carefully. Ogilvy even claimed, "that the subject of an illustration is more important than its technique".[48] This could be interpreted to mean that how the saxophone is used in advertising is less important than the fact that it is used in the first place. On the other hand, however, it is said in semiotic literature that the way in which icons are used in advertising decides whether or not they will attract attention, elicit different emotions and influence attitudes and perceptions, and thus have different effects.[49]

The explanation of the reasons why some signs work better than others is given by Oller & Giardetti who claim the reason being that some signs are more faithfully connected with their objects than others are.[50] This means that the sign used (the image of the saxophone) in an advertisement needs to have access or

[44] For a list of Umberto Eco's publications on semiotics see No author identified (2003), http://www.teamup.de/EcoOnline/Bibliografie.html, 3 June 2003

[45] cf. Hübner (2003), in: http://www.rossleben2001.werner-knoben.de/doku/kurs76web/node 16.html, 3 June 2003

[46] No author identified (2003), http://pespmc1.vub.ac.be/SEMIOTER.html, 8 June 2003

[47] Oller & Giardetti (1999), p. 11

[48] cited in ibid., p. 16

[49] cf. Messaris (1997), p. 51

[50] Oller & Giardetti (1999), p. 49

links to the minds or thoughts of the target audience, so that they can identify with the image used. Bang[51] confirms this by saying:

"This word associate is the key to the whole process of how picture structure affects our emotions. ... We feel differently looking at different pictures because we associate the shapes, colors, and placement of the various picture elements with objects we have experiences in the 'real' world outside the picture".

This shows once again that images and the target audience have to be carefully matched in advertising, as those outside the target group may not understand particular images correctly. Only those who direct their selective attention towards the image and are ready to make the appropriate associations will be affected by the advertisement.

2.4.3. Shapes and Colours

Images used in advertising need special features, which can be recognised by the targeted audience. So what are these special, characteristic and recognisable features or individual forms of the saxophone? Footnote 234 offers a suggestion: the most noticeable and distinctive feature of the saxophone seems to be its characteristically folded U-form, a characteristic which straight saxophones (mostly soprano and sopranino) do not have. Furthermore, the keys, which are spread over the body of the saxophone according to acoustic reasons, are round. The S-shaped crook which links mouthpiece and body of the instrument is curved. All in all, it is the rounded shape that stands out.

Messaris investigated shapes in connection with style and gender in advertising in his study of *Visual Persuasion*. He points out that, citing Baker, "The harsh, angular edges or square objects ... suggest masculine temper while the round shape of a circle implies the gentleness of a woman".[52] Thus round shapes are used to symbolise feminine features. This can be directly applied to the semiotic study of the saxophone. Its curves symbolise the gentleness of a woman. This also leads to the sexy sax, actually just an alliteration, but seen in connection with forms and their associations with gender, a new explanation for the sexy sax seems to have been found: the saxophone is seen as a sexy instrument, as its forms reflect or symbolise the shape of a woman's body.

[51] cited in Messaris (1997), p. 58
[52] ibid. (1997), p. 76

Apart from shapes it has been investigated how congruity and incongruity of pictures influence perception and recall as variables of consumer behaviour. Incongruity resorts back to saved information in one's memory. A stimulus consists of various parts, which represent an experience respectively. Each element has got a meaning. A level of expectation is developed by recognising the element and its meaning. This experience, together with other stimuli and the possibly identified element, will influence the perception process.[53] If e.g. a figure is perceived, whose head belongs to an elephant, the body of this elephant is also expected. Should there, however, be the body of a lion instead, then there is a conflict between expectation and perception. The same applies for a human body with the head of a dog and other examples that have been tested empirically. This perception of certain non-related parts within a stimulus creates a conflict and uncertainty, since a clear interpretation of this stimulus is not possible or only to a limited extent. Research has dealt with the variable 'incongruity', which is considered to be a potential variable for increasing the level of activation in the activation theory. In two experiments recall performance has been tested for congruous and incongruous pictures. It could not be found that with the use of incongruous pictures the recall of the message as a whole was higher. Higher recall that went beyond the recall of the message could only be noted for elements with a continuous text in combination with an incongruous picture. This shows that there is an influence on the perception of the message by its topic (the product category that the advertising is for). It is further assumed that there is an overlay of an unspecific activation by a specific reaction of the consumer, to look for elements like continuous text as a possible hint to solve the problem of perceiving the picture.[54]

A second experiment investigated the possible effects of the contents of a page with incongruous pictures. The hypothesis that there is a significant influence on the perception of this advertisement could not be accepted. This result is explained with the limited effects of activation. Should the picture be within a context, that has some relevance to the personal atmosphere of a customer, then the activating effect of a picture is overlaid in a way that a relatively high level of picture processing will not generate a possible further increase.

Colours are an element of advertising design, but they also play an important role in the interpretation of signs. The original colour of the saxophone is gold, which is very similar to yellow. Yellow, according to semiotic theory, belongs to the warm colours together with red and the colours in between. They are called warm colours because they resemble the colour of fire, the sun and other hot things. Warm colours are said to draw towards the foreground of an image

[53] cf. Kasprik (1993), p. 25
[54] ibid, p. 159

and they initiate warm visual and emotional responses. The opposite of warm colours are cool colours. They cover blue and mixtures like green and violet. They are called cool colours because they resemble water and grass and other cool things. Cool colours also have the opposite effect of warm colours: they draw attention towards the background of an image and they induce cool and quiet emotions. Neither warm nor cool colours can create any effects on their own, but they are always dependent on and to be considered in connection with other formal features.[55]

The effects of colour in advertising have been also studied in order to find out whether coloured, black and white or colour-highlighted advertisements have different effects on consumer attitudes. Nowadays, many advertisements are designed in full colour, as full colour photographs are able to attract attention more easily, and prolong the time a viewer spends looking at an advertisement, although they are more expensive than those in black and white. In a study it was found out that under different processing resource conditions, the use of colour in advertisements has different effects on consumers. When the viewer's processing motivation is low, which is usually the case with low involvement, advertisements in full colour or with some colour in the photograph achieve better results. The picture appears to be more attractive and catches the viewer's attention. When, instead, the viewer's motivation is high, his or her attitudes are more sensitive, and the viewer tries to find out, if the resources have been used in an appropriate way. The interested viewer is rather interested in the claim and favourable product attitudes and not in the colours of the advertisement. Colours may even distract the interested customer from the important points the advertisement is trying to tell. And if the whole setting of a coloured advertisement is not appropriate, such an advertisement may even be less convincing than a black and white one.[56]

2.4.4. Visual Persuasion

It is generally felt today that we live in a society of over-stimulation and an information overload. Thus an advertisement is in danger of remaining unnoticed amongst all the other images by which we are surrounded. In order to avoid this lack of response in not being noticed, not drawing attention and not being received, advertising has to be 'Zeitgeist oriented'.[57] Leppälä points out that nowadays there is a tendency in advertising towards more pictures and less

[55] cf. Belton (2001), http://www.arts.ouc.bc.ca/fiar/glossary/w_list.html and http://www.arts.ouc.bc.ca/fiar/glossary/c_list.html, 13 September 2001
[56] cf. Meyers-Levy & Peracchio (1995)
[57] cf. Schmidt & Spieß (1995), p. 40

text. Instead, advertisers are trying to address people by creating certain emotions.[58] Tests have also shown that the presentation of a visual image that implies certain features is more effective in persuading consumers than just using the word, which describes the same object or feature.[59]

It could be shown that interactive pictures, i.e. pictures that integrate the brand name and product class into a single illustration, increase recall of a brand name.[60] Imaginal processing is an explanation for the effects of pictures on recall or related verbal information. Pictures increase recall of verbal information by increasing the likelihood that the verbal information will be represented by dual codes, a verbal and an imaginal code. When subjects (i.e. consumers) are exposed to low imagery information, the addition of pictures should increase the likelihood that dual codes will form. This in turn should increase the subjects' ability to recall that information. When verbal information is low in imagery, the enclosure of pictures providing examples of that information increases recall of the verbal information.[61] When two types of pictures instead of just pictures versus words were used, similar results could be obtained. Mental imagery has a mediating role when it is stimulated by an advertisement using concrete pictures in the stimulus object.[62] This leads to a tendency towards visual advertising and an aversion to advertising without visuals.[63] It also means that it is the iconic picture of the saxophone and not just the name of the instrument, which can persuade. Just using the word 'saxophone' as a symbol in an advertisement, which advertises something other than a saxophone, would not have this persuading effect.

However, visual advertising does not mean that words are no longer needed. It is true that a picture can say more than a thousand words, but "...it was noted that visual communication does not have an explicit equivalent of adjectives or adverbs, and that a common way to make up for this lack in advertising is to imply a visual analogy." [64] As there is no mutual understanding of all pictures, symbols and images, and to avoid misunderstandings, pictures still need a good

[58] cf. Leppälä (1999), p. 126
[59] cf. Koeppler (2000), pp. 99-106
[60] cf. Childers & Houston (1984), p. 649. In an earlier study Edell & Staelin (1983) found out that when the information content in pictures and words was the same, the presence of pictures did not affect recall.
[61] cf. Unnava & Burnkrant (1991), p. 229
[62] cf. Babin & Burns (1997)
[63] cf. Mitchell (1986) for an empirical investigation of the role that pictures (visuals) play in the formation of brand attitude, and how this attitude towards an advertisement is strongly influenced by the valence of the photographs used in the advertisements.
[64] Messaris (1997), p. 204

slogan or strong leitmotif so that the majority of people understand the same message as intended.[65]

In order to initiate behavioural changes,[66] pictures used in advertising have to be eye-catching and stimulating. Not only do the picture or visual elements need to draw the eye, the iconic signs used in the picture must also be immediate and vivid so that the image remains in the viewer's memory and establishes a link to the advertised product or service, which will be remembered later.[67] Furthermore, Messaris, citing Rossiter & Percy (1983), stated that the "mere association of a product with a positively evaluated stimulus such as an attractive picture ... may be sufficient to alter attitude toward the product without any 'rational' belief change preceding the effect".[68] This shows that advertising has the ability to change opinions by being attractive and giving added value to a product or service. Messaris further stresses "that the juxtaposed image may have the power to affect viewers more strongly than can a picture of the product itself".[69] In the context of this investigation the juxtaposed image trying to affect viewers is the saxophone.

Furthermore, there are some areas of which the advertiser needs to be aware when trying to create visually persuasive advertisements: Pictures are generally accepted, as they are entertaining.[70] However, the advertiser should always bear in mind the objective, or, as Oller points out: "A good message captures attention and directs it to its content, not to its own cleverness." [71]

In this context, one more aspect has to be taken into consideration, which is important when looking at the examples of the saxophone in advertising. It is the aspect of photographs versus drawings. The first question that needs to be addressed in this context is the kind of image of the saxophone that is used in advertising. As explained in the discussion of icons, indices and symbols, and as it will be shown by examples in Chapter 5, advertisers mostly make iconic use of the saxophone. The characteristic of an iconic sign is some kind of similarity between the object and its image. Therefore, generally, both a photograph and a drawing of a saxophone comply with the requirements of an icon. However, Ogilvy said in 1964:

[65] cf. Lois (1993), pp. 56-57
[66] Initiating behavioural changes is an essential objective of advertising and persuasive communication; cf. Koeppler (2000), p. 4
[67] cf. Dieterle (1992), p. 1
[68] Messaris (1997), p. 207
[69] ibid., p. 193
[70] cf. Koeppler (2000), pp. 79-80
[71] Oller & Giardetti (1999), p. 59

"Over and over again research has shown that photographs sell more than drawings. They attract more readers. They deliver more appetite appeal. They are better remembered. (...) Photographs represent reality, whereas drawings represent fantasy, which is less believable".[72]

These few sentences sum up the argument. There is a considerable difference between presenting an advertisement as a photograph or as a drawing. Photographs are the better instruments in advertising as they show reality. What can be seen in a photograph must be true, as otherwise no picture could have been taken. Is this still true today? It cannot be strictly true since with modern techniques photographs can be changed, amended or manipulated. Still, a photographic presentation of something appears to be more real than a painting or drawing. Another aspect is colour. According to Oller, colour photographs work better than those in black and white.[73] That again is due to the fact that a coloured photograph resembles reality more than a black and white picture. Black and white photographs, on the other hand, have the advantage that they can make things look old or give them an old-fashioned image.

At the same time, a drawing may be sufficient to put across a message. It may even be more effective than a photograph as the painter can leave out details, which are not important for the advertisement. Although this would also be possible with a photograph, it cannot be achieved so easily or elegantly. The advantage of a drawing is that it can simplify situations or figures. On the other hand, it may become necessary to add information in words, which might not have been necessary had the picture been a photograph, as very often photographs can speak realistically for themselves.[74] Drawings can also show some images that a photograph cannot show, as Figure 2 proves. This picture is a joint advertisement for a jazz workshop and a brewery - the red button in the foam is the logo of the brewery Villacher. The advertisement is a highly sophisticated way to advertise both at the same time. The foam clearly indicates beer, and the musical workshop is shown through the saxophone. Further information about the workshop was given in a text, which unfortunately cannot be shown here.

[72] Ogilvy (1964), p. 118; also cited in Oller & Giardetti (1999), p. 43
[73] cf. Oller & Giardetti (1999), p. 87
[74] cf. Messaris (1997), pp. 130-132

Figure 2: Villacher and Workshop Advertisement[75]

2.4.5. Advertising Effectiveness in Relation with Images in Advertising

It is very hard to tell if an advertisement is effective. One problem is that advertising is rarely used in isolation but is usually used in conjunction with other marketing instruments within the marketing mix, and it is therefore impossible to specify exactly which part of a favourable result is due to advertising.[76] The next task is to identify the kind of objectives to be reached: whether they were of an economic or of a communicative nature. Whereas economic effectiveness can be measured in figures (sales, turnover, profit, etc.), communicative effectiveness would show itself in a better image of the product or service. This is much harder to measure and specify, as a better reputation does not necessarily lead directly to higher sales or other measurable improvements. Another point that needs to be considered is the timescale; yearly budgets dictate that most businesses concentrate on short-term results, but the true value to advertising is its long-term contribution.[77] Due to these and other uncertainties, one cannot be sure what advertising effectiveness really is and how it should be defined, applied or measured. There is no single definition that is always applicable; it always depends on the context, objectives to be reached and definitions applied to a particular case.[78]

The effectiveness of images in advertising further depends on whether and how the advertisement is perceived and received by the target audience. With respect to visual images, "Phillips (1997) has pointed out that despite the increasing use of complex visual images in advertisements (Dyer, 1982; Scott, 1993), little

[75] Dorn (1995), p. 15
[76] cf. Meffert (2000), pp. 678-682
[77] cf. Wright-Isak et al. (1997), pp. 2-12
[78] cf. Wöhe (2000), p. 592

research has been done to determine how consumers read and interpret them (p.77)." [79] As can be seen from the previous discussion, the message sent to the audience needs to be understandable. An advertisement that is liked does not necessarily lead to a more positive attitude towards the product or service advertised or an increase in sales. [80]

Possibly the best way to approach the issue of advertising effectiveness in relation to images in advertising is to attempt to answer the question "What is a good advertisement?". Ogilvy answered that question in 1994 by saying, that it is one, "which sells the product without drawing attention to itself." [81] A balance has to be found between the ability to convey information and the ability to please, and the 'big idea' and images used in the advertisement have to be understood by the audience. Oller recommends three basic principles:

1. Make the message consistent with its facts – the *consistency principle*. (Then *we* will know what it means.)
2. Make it comprehensible to its audience – the *comprehensibility principle*. (Then *they* will also know what it means.)
3. Present the message in a way that gets attention and increasingly motivates action from start to finish – *the belief/action principle*. (Then our message will have its desired effect). [82]

There are various methods to test advertising effectiveness. These will not be dealt with here due to the diversity of the methods proposed and as a discussion about measuring the effectiveness of advertisements would do little to explain the saxophone's role in advertising. However, showing and explaining examples of advertisements with a saxophone will establish some common ground on the topic.

2.5. Emotion in Advertising

As it is important to understand the different appeals that are used in advertising, this section is dedicated to the aspect of emotion in advertising. The appeal itself is an approach to attract the attention of consumers and to influence their feelings towards a product or service. These approaches are generally broken

[79] Oller & Giardetti (1999), p. 174
[80] cf. Koeppler (2000), p. 69
[81] cited in Oller & Giardetti (1999), p. 171
[82] ibid., p. 7

down into two categories: the informational or rational and the emotional appeal.[83]

Emotional appeals relate to the customer's social or psychological needs for purchasing a product or service. For many customers, feelings about a brand can be of more relevance than the knowledge of its features or attributes.[84] As already mentioned when discussing the aspect of involvement, it is common belief that appeals to consumers' emotions work better with brands that do not differ enough from competing brands, since here rational differentiation is difficult. Many feelings or needs can serve as a basis for advertising appeals that are designed to influence consumers on an emotional level. Examples for these emotional appeals are:

Personal states or feelings			
Safety	Achievement	Security	Nostalgia
Love	Actualization	Affection	Excitement
Happiness	Ambition	Joy	Pride
Sorrow/Grief	Sentiment	Arousal/Stimulation	Self-esteem
Pleasure	Comfort		
Social-based feelings			
Involvement	Rejection	Affiliation	Recognition
Embarrassment	Approval	Acceptance	Respect
Status			

Table 2: Emotional Appeals[85]

These appeals are based on the psychological states or feelings directed to the self as well as to those with a more social orientation. An objective of such an advertisement can be to evoke emotional response, such as pride or sentiment that may then be carried over to the product. Advertisements using humour, sex, and other appeals that are very entertaining, arousing, cheerful, or exciting can affect the emotions of consumers and put them in a favourable frame of mind. Especially TV spots are often created in a way to evoke feelings of warmth, nostalgia, and sentiment.[86]

Emotional appeals are used to evoke positive feelings that in turn will transfer to the brand. The reason for this is the finding, that an emotional advertisement is better remembered than non-emotional messages. Other reasons that are given

[83] cf. Belch & Belch (2001), p. 275
[84] cf. ibid., p. 277
[85] ibid., p. 277
[86] cf. ibid., p. 277

for the use of emotional appeals are e.g. the influence on consumers' interpretations regarding their experiences with respective products' usage. If an advertisement associates the experience of using or consuming the advertised brand with a unique set of psychological characteristics, which would not typically be associated with the brand experience to the same degree without exposure to the advertisement, then it is called a transformational ad. These advertisements create feelings, images, meanings, and beliefs about the product or service that may be activated when consumers use it. Such an advertisement has two characteristics:

1. It must make the experience of using the product richer, warmer, more exciting and/or more enjoyable than it would appear through an objective description of the advertised brand.
2. It must connect the experience of the advertisement so closely with the experience of using the brand that consumers cannot remember the brand without recalling the experience generated by the advertisement itself.[87]

The basic components of a print advertisement are the headline, the body copy, the visuals or illustrations, and the layout. Like print advertisements, TV spots also have several components. The video and audio must work together to create the right impact and communicate the intended message. The video elements of a commercial can be seen on the screen. The visual part dominates the commercial, so it has to attract viewers' attention and communicate an idea, message, and/or image. A number of visual elements may have to be coordinated to produce a successful advertisement. The decisions of how to coordinate these elements relate to the product, presenter, action sequences, demonstrations, as well as to the setting, and the talent or the characters that appear in the spot, and other factors, such as lighting, graphics, colour, and identifying symbols.[88]

[87] cf. Puto & Wells (1984), p. 638; Puto & Hoyer (1990), p. 71
[88] cf. Belch & Belch (2001), p. 278

## 3.	Music

The following chapter will take a closer look at music, in combination with various elements that have to be understood as a preparation for the examination of the saxophone's role in advertising. Although the main investigation of the saxophone's use in advertising will concentrate on the musical instrument and not its music, an understanding in how far research has been done on music in advertising in general helps preparing and understanding the topic. Therefore, emotions will now be discussed in the context of music. The topic of semiotics, which has already been explained in the previous chapter in general, will now be looked at from a musical point of view. Further, it will be shown in how far research has dealt with the topic of music in advertising and what effects music can have on consumer behaviour and attitudes. Cultural aspects play an increasingly bigger role nowadays in advertising. Before then finding a bridge between this theoretical part and the saxophone, the different types of media will be examined in order to show the differences when advertising with these kinds of media.

### 3.1.	Music and Emotion

Interestingly enough, the role of emotions in music has been seriously neglected over the last decades, although a lot of research exists within the field of psychology and music.[89] In recent books that give state-of-the-art overviews of the research in this field, emotion as a topic has not been analysed. Since the 1950s, when Meyer published his influential analysis on emotion and its meaning in music,[90] many studies were conducted in which the reactions towards music, e.g. the affection created by music, were not in the centre of attention. As many people are interested in why they develop an affective response towards music, for some time representational processes that are central to the recognition, the identification and the performance of music have played a central role in studies regarding the perception of music and cognition. Although various groups of scientists, such as psychologists, philosophers and musicologists have been trying to understand the emotional power of music for some time now, there is still no complete theory of how it works.[91] Therefore, the topic is still one of psychology's most controversial and discussed areas.[92]

[89] cf. Juslin & Sloboda (2001), p. 3
[90] cf. Meyer (1956)
[91] cf. Stout & Leckenby (1988) for an overview of (then) previous research in psychology, music theory, and consumer behaviour and the effects of music.
[92] cf. Rosenfeld (1985), p. 48

In addition, the evaluative aspect of music within these processes has not been dealt with intensively. Although musicological thinking has historical roots dating back many centuries, views on musical emotions have been much shaped by contemporary conceptions of emotions in general, e.g. the 18th century's affect as a rationalised emotional state, in contrast to the 19th century's emotion as personal and spontaneous expression.[93] The topic is more about the possible determination or awareness of music such as liking or disliking, preference, emotion and mood, possibly also aesthetic, transcendent, and spiritual experiences. Reasons for this neglect can be found in the fact that it is very difficult to understand, observe, and measure emotions associated with music in the laboratory. In the 1980s the influence of cognitive sciences on psychology increased, which according to various academics has resulted in a strong emphasis on cognitive aspects of musical behaviour, both in perception and performance.[94] In August 2000, 94 out of 310 papers (30%) presented at the *6th International Conference of Music Perception and Cognition* in Keele, UK, contained the word 'emotion' in the text.[95] So far, the focus has been on theory and research in connection with music and emotion rather than practical problems or applications.[96] Among the few exceptions, there are music therapy, performance anxiety, and film music.[97]

For the latter, Boltz et al. concluded from their research about the role of music on inferences that viewers rely on the emotional expression of music to either generate expectancies about future scenarios or to direct attendance towards corresponding aspects of visual activities.[98] In another study an investigation about the ability of music to alter the interpretations of simple visual presentations was conducted. The effects of two different soundtracks on impressions about three geometric forms, a large and small triangle and a circle,

[93] cf. Cook & Dibben (2001), p. 46

[94] cf. Juslin & Sloboda (2001), p. 4 and the listed authors, e.g. Gabrielsson (1999), Palmer (1997), Deutsch (1999), Dowling & Harwood (1986)

[95] cf. Juslin & Sloboda (2001), p. 6

[96] cf. Madsen (1997) for an overview of findings and the discussion of the use of the *Continuous Response Digital Interface* (CRDI) which was developed at his own University (Florida State). It is a technology that enables both discreet and/or continuous non-verbal measurements of subjects' responses to variables. An example where this technology was used to detect emotional response to music can be found in Adams (1994), who randomly assigned (non-)musicians to three different types of stimuli, visual only, aural only, and visual/aural.

[97] cf. the overview of studies that concentrate on affective responses to music such as anxiety or arousal at Abeles & Chung, (1996), p. 306, with its discussion of the validity to measure affective responses to music. For music as a therapy, cf. Hodges & Haack (1996), p. 541. For the role of music in the history of film advertisements, cf. Schmidt (1997)

[98] cf. Cohen (2001), p. 256; Boltz et al. (1991), p. 602. The latter conducted a study that compared music foreshadowing an outcome versus music accompanying an outcome.

were measured in a short animation. The two musical soundtracks were judged to have approximately the same level of activity, measured by averaging responses on scales of fast/slow, active/passive, agitated/calm, and restless/quiet.[99] The relative levels of activity of the film characters differed by the two different musical backgrounds. One object, the large triangle, was judged to be the most active in one soundtrack while the small triangle was judged to be the most active in the other one. It was stated that shared accent patterns in the music and in the motion of the figures operated to focus attention on the temporarily congruent part of the visual scene, and subsequently associations of the music were ascribed to this focus. Considering this 'music and film' example it could be concluded that music alters the meaning of a particular aspect of a film.[100] Cook suggested to transfer this aspect into generality, and therefore to other multimedia examples in which music and its meaning alter the interpretation of events that are in the focus of visual attention.[101] In car advertisements the car assumes both the vitality and the highly cultural association of the classical music in the background. Music, therefore, does more than echo a counterpoint to a concept already present in the film. Music can also direct the attention to an object on the screen and establish emotionally laden inferences about that object.

The attention to a visual object might not only arise from structural congruencies but also from semantic congruencies. A soundtrack featuring a lullaby might direct attention to a cradle rather than to a fishbowl when both objects are simultaneously depicted in a scene.[102] Additional associations from the lullaby would be ascribed to the cradle. However, empirical evidence that music has the ability to focus the viewer's attention to a particular object is scant and tends to appear with simple geometric figures. It has not yet been demonstrated with more complex displays.[103] That music can simultaneously carry several kinds of emotional information in its harmony, rhythm, melody, timbre, and tonality in real life, where multiple emotions are often entailed, has still to be tested.

Apart from this more composer-oriented approach, several studies have put the performance and/or the performer in the centre of attention. Topics such as performance motivation and interpretation, the learning, and the conceptualisation process of constructing musical meaning have been investigated. Another issue is the possible contradiction of positive emotions in

[99] cf. Marshall & Cohen (1988), p. 95
[100] cf. Välinoro (1993) and the comparison of music in a commercial that acts as a 'cinematic element' to intensify a message or image.
[101] cf. Cook (1994), pp. 27-40
[102] cf. Cohen (2001), p. 258
[103] cf. Lipscomb (1999)

the recipient or listener and the negative emotions in the performer, such as distress and anxiety.

More important for the understanding of emotion in advertising is an explanation for the ability of measuring individual responses. One of the questions is, whether a listener's emotional response to music can be described as a status or rather a process. It is argued that the heart of the emotional experience of music lies in processes that can be understood in terms of creation and minimisation of uncertainty.[104] The degree of uncertainty appears to be the basis for the distinction made by psychologists between 'pleasant' and 'unpleasant' emotions. That is supposedly the case because intensity influences the sense of control experiences by the listener. In other words, emotions are felt to be pleasant when associated with confidence in the power to envisage and choose; they are experienced as unpleasant when intense uncertainty precludes the sense of control that comes from the ability to envisage with confidence. Uncertainty itself is not an emotion, it is rather one of the sustaining conditions for emotion; it is a function of the amount of information the mind is required to process. Uncertainty increases with direct relation to the number and strength of implied musical alternatives.

Other psychological aspects that are discussed in connection with music are mood, preference, attitude, personal trait, interpersonal stance, physiological arousal, motor-expressive behaviour, action tendencies, and subjective experience.[105] It is being discussed whether music can induce emotions, which should be instantiated by studies showing that listening to a piece of music leads to a synchronisation of cognitive, physiological, expressive, motivational, and experiential processes. The status of research regarding all these criteria can only be described as preliminary, therefore substantial research in several areas of measurement is required. One still needs to define the theoretical suppositions in greater detail if the work in this area is to achieve a status that permits systematic comparison, replication, and eventually accumulation of findings.[106] The future could lie in the multi-modality of criteria, e.g. verbal report complemented by non-verbal measures such as physiological responses and

[104] cf. Meyer (2001), p. 351; Meyer distinguishes anxiety from uncertainty. Unlike uncertainty, anxiety occurs when governing constraints are not known and cannot be inferred from the perception of overly complex stimuli. So anxiety is not implicative but endures, fluctuating in a persistent present; Meyer (2001), p. 359

[105] cf. Scherer & Zentner (2001), p. 361; cf. also Parrot (1982) for a study in which emotional judgments of music that was presented either alone or in combination with paintings were studied. Music judgments were more affected by the presence of paintings, especially by complex paintings with high activity levels, which were possibly acting as significant distracters.

[106] cf. Scherer & Zentner (2001), p. 385

expressive behaviour. It might further be necessary to develop a vocabulary of emotion specific for the domain of music.

Along with that come other requirements concerning the possible emotional effects of music. There is the motivational construct that might be specific to music. This is important when one attempts to assess the goal conduciveness or obstruction in cognitive appraisals of musically induced emotions. This leads to the use of music in everyday life, away from the concert hall, where music is a cultural resource in the social construction of emotions. Obviously music is heard in various circumstances, alone or with other people, along with other activities at the same time or just by itself. Researchers have to acknowledge the differences among these factors.[107] The social context plays an important role when it comes to emotional feelings and their display. It exerts an influence (albeit often implicitly) on our music listening. Music then becomes a part of the construction of emotional feelings and displays that are both reflective and communicative 'embodied' judgements used to accomplish particular social acts. Therefore, musical emotions are a form of social representation, which is negotiated as an interaction between cultural and ideological values of a society, the values and beliefs operating in a social grouping or subculture in that society, and the individual's own social and personal experience. Listeners use music to manage their moods in a number of different ways, almost as 'emotional functions' in different situations.[108] The deliberate use of music to achieve special psychological outcomes can therefore be described in terms of 'self therapy' - not to be confused with the term music therapy, where emotions have a different meaning.

Another interesting aspect concerning the previous research is the comparison of different settings and their effects. Musical and textual settings have been tested regarding their influence on affective response and the mood of naïve listeners, (listeners with no specific musical experience).[109] The settings were text alone, commercial-type background music, commercial-type background music with text, atonal music, and atonal music with text. Non-musicians were assigned to one of the five experimental conditions. As results, there were significant differences across the experimental conditions for affective responses and a significant difference in mood from pre- to post-testing. Previous findings in

[107] cf. Sloboda & O'Neill (2001), p. 427; they recommend the discursive analysis 'positioning triad' as a particularly useful method in the study of music and emotions. It supposedly provides a framework for investigating the dynamics of real-life situations that could be used for identifying the role of music and the people engaging in emotional displays.

[108] cf. Sin (1992) for a model that establishes a relationship between mood and advertising persuasion

[109] cf. Gfeller et al. (1991)

experimental aesthetics suggesting that properties like complexity influence the evaluation of music could be supported. Listeners tend to use higher evaluative and liking ratings on that music following the traditional harmonic, rhythmic, and form patterns of common western popular music, i.e. commercial-type background music. The addition of text to the background music resulted in a significantly greater effectiveness than the setting with background music alone.[110] However, the addition of background music to the text reduced the perceived potency of the text alone. The evaluation showed more positive results for the commercial-type background music conditions compared to the atonal conditions. Subjects responded to the commercial-type background music plus text with significantly higher ratings for the variables of evil and depression than on the background music alone. Background music with no text, however, received higher ratings for variables of pastoral, sensual, and sedative than atonal music. When text was added to the background music, a significantly lower rating for pastoral and sensual occurred.

A negative feeling after having listened to music and words may be the desired effect by some composers, where they and possibly the lyricists may wish to create an aesthetic experience that includes e.g. anxiety or other uncomfortable moods. In the above mentioned experiments, where atonal music resulted in a downward shift in mood it was suggested that this style of music might be more appropriate for the initial intention of the composer of the examined text, a poem. There might be instances where music is created with an intentional higher complexity in order to evoke negative feelings. Music that is used for background music in a commercial context, however, serves different purposes. Stimulus complexity either increases or decreases from an optimum in terms of producing positive evaluations. Not only does the type of music or text to which a respondent is exposed influence mood, but it can be said that with increasing complexity of the stimulus the direction of mood shift is negative and the amount of mood shift expands. The notion has been supported that music can alter affective response to verbal information and that it can communicate in a unique way from discursive forms of information.

The reactions to music that was involved in respective studies were quite positive. However, there is evidence that there could also be negative emotions based on memories of childhood experiences, often related to an evaluative context and reminiscent of the negative emotions experienced by adult performers. As a consequence, one has to be careful before generalising these

[110] cf. Gfeller et al. (1991), p. 133

positive effects on emotion of music. And that is why the findings from studies dealing with emotional responses to music should be given a closer look.[111]

In the early 1990s Sloboda stated that there is a general consensus about music being capable of arousing deep and significant emotions in those who interact with it.[112] Most adults have experienced a range of emotions to music in their lives. It has been shown that children during their pre-school years learn to identify emotional states represented in music, and that this ability improves during the school years.[113] It could further be shown that by the age of four, children perform well above chance in assigning one of four affective labels (essentially 'happy', 'sad', 'angry', and 'afraid') to musical excerpts in agreement with adults' choices.[114] Performance improves over the school years, even though it could be shown that 5-year-olds, while performing almost like adults, tended to confuse 'afraid' and 'angry', just like all other age groups.

Other studies focused on specific musical features such as the contrast between major and minor. It was found that 8-year-olds and adults – but not 5-year-olds – applied 'happy' and 'sad' consistently to excerpts in major and minor in Western music.[115] Only adults consistently chose 'happy' for ascending contours and 'sad' for descending. In another study subjects were allowed a choice of four faces – 'happy', 'neutral', 'sad', and 'angry', and were exposed to three different tunes presented in major and minor, with or without accompaniment.[116] When relatively positive responses (happy or neutral) were contrasted with negative responses (sad or angry), even 3-year-olds consistently assigned positive faces to major and negative faces to minor. With increasing age this tendency becomes stronger. Therefore, there is some indication that young children are able to grasp the emotional connotation of the two modes at an earlier stage than they can differentiate their response in a more cognitively oriented task.

The frequency of response is less a function of the type of cognitive appraisal underlying the emotion than of its cognitive specificity. The problem is that there are major problems with any empirical approach that limit subjects' responses to a set of experimenter-determined categories. While hearing the same recording of music on two different occasions one can be moved to tears

[111] cf. Holbrook & Anand (1992) and their study in which they tested music (a computerised jazz piece played at 14 different tempos while respondents were in a low or high arousal condition) and its influence on perception and affection towards product design.

[112] cf. Sloboda (1991), p. 33

[113] cf. Dowling (1999), p. 618

[114] cf. Cunningham & Sterling (1988) and Dolgin & Adelson (1990)

[115] cf. Gerardi & Gerken (1995)

[116] cf. Kastner & Crowder (1990)

the first time, while remaining completely detached the second time.[117] There are several reasons for that; one is that the same piece of music may be appraised on different criteria, e.g. a musical passage appraised as an event may incline a listener to an event-based emotion such as sadness. On the other hand, the same piece appraised as the action of an agent may incline a listener towards an emotion such as gratitude. Another reason could be the prevailing mood that determines the extent to which a piece of music will lead to strong emotional experience of particular sorts. It may be heard to extensive grief or sadness in response to music when somebody's prevailing mood is cheerfulness, even though one is carrying out the relevant cognitive appraisals of the music, which in other circumstances would lead to sadness.

The pioneering psychologist Hevner stated already in the 1930s that listeners often judged the mood of various pieces of music similarly. She found out that high-pitched music was usually felt as being happy and playful, whereas low-pitched music was often described as sad and serious. The topic of how tempo and pitch affect the listener's emotional reactions has also been studied by Thayer, who found out that the listener's reactions to musical tempo might be due to their body's own rhythms. It is certain that musical rhythms affect both heart and brain, but although this topic has been studied thoroughly since the 1960s, there still seems to be no answer for the exact processes.[118]

The third and last possibility is that there may be some emotional states, which simply preclude any relevant appraisal-based emotion to the music from occurring at all. It was found out that there is an almost complete absence of differentiated responses to the music itself when the context was being appraised as negative. A typical negative context was a situation of threat, anxiety or humiliation, brought about by being placed in a situation or playing in front of an audience or a music teacher. They often included fear of verbal or physical punishment. For many subjects this had a long-lasting effect, leading to a refusal of playing music, or to considering oneself as completely unmusical. There is evidence that the likelihood of experiencing positively valued emotional responses from music is a direct function of the degree to which the subject feels relaxed and unthreatened. Under negatively associated circumstances the music itself will not be likely to yield appraisal-based emotions. The reason for that could be that appraisals are not undertaken at all or that appraisals are in some way 'blocked' from access to the system, which produces emotional experience.

It is considered as certain that expectancies and violations of expectancy play a major role in the promotion of emotional reactions to music. The presently

[117] cf. Sloboda (1991), p. 38
[118] cf. Rosenfeld (1985), p. 48

46

available data shows that the nature of an emotional experience depends on the particular character and pattern of an interlocking set of implications and their realisation or non-realisation.

To what extent is the emotion 'induced' in someone by the 'force' of the music, or does someone appropriate the music in order to generate an emotional experience, using the music as a resource in a more active process of emotional construction? In such a case, emotion only appears if the person decides that it should be there.[119] As a consequence, the issue is whether we think that a more receptive or a more constructive approach is suitable to characterise and analyse emotions in the context of music. The receptive approach acts on the assumption of a listener's role, preferably in a concert hall or in a psychological laboratory. Listeners are more passive when music is presented in order to influence their thoughts and feelings. A more 'active' view of emotional engagement changes several of the previous approaches to music. This places the listener in a network of forces and influences: the person lets emotions happen.

The question remains as to whether emotions have a more biological basis and reflect neurological and neurochemical mechanisms developed by natural selection, or whether a more sociocultural approach to musical emotions should be applied. In the biological perspective on music and emotion these neuropsychological and evolutionary considerations are crucial. Humans have always communicated emotions via their voice; animals do that via acoustic signals.[120]

A sociocultural approach to music is rather new and tries to generate a greater understanding of wider non-musical settings. Music, however, is a cultural artefact,[121] and is therefore unlike other things and events to which we may experience emotions. Certain responses to evolutionarily threatening situations are often non-optional. For a cultural artefact a more complex framework is necessary. Over the last years researchers have found a middle position regarding this biology–culture dimension.

It should be taken into consideration that for the purpose of this study biological issues are not important. It is more about the influence of culture in general, in

[119] cf. Sloboda & Juslin (2001), p. 453

[120] For an example of neurophysiological/psychological research see the German study of Rötter (1987). He conducted a research on 'analytical hearing' and its subjective effects in terms of intensity of experiencing the music and increased electrical conductivity of the skin. See also Bartlett (1996), p. 355, and the extensive overview of studies in this area, that date back as far as 1934, as well as to other biological effects like muscular tensions and motor activity, p. 364, and blood pressure, p. 361

[121] cf. Sloboda & Juslin (2001), p. 455

terms of possible differences between the perception of the saxophone in a social context such as the reception of an advertisement in a specific geographic location. The 'special' history of the saxophone in Germany, which will be discussed in Chapter 4.3., might have a significant sociocultural impact on emotions that are associated with the music played on or associated with this instrument.

3.2. Music and Semiotics

As explained above in the introduction to general sign theory, symbols, indices and signs are three important aspects within the semiotic theory of Peirce.[122] In order to understand not only the connection between advertising and semiotics, but also its importance regarding music, in the following paragraphs some light will be shed on this topic.

In terms of music, the reproduction of acoustic phenomena of nature, such as the imitation of birds' voices, can be characterised as an iconic sign. In addition, evoking affective reactions by music is considered as an iconic sign.[123] The idea of iconic signs in music is that certain emotions evoked by music feature common criteria with other non-musical physiological experience patterns. An example for this could be the correlation of musical moods and certain biorhythms of human beings. Generally, iconic signs do not have more than an average relevance in music.

Regarding indexical signs in music there are only few examples. If at all there is a musical indexical sign it would be the sign that indicates a break or the length of a note.

Within musical communication symbols are the most relevant category of signs. In cultural and ceremonial actions, they, as a simple instrumental sound, represent a symbolic sign. Within 'functional' music certain styles such as marching band music, classical music or folklore can represent symbolic signs. For marching band music e.g. the tradition was that this type of music stood as an icon for war and soldiers, whereas today it is merely a symbol of strength and victory. For musical communication it is supposed that by a joint sound system

[122] For other important semioticians see Tarasti (2002) and his historical perspective about music and semiotics, pp. 4-9
[123] cf. Tauchnitz (1990), p. 51

and a rather identical process of socialisation sender and receiver can, at least rudimentarily, decode musical signs.[124]

The sum of these associations is caused by a sign and can be called a connotation. It is considered as an extension of the culturally induced and conventionalised meaning of a sign. They are sub-codes, in a situation, in which a receiver possesses several sub-codes.[125] The type of sub-code that is coming into effect is determined by the specific situation. Connotations can be equated with affective meaning. For music they are the result of the associations between aspects of musical structure and learned non-musical experiences. The musical structure can be considered as a basis of stimulant for further physiological processes. The function of music is predominantly seen as mediation of connotative meanings. The equation of connotation with affective meaning implies that music first of all communicates emotional meaning.

The question remains as to what degree music enables the expression of non-musical contents. Supporters of this idea argue that music, as a product of society, has always been associated with functions that are reflected within music. Therefore, music can bear reference to semantics by sound 'events' like the iconic illustration/description of acoustic incidences like bird voices, bells and post horns, by emotions, by style, genre, era or culture, where music depicts a whole era or culture like folklore, such as music of the 1960s, or by synesthesia. This refers to the ability of stimuli to create more perceptions or sensations other than the directly addressed channel of senses, such as the associations between bright light and bright sounds, fast movements with fast tempo etc. Research has also found out that certain tones bring about specific associations of colour. High tone pitches seem to create associations with yellow and green, low tone pitches rather violet and blue. 'Tender' music is associated with the colour blue, 'cosy' music with green, 'playful' music with yellow, 'energetic' music with red, and 'jolly' music with orange.[126] The basis for such a synesthesia is the mood that is evoked by music, even though one has to concede that these correlations of colour and type of mood are not consistent, and each colour can bring about different moods, as well as each mood can be caused by different colours.

[124] cf. Tauchnitz (1990), p. 52

[125] Eco calls connotations sub-codes, which are built on a denotative code. In the communicative situation the receiver of a message usually possess various sub-codes. What sub-code will be activated depends on the situation and the denotation, as this limits the choice of possible associations. cf. Tauchnitz (1990), p. 97

[126] cf. e.g. Simpson et al. (1956) for tone-pitches and colour-relations, p. 97

3.3. Music and Meaning

In the 1970s a large percentage of commercials already contained music, for TV in Germany the proportion was estimated about 65%, for radio even 70%.[127] Music is not included for the sake of itself, and not only producers choose it according to its artistic and/or qualitative criteria, but also for clearly determined functions, that lie in non-musical areas. In the 1980s it was estimated that North Americans alone encountered 60 billion advertising hours, out of which three quarters employed music in one way or another.[128]

The question is what relevance or meaning music has in commercials, primarily on TV but also in print advertisements where obviously no sound can be heard. However, the idea of music serves other purposes. From a musicological point of view it would be reasonable to start an analysis of music with its internal structures, its symmetries and directional motions, its patterns of implications and their realisation. This type of an approach moves from the music itself to listeners' responses and therefore offers a psychological approach to the meaning of music.[129] The alternative would be to discuss the context of the creation, the performance, and the reception of music. The assumption here would be that music acquires meaning through its mediation of society.

A way to oscillate between these two standpoints would be the assumption that meaning arises from the mutual mediation of music and society. In any case, different questions regarding the possible meaning of music will lead to different answers, or "each answer follows as the consequence of posing the question of musical meaning in a different manner".[130] There is no questioning that music has effects and that these effects can be measured. The meaning of music, given its enormous application in (non-)commercial contexts, has received a number of explanations, and the whole system of musical aesthetics has been built on the premise that music does not have a meaning. However, this should not be the end of the discussion as the communicative context in which music is performed (with real sound) or symbolised (in print media shown through pictures) does exert an influence on the viewer or listener. Especially in multimedia and a commercial the context is clearly defined. The music in a commercial carries various attributes or qualities that enter into the discursive structure of the commercial and become associated with the product. The significance of these attributes and qualities – their meaning in terms of the shown commercial – emerges from their interaction with the story line, the

[127] cf. Rösing (1975), p.139
[128] cf. Huron (1989), p. 560
[129] cf. Cook (1994), p. 27
[130] ibid, p. 27

voice-over, and the pictures, which is applicable in particular for print media. If the music gives meaning to the images of a commercial, then vice versa the images give meaning to the music. As a consequence, meaning is created within the context of the commercial, resulting in the fact that music rather than *having* (owning) a meaning it *does* a meaning within a context.[131]

Words and pictures in a commercial tell a story, but they do it incoherently. What ties the commercial together into a convincing whole is the music that is used. This is done through the associations and values that it brings to the story of the commercial, and through its ability to enforce continuity. The connotative qualities of the music complement the denotative qualities of the words and pictures; in a way it interprets them. Music therefore does not just project meaning in the commercials, it is a source of meaning. It generates meanings beyond anything that is said in words, and sometimes anything that *can* be said in words. The emotions in music are experienced in a context and not just in an abstract way. The broad expressive potential of musical sounds acquires specific meaning by virtue of its alignment with words and pictures. It is a transfer to a variety of various objects. Here, music does not have a meaning, because it is music 'alone'. Nonetheless, it has a potential for the construction or negotiation of meaning in specific contexts.[132] If in commercials meaning emerges from the mutual interaction of music, words, and pictures, then meaning at the same time is something that forms the common currency among these elements.[133]

This aspect of looking at the meaning of music is just one possibility. In a non-commercial environment,[134] like the relationship between music and words in a song, the same theory applies; it is also an arena of creating meaning. If words alone want to describe what music is and conveys, there is a potential conflict as to the alleged inability to capture music in words. If however, words are not considered as a substitute or duplicate for music, but as something complementing it, then this results in a counterpoint between word and music, denotation and connotation. With this counterpoint music has the potential for meaning. Words mediate the transfer of music into meaning, into

[131] Cook (1994), p. 30

[132] cf. ibid. (1994), p. 39

[133] cf. Hung (2000) for an investigation of the effects of music, where TV viewers relate the advertisements to other advertisements, brands, and films with which they are familiar; they could assign meaning to the commercials because the music reminded them of a certain movie, a scheme relevant to reading the advertisement that was not apparent in stand-alone advertisement elements.

[134] cf. Toivonen (1993) for an analysis of TV advertisements and their myths (male and female), social messages, stereotypes, and its role in the signification process. Klempe also uses the term mythical for music and investigates the relation between music and its use for advertising strategies, cf. Klempe (1994), p. 250

communication, into discourse. How this meaning is derived in a special context like advertising with its different contexts (print, TV, outdoor, pictures, text, and combinations) will be investigated in the next chapters.

3.4. Music and Advertising

The audio portion of a commercial includes voices, music, and other sound effects. Voices can be utilised via the direct presentation of a spokesperson or as a conversation among various people appearing in a commercial. Further, a voice-over is quite common for presenting the audio portion, in which the message is delivered or action on the screen is narrated or described by an announcer who is not visible.[135]

In TV advertising, music is a very important factor with brand-building potential. Advertisers who develop commercials rely on the fact that well-known songs help to create attention towards their advertisements and hence, their brands and products.[136] Music is important in advertising, as it represents lifestyle, especially for the under-40 generation.[137] However, advertisers should be careful in choosing the right piece of music for the right brand, product, or situation. Otherwise they might not reach the intended effects but may even damage the product's image.[138] When employing music in advertising one has to be aware that music serves as a means to introduce products.[139] That means among other factors that in terms of composition criteria the music has to comply with criteria such as image or degree of innovation. According to a table

[135] In recent years celebrities with a distinguishable voice have often performed this.

[136] cf. Adelson (1998), p. 3

[137] cf. Bullerjahn et al. (1994) for the special circumstances of music and advertising for schools and school children, where they discuss the capacity of music to represent either manipulative or cultural factors; cf. Holmer & Nienhaus (1994) for the use of this topic for educational purposes, and No author identified (1994b) for the 'youthfulness" of advertising that uses music as a device.

[138] cf. Michaelson (1986), p. 133

[139] cf. Hung (2001) for teaser advertisements where advertising is highly visual, provides incomplete information, relies on lush visual image, is accompanied by music or other sound effects, and tries to create a desirable image for the advertised brand and its users. She found out that there seems to be support for the proposition that music can connect with and accentuate specific visual images to communicate meanings. Music has the ability of being corroborative with visual images to alter perceptions of individual visual clips at a profound level. Cf. also Rumpf (1997) for snippets of pop music as advertising trailers on German media.

of musical instruments and their use in music, all types of saxophones can be utilised in various ways.[140]

In the 1980s, when rock music was discovered to have a universal appeal,[141] there was an increase of rock music in advertising.[142] More and more rock stars became interested in selling their music to the advertising business as they realised that this was a lucrative thing to do. Music in TV commercials became an interesting topic to study,[143] as it had lost its back-seat status, and had acquired almost the same importance as visuals or other elements of an advertisement.[144] In the early 1990s alternative rock and post-punk music were used increasingly in advertising, as this kind of music appealed primarily to people in their teens and twenties, and could therefore be used to attract this consumer group by letting the music communicate that products were hip, dynamic and in.[145]

According to an article from 1998, advertising agencies were paying huge sums of money to buy pop songs, or get rock stars, such as David Bowie or Michael Jackson, to sing for their advertising campaigns. Companies believe to create a strong and instant emotional connection between their products and the people who like that kind of music with real stars and recognise it in their TV commercials. Although this is a good source of income, not all rock or pop stars like to be connected that closely with a company or a brand. Therefore they deny the use of their songs in advertising.[146]

[140] cf. Wüsthoff (1999), p. 42. Wüsthoff examined a characterisation of all saxophones and their possible use for advertising music. He describes the soprano saxophone as practical for high pitches, as gaudy and sentimental, jazz related; the alto saxophone for medium pitches, as sentimental or hard, variable, jazz related; the tenor saxophone for low and medium pitches, similar to the alto saxophone, the baritone saxophone for low (deep) pitches, as hard and loud, and the bass saxophone for very low (deep) pitches, hard and powerful accentuation.

[141] cf. Jauk (1994) and his study on different styles of rock music with differences in coherence between the elements of musical and visual structures that eventually lead to various increases in the complexity-ratings of video-clips.

[142] For the role of music in advertising in the 1970s see Schmitt (1976) who also deals with the effectiveness and contents of this type of music.

[143] cf. Bruner (1990) who stated that until the end of the 1980s fewer than twenty empirical published studies in marketing had music as their focus.

[144] cf. Demkowych (1986), p. S-5

[145] cf. Elliott (1992), p. 15

[146] cf. Marks (1998), p. 51

In the early 1990s, apart from rock music, classical music appeared in advertising to a great extent.[147] Advertisers usually use classical music to project classiness and sophistication on to their shops, brands or products. However, by using classical music, sometimes the opposite effect of using rock music is intended: children do not usually like classical music and are therefore being kept out of shops that play classical music. Compared to pop or rock music one of its big advantages is that classical music is often in the public domain, therefore advertisers do not have to negotiate with the composers about the fees, and is therefore relatively cheap.[148] Another kind of music being used in advertising is jazz. Since the 1990s there is an increased use of jazz in advertising. Especially commercials for expensive cars such as *Cadillac*, *Mercedes*, or *Jaguar* use jazz as background music in their commercials. It is supposed to transfer 'timeless quality' onto the advertised products.[149] Over the last years many companies have paid large amounts of money for music rights to use them in their commercials.[150] And not to forget, as David Ogilvy once declared: "If you have nothing to say, sing it".[151]

Music can play different roles in TV advertising. It can provide a background that, by being perceived as pleasant, can attribute to the creation of the appropriate mood. It is then called needle drop, where the music is prefabricated, multipurpose, and highly conventional. It is the equivalent of stock photos, clip art, or canned copy, and is a rather cheap way to introduce music into a commercial, when a particular normative effect is desired. In other commercials music is more central to the advertising message and is supposed to attract attention, break through the advertising clutter, communicate a selling point, help establish an image or position, or add feeling.

Jingles are another element in TV and radio commercials. They are songs about a product or service that usually carry the advertising theme and a message.[152] In some commercials, jingles are rather used as a type of product identification and

[147] The 1990s were also the only time that an article dealt with marketing for the saxophone, but this article was looking into the possibilities of utilising marketing know-how for musicians playing the saxophone. In particular it was meant for (saxophone) repair technicians; cf. Laws (1994)

[148] cf. Qeenan (1993), p. 214

[149] cf. Gladstone (1998), p. 34

[150] *Microsoft* paid a reported 4 Mio. US$ to use the song "Start me up" by the Rolling Stones in their campaign for *Windows 95*; *Nike* was allowed to use the actual voices of the Beatles (song: Revolution) for athletic shoes for 500.000 US$; cf. Belch & Belch (2001), p. 293 for more examples of products and songs.

[151] No author identified (1989), p. First Business Page

[152] Probably the best-known example is the jingle "It's the real thing" from the 1970s *Coca-Cola* advertising.

appear at the end of the message. Jingles first came up in the 1950s in the USA, with an increasing importance until the 1970s, which could be described as the "golden era of jingle-writing". After that, jingles were and are still used, but no longer to the same extent.[153] Today, there are in addition so called needle drops, a type of music that is prefabricated, multipurpose, and highly conventional. It can be described as the musical equivalent of stock photos, clip arts, or canned copy. It is an inexpensive substitute for original music, paid for on a one-time basis and is dropped into a commercial or film, when a particular normative effect is desired.[154]

Regarding the topic of music and advertising, researchers have looked at various aspects. Methodological approaches have not always been the same. This might explain the different results, but even studies with rather similar approaches have come to contradictory evidence. An example is the research by Gorn and Kellaris & Cox, where test arrangements were almost identical, the same stimuli were used, and the authors still came to different conclusions.[155] In most studies the specific characteristics of advertising stimuli were not debated closely. The premise was a standard commercial, where the message comes as text, and the music has either an illustrating or accompanying function. The following table shows that function and meaning of music depend on the idea of commercials.

[153] cf. No author identified (1989), p. First Business Page and D7
[154] cf. Scott (1990), p. 223
[155] cf. Gorn (1982) and Kellaris & Cox (1989)

Meaning & relevance of single commercial components	Type of commercial		
	Product description	*Musical entertainment*	*Ad history*
Picture	High relevance – Conveying product information and emotions	Medium relevance – Showing musical entertainers or other scenes with entertaining character	High relevance – Describing a sequence of action, in which the product or its use are demonstrated
Text	Medium relevance – Mediation of factual information	Low relevance – Mediation of necessary information	High relevance – Explanation of the presented scenes
Music	Medium relevance - Increase of emotions that have been stimulated by the pictures	High relevance – Arousal of attention of the target group via their interest in music	Medium relevance – Illustration of shown scenes and creation of emotions (e.g. tension)

Table 3: Exemplary Description of Various Types of Commercials and the Relevance of the Respective Components of the Spots[156]

Such a scheme of categories provides a structure for looking at spots. It also enables an analysis of possible functions of music in the respective cases. It is of importance whether the music is background music, whether single parts of the sound or the song serve to create a certain mood, whether it is a jingle or whether one tries to establish a contact with a certain target group by using a known piece of music. The effect of background music with a spoken text is supposed to be different from the one with a jingle.[157]

Another aspect could be the selection of the study objects. It is probable that affiliations with a certain group and the special interest of test persons, as well as other socio-demographic criteria, can have a significant influence on the study results. Therefore, one either has to use a sample that is big enough, or the test persons are chosen according to criteria that are relevant for the purpose of the research. One criterion could be the musical tastes of the test persons. A general assumption is that age, level of education, and social status of a target group exert a high influence on their musical taste. If the musical style is of

[156] cf. Vinh (1994), p. 81
[157] cf. Yalch (1991), p. 268

interest for the advertising conception, the relevant criteria for that style with a given socio-demographic criteria have to be identified.[158]

Another issue revolves around the characteristics of the advertising object for the effects of music in advertising. Interest and receptive behaviour are determined by the knowledge of the advertised product, as well as the relevance for the person. As already mentioned above, this construct has been described as 'involvement'. Controlling and manipulating the type and extent of such a psychological construct in an experiment can be extremely difficult. Therefore, it might be better to isolate the factors that lead to involvement individually, and deduce implications for the test persons and their expected behaviour.[159] The issue of directed or undirected attention cannot be solved easily, not even with technical equipment. It has been attempted a situation in which the test persons do not realise that they are part of an ongoing research, or at least where they do not identify their reaction to the music of an advertisement as the primary task of the study. Tauchnitz conducted experiments with directed as well as undirected attention. As part of the undirected research, the test persons received a 'dummy' job, where the commercials in question were part of a video clip programme. In this way their interest in the spots was deflected. The special advantage of this procedure was that the test persons were not aware that they were part of an experiment.[160] One of the findings was that there is a positive influence of music on the perception of brands and therefore the use of media vehicles with music leads to a distinct and improved perception of brands.[161]

Galizio & Hendrick examined the effects on attitude, recall and mood of a guitar being used in communication from a psychological point of view. According to them, the research of music has so far concentrated on aesthetic and emotional responses to stimuli, but, as literature from the late 1960s and early 70s showed, music was already recognised as being capable of serving as means for attitude formation and change. Although studying music as a means of communication is not easy according to various surrounding circumstances, they found out that with the presence of guitar accompaniment or singing, the test persons showed greater positive emotional arousal and greater persuasion than dramatic speaking or no guitar accompaniment did. With the guitar accompaniment, communication was facilitated and more easily accepted. As their study was done on folk songs and not on advertisements, and as other studies from the

[158] cf. Vinh (1994), p. 82
[159] Vinh shows a scheme in which the correlations between involvement, involvement-inducing factors and the audio and visual attention of listeners are described, cf. ibid., p. 84
[160] cf. Tauchnitz (1990), p. 196
[161] cf. ibid., p. 207

1970s showed that music could also distract or inhibit communication, one cannot simply generalise these findings.[162]

One strength of TV and radio advertising is that they are both known to spread brand awareness. Unfortunately, it is impossible to precisely measure the effect on sales.[163] The effects of music in general on the perception of media vehicles should not be overstated. Music can lead to a more positive perception than pure text oriented advertising. Therefore, it is appropriate to use music in order to distinguish messages. On the other hand, advertising with different kinds of music gets distinguished only marginally. The reason for this could be the use of a measuring instrument that is primarily able to measure cognitively oriented perceptions and judgements. Results concerning the effects of music with an audio-visual media vehicle show that by using a sensitive instrument like the semantic differential, there is a significant distinction among music-added commercials, albeit on a more emotional level. The problem seems to be that a direct effect of music accompanying an advertisement on recipients of audio-visual advertising is hard to measure. Indicators provide a more or less valuable hint as to the possible behaviour of the exposed people. It has been found out that test persons cannot recall a commercial significantly better when a popular piece of music is utilised, neither when music has an entertaining function, nor when music is used to help describe the product features. Conflicting results exist concerning the correlation between the judgement of the music in a commercial and the attitude towards the commercial itself and the brand.[164] The popularity of the music was a major determinant for the attitude of respondents to a commercial. This, however, was valid only as long as the people had an interest in the product or were familiar with it. Positive attitudes towards the commercial and the brand generated by popular music were not reflected in a higher intention to buy. This might be explained with the previous knowledge of the product,[165] where it is assumed that most recipients have already had some respective experiences. In those cases there could be buying habits that prevent an easy influencing by any commercial on intentions and behaviours. Concerning the attitudes of consumers towards commercials, a significant correlation between the product interest and the popularity of the music within the commercial could be identified. This interest was especially important for the attitude towards the commercial when it contained a high density of information.[166] Statistical analysis gives a hint for the assumption that the choice

[162] cf. Galizio & Hendrick (1972)
[163] cf. Yang & Warner (1993), p. 70
[164] cf. Vinh (1994), p. 158
[165] In the experiment the product was *Coca-Cola*.
[166] cf. Vinh (1994), p. 163

of music and pictures in a commercial does have an impact on indicators that measure the effectiveness of advertising.

Taking influence on the brand perception was much more difficult. A study by *Video Storyboard Tests Inc.*, an advertising testing firm, found out in 1984 that musical advertisements achieved higher rates in persuasiveness than advertisements with celebrities, product demonstrations or hidden-camera testimonials, but lower rates than advertisements using humour or children.[167]

3.5. Cultural Aspects

The context of music has always to be considered within its cultural environment. The cultural world of western Europe with its American influences grew out of earlier centuries, marking the decay of classical Greco-Roman civilisation. For about three quarters of our social evolution the primary function of music was the ancient idea of prayer. Western musical harmony, notation, and melodic conceptions arose within Christian church chant, directed to the Divine, rather than human listeners.[168] The audience as a recognised social grouping emerged only slowly, when music-making moved from the church to the court, the *bourgeois salon*, or the private theatre. The pivotal shift was the move to 'commodified' music, where music beyond the relish of creators, performers and accidental listeners eventually became a 'product' mass-produced and marketed. The 19th century saw new media and building technologies evolving which created the large urban opera houses and concert halls to bring performers and audience together.

Both composers and listeners grew up in a cultural environment that shaped their understanding of music. The musicologist Mayer argues "that while listening to music (as when we listen to language), we spin out certain expectations about how things will proceed, based on our cultural learnings. When the music conforms to our expectations, we relax, but if it deviates somewhat, we become tense".[169] This cultural aspect should always be kept in mind when discussing music.

In recent years there has been an increase of the so called 'world music' in the media in general and in advertising in particular.[170] The idea behind it is to 'sell'

[167] cf. Alsop (1985), in: http://global.factiva.com/en/arch/display.asp, 27 October 2002
[168] cf. Carlton (1995), p. 124
[169] Rosenfeld (1985), p. 48
[170] The term 'world music' denotes non-western music.

something that is associated with exotic things, to which first and maybe foremost this kind of music belongs. The question, however, remains as to whether the music that is employed relates to indigenous or traditional practices, or whether it has been composed by performing musicians or those who work in advertising. These kinds of music usually employ what sounds like children choirs and untexted vocal lines; in some cases the language sung is wholly invented.[171] The instruments used to accompany the singers are usually drums, and frequently there is the sound of a wooden end-blown flute. Sequences often give the music a rather rudimentary or 'primitive' sound. The lyrics are either in simple nonsense syllables, in an uncommon or even a fake language - a technique that has been used for centuries in the western world to depict people from other cultures.[172]

The concept of utilising images and sounds of foreign countries and cultures is not new. It has fascinated people in the western world for a long time, be it the 'Turkish' music in Vienna in the 18th century, the 'chaotic exotic' in France in the 19th century, or 'exotica' music from the 1950s America. Via the Internet and other new technologies, nowadays most people have instant access to information from the entire world, which was impossible until only a few years ago. All the more paradox it might seem to have a lack of cultural and geographical specificity, where 'world music' to the listeners is music that makes use of sounds from all over the non-western world. Knowing the world is becoming an important prerequisite for success in business. This success in business is, however, achieved by particularly high social groups. These people are increasingly cultivating a 'multinational multicultural' approach that advertising agencies try to duplicate or copy in their commercials. Therefore, the target group could be people who presumably possess the necessary global information and can cope with it. For them, coping means being able to retain classical historical *haute bourgeois* ideals such as the autonomous individual. A musical style that denotes internationalism and interculturality hence serves the purpose of conveying a message that these people do not need to be bothered with except to the extent that they require global informational capital for business. The individual is wrapped up in its own minds and worlds.[173]

[171] cf. Taylor (2000), pp. 165 and 179; Taylor mentions the example of an English group called *Adiemus* that was founded in 1994 with a commission from European *Delta Airlines* to score a 60 second commercial, known as *Shadowlands* featuring disjointed images. This advertising campaign was aimed at business travelers, to show the human side of high-quality service and the excitement of flying. The campaign boosted business and first class cabin sales, European revenues rose up to 600 Mio. US$ within less than two years after the launch

[172] cf. ibid., p. 163

[173] cf. ibid., p. 179

Whereas this approach provokes unilaterality, music as well as language is usually considered to have the potential to invoke complex, culture-dependent symbolic schemata. Only if the assumption is that effects of music in advertising are indeed universal and thus occur across time, situations, and individuals, then there is no need to study the use of music and lyrics in advertising for different cultural contexts. The idea would then be that any cross-cultural differences would be insignificant. Therefore, in the last ten to fifteen years some studies have been conducted to find out whether there are differences in the use of commercials and other marketing instruments in various countries. Part of these studies was also the culture that was or was not reflected in the respective countries' advertising.

During the 1980s and 90s a lot of attention was directed towards Asia with its economic boom and the questions about the behaviour of customers in this region. The majority of studies dealt with China and Japan, but India, Taiwan and the Philippines were other Asian nations under review.[174] As non-Asian countries, Brazil and the UK were investigated. Most of the studies of the cultural content in advertising were conducted between the USA and the above-mentioned countries. The reason seems to be the sheer size of the US advertising market – in the mid-90s it stood for about 50% of the world's total advertising expenditures – and the notion that the USA are a typical country for western culture and therefore appropriate as a reference model. With China as one example the values in question were tradition versus modernity. Tradition in this respect is defined as a society that has little specialisation, a low level of urbanisation, and low literacy. Modern could be defined as having a very high level of differentiation, urbanisation, high literacy, and wide exposure to mass media. The respective political systems are considered to be authoritarian or offering a wide participation from the citizens. Cultural values that were investigated (Chinese example) were
- adventure (boldness, daring, bravery, courage, or thrill),
- beauty (loveliness, attractiveness, elegance, or handsomeness),
- collectivism, competition (distinguishing a product from its counterparts), convenience,
- economy (inexpensive, affordable, and cost-saving nature of a product), effectiveness, enjoyment,
- family,
- health,
- individualism,
- leisure,

[174] cf. Cheng & Schweitzer (1996) and their literature review; cf. Strauss (1998) for language and culture of TV advertisements in Japan, Korea, and the USA.

- magic (miraculous effect and nature of a product), modernity (new, contemporary, up-to-date, ahead of time),
- nature (harmony between man and nature), neatness, nurturance,
- patriotism, popularity,
- quality,
- respect,
- safety, sex (glamorous and sensual models), social status,
- technology (skills to engineer a product), tradition (experience of past, customs, and conventions),
- uniqueness,
- wealth, wisdom, work (respect for diligence and dedication), and
- youth.[175]

Among these variables, the ones most dominant in Chinese commercials were family, technology, and tradition. On the contrary, the dominant values reflected in the US commercials were enjoyment, individualism, and economy. Common to both countries were modernity and youth. The results from this study fail to support the hypothesis that Chinese TV commercials would tend to use more utilitarian cultural values than those from the US. However, the hypothesis that Chinese commercials would tend to use more Eastern cultural values than US commercials was supported. The results show that cultural values depicted in TV commercials from these two countries have much to do with the product categories advertised. Modernity, the most dominant cultural value in Chinese TV commercials, is mostly used for automobiles, industrial products, clothing and household appliances. The value tradition, however, is mainly used for food & drink and medicine. Enjoyment is used for travel and food & drink; economy is used for service and medicine. Individualism, modernity, and sex, three typical Western values portrayed in Chinese TV commercials, were used most frequently with imported products, followed by joint-venture products. These findings imply that transnational advertisers should be sensitive to the effects of differences regarding cultural values used in their advertising campaigns. They need to pay attention to the effects of product categories on cultural values portrayed in their advertising messages. Even though Chinese customers might become as sophisticated as their counterparts in Western countries, it does not suggest that advertisers in China will have to resort to utilitarian values as they are doing in the USA today. The adoption of utilitarian and symbolic cultural values in advertising has as much to do with cultural heritage as economic development. The example shows that although there is a considerably strong influence of Western culture in China and the country is more open and tolerant towards foreign influence, it depends on specific product categories to determine

[175] cf. Cheng & Schweitzer (1996), pp. 27-46

as to whether 'own' or 'foreign' values should be used in an advertising campaign.

For this study, music and lyrics in commercials are of special interest. Only very few studies have investigated the meaning that music plays or can play in various cultures when applied in advertising. One example is the study in which music and lyrics in commercials in the Spanish speaking Dominican Republic and the USA were compared.[176] The focus of this cross-cultural comparison was on the use of music and lyrics in TV commercials. The reasons to choose the Dominican Republic were that it has an indigenous TV industry and programming environment, which are not dominated by the US media influence. Therefore, it can be assumed that the programming reflects cultural values particular to this country. The country is Spanish speaking and has a distinct music tradition that is predominant in local programming. If the use of music in commercials in the Dominican Republic were similar to its use in commercials run in the USA it would have to be conceded that the effects of music in commercials are universal across cultures. Four different criteria with possible differences were tested.

Regarding the frequency of music, a significant difference was found out: 94.3% of Dominican commercials contained music versus 84.5% of US commercials. There were also noted differences regarding the frequency and extensiveness of lyrics in commercials: 21.8% of commercials in the Dominican Republic versus only 12.8% in the USA. Another significant difference was the kind of music used for international or for domestic brands. Domestic brand advertisers use Latin background music in their commercials more often than international brand advertisers. The hypothesis is supported that domestic brand advertisers use lyrics with Latin music more often than international brand advertisers (28.1% versus only 3.9%). It was also found out that commercials in the Dominican Republic contained fewer lyrics with product-related meanings than commercials in the USA. The latter made more frequent reference to product attributes and the functional appearance of a product's use than lyrics in commercials run in the other country. Even more so, 40% of the lyrics in commercials in the Dominican Republic made reference to psychosocial consequences of product use versus only 18% of lyrics in the USA.

These findings support the notion that music plays an important role in the creative executions of commercials in the Dominican Republic. As opposed to commercials in the USA they are more likely to contain music, to have extensive lyrics, and to have self-related meanings. It can be stated that there are

[176] cf. Murray & Murray (1996); another study was the bi-cultural perspective on consumption imagery in music television for Sweden and the USA, cf. Englis et al. (1993)

systematic differences in the kinds of information carried by music and lyrics in the two countries. The study shows that there is support to the theory of music that incorporates culture as a key element. International commercials reflect aspects of both the North American and Latin culture, but cannot replicate the indigenous culture of each specific Latin American country. In other countries of the region commercials produced for their domestic markets would and will differ in formal features from those produced for a pan-Latin American market, or audience. Learned ways of music production and assumptions about audience response to music are most likely to be specific to a certain culture. The findings of the study do not indicate that music utilised in commercials in one country - the Dominican Republic - plays a bigger role than in commercials in another country - the USA - or that those commercials are more effective. Nevertheless it can be said that lyrics obviously play a greater role in carrying symbolic product information than current perspectives among advertising experts would suggest.

Music is symbolic communication that receives its meaning from the context within which it is perceived. Following this argument, the same would have to be said for the musical instrument as a prominent part of music, whether in terms of the ability to hear it acoustically on TV or radio commercials, or in a printed advertisement with a symbolic effect rather than a generic one.

3.6. Music and its Effects on Consumer Behaviour

In order to understand possible effects of music on consumer behaviour there should first be a look at the possible development of a musical taste that then eventually leads to a liking or disliking of music in a commercial context. The question is whether age plays a role in the development of musical tastes. In an experiment with more than 100 respondents, ranging from 16 to 86 years of age (with an average age of 54.3 years) it was found out in accordance with previous findings that there are age group differences in values.[177] Age is a surrogate predictor and accounts for a unique portion of the variance in values over and above life status. Cohort-historical, maturational, or some other age-related influences on values are present. The extrinsic determinants in human rights embrace any number of socially based factors involving peer pressure, group norms, media exposure, and purchases of recorded music. One likely determinant of a critical period for the development of musical tastes involves the familiarity that results from frequent exposure; another one is that musical

[177] cf. Holbrook & Schindler (1989), p. 124

tastes evolve from infancy through childhood and teenage years, but finally 'consolidate', 'crystallise', or 'coalesce' in early childhood. This can be seen from the fact that pressure from the consensus of predominant peer-group norms might be more influential when consumers leave home for the first time.

Another possibility is that consumers associate musical preferences with emotionally powerful 'rites of passages' (e.g. fraternity parties, school dances, and other social gatherings) that guide their 'coming of age' during the years of college and during their A-levels. For other consumers such rites of maturation might simply correspond to the relatively carefree period of socialising that occurs prior to settling down to a marriage, career, and a family. Lastly, musical preferences might reflect some consumers' periods of peak involvement with various social causes such as civil rights, political parties, or current events. The respondents preferred the kind of music most that was popular when they were about 23.5 years old. Earlier and later music was disliked by comparison.

As already explained, music as a background activity can have various effects. In the following table possible effects of music and background music are listed.

Effects of music ...	Effects of background music on ...
• while listening to music	• test performances (education)
• in music therapy	• home work (pupils)
• in a hospital	• behaviour at the workplace
• in a movie	• behaviour in the public (airport, shop, bank)
• in a music film/music video	• behaviour while being on the phone
	• understanding of (film) documentations
	• experiencing advertising commercials
	• behaviour while driving a car
	• sports training

Table 4: Distinction of Music and Background Music Effects[178]

[178] cf. Behne (1999), p. 9

A commercial situation where background music is involved is just one of many contexts.[179] Typically, there is a distinction between the focussed attention to music in a concert, and the generally shared attention, where music is perceived as a background stimulus, while other activities come to the fore.

Regarding the effects of background music, a large number of studies from the last twenty years is available. Empirical data can possibly prove that there are significant positive or negative effects, or that ambivalent, complex or very weak effects have been identified, or that no statistically significant effect (e.g. for a level of 5%) could be identified. The latter category also consisted of those studies, where musical effects were found on secondary, 'soft', variables (such as the length of stay in a department store or the prevailing mood), but not on the relevant variables like sales.[180] Since negative effects were rarely found, they have been categorised together with positive effects. The following table shows a list of chronologically ordered studies (153 in total) from 1911 to 1997, where results regarding the three mentioned categories were published.

	Effects proven (positive or negative)	Complex or weak effects	Positively no intended effects proven	
until 1969	17	10	10 (27,0 %)	37
1970 – 1979	19	7	11 (29,7 %)	37
1980 – 1989	18	11	12 (29,3 %)	41
since 1990	13	7	18 (47,7 %)	38
	67	35	51 (33,3 %)	153

Table 5: Results from Studies Regarding the Effects of Background Music[181]

It can be seen, that in one third (51 of the 153 available studies) no general effect of music could be proven, which at first sight denotes ineffectiveness. However, while the percentage of those studies up to the late 1980s was only 30%, it has increased to almost 50% since the 90s. This meta-analysis with only three categories is rather inexact. Nevertheless it serves the purpose of demonstrating that there were and presumably still are a lot of studies with the result of no intended effects. Other meta-research that is more sophisticated in terms of methodology has rather concentrated on the effects of music as reinforcement for education and therapy objectives or for dental and medical

[179] cf. Olsen (1995) for a study, in which he distinguished between background music and silence and investigated the respective influence on recall and attribute importance.
[180] Rötter & Plößner (1994), p. 160
[181] cf. Behne (1999), p. 10

treatment.[182] One third of non-significant results is a remarkably high percentage, and there are other indicators, that this is even an underestimation of the ineffectiveness of background music.

The first reason might be the *Hawthorne Effect*, which means that the mere fact that workplace conditions have been changed will result in a positive effect on production. That would mean that background music, strictly speaking, is not the cause for the result; it has been assumed, that the music effect and the Hawthorne effect are one and the same thing. Another reason might be found in the selection process of scientific journals, where it seems that results with no significant results could be judged more reservedly by referees than those with 'nice' effects. Especially with the so-called 'Functional Music' it is clear that scientists have conducted mission-oriented research on behalf of companies. It is quite obvious that in those cases a positive result can be created, firstly because studies with no significant result will not be published in the first place, and secondly it might be anticipated which analyses and interpretation of the data are desired and which are not.[183] It could then be expected that the number of published studies with non-significant results is much smaller than the actually conducted ones. If one also adds the possibility that the reality of the utilisation of music within a 'normal' everyday life situation is conceived by researchers according to possible effects, or that respondents demonstrate a certain expectation regarding the measured effects that then favour a positive result, the reality of music employed is reflected in a biased way. Inasmuch the finding of one third non-significant results of those studies will, with a certain likelihood, over-estimate the power of music, or in other words, for the majority of studies (see Table 5) that dealt with the effect of background music based on an attention-oriented definition, no effect of music should be expected. Even if one supposes that in the 1990s research has become methodologically more sound than in previous decades, the 47.4% of ineffectiveness (studies after 1990) and given the above mentioned situations, in reality should be assumed as the majority of cases. An additional prove for that is a study in which music and other variables have been investigated with a path-analysis; the path of music proved to be rather weak.[184]

Several reasons can be identified for the relative ineffectiveness of background music. Familiarisation, blunting, and habitualisation are the factors that are mentioned. It is argued that the increasing availability of respective media leads to global musical habitualisation. It would mean that initially there are effects caused by music, that these effects however disappear over time. The 153

[182] cf. Standley (1986) and Standley (1996)

[183] cf. Behne (1999), p. 12

[184] cf. MacInnes & Park (1991)

studies in question do not give further evidence to this assumption, since a comparison between studies from the 1980s and the 1990s is statistically significant only on the 10%-level.[185] A theory of ineffectiveness of background music cannot be formulated; present data would only partially support it. In the context of functional music those reasons have been discussed extensively. It is a means to bring about a mood for the creation of business or stimulation of sales.[186] The application in marketing lies in five areas:

- buying (discounter, shopping malls, etc.),
- eating (restaurants, cafes, hotels, etc.),
- waiting (restaurant, medical clinics, aircrafts, etc.),
- relaxing (sports facilities, beaches, etc.),
- servicing (dentists, hair stylists, etc.).[187]

The different functions or characteristics of this type of music are:

- to accompany people (while they shop),
- to attract people (to enter a restaurant),
- to dub (noise of escalators),
- to design (interior architecture),
- to convey (verbal information),
- to inspire (day dreams and wishes),
- to bring about identification (self-confidence),
- to bring about integration (safety, security within a group),
- to influence (mood, sentiments),
- to harmonise (consumers' critical thinking and their distance/fear of unwilling consumption),
- to generate good-will/trust,
- to influence behaviour (unpremeditated buying),
- to influence performance (of employees at their workplace; works as stimulating in the short run, but there is no scientific proof for a long term effect),
- to change social attitudes (relations of employer – employee, employee – employee, customer – supplier), and
- to change moral attitudes (by decreasing the likelihood for shop lifting).[188]

Table 6 lists the relevance of characteristics of functional music:

[185] cf. Behne (1999), p. 16
[186] cf. Stromeyer (1992), p. 10
[187] cf. ibid., p. 14
[188] cf. ibid., p. 66

Characteristics	Disco	Drug Store	Boutique	Bar	Restaurant	Hotel	Bank	Dentist
Accompany people	vr	vr	vr	vr	r	r	r	vr
Attract people	i	r	vr	vr	vr	i	i	r
Dub (noise)	vr	r	i	vr	vr	vr	vr	vr
Design	vr	vr	vr	vr	vr	vr	vr	vr
Convey (verbal information)	vr	vr	i	i	i	i	i	i
Inspire	vr	vr	vr	i	r	i	i	i
Bring about identification	i	vr	vr	vr	vr	vr	i	i
Bring about integration	i	vr	vr	vr	vr	vr	r	r
Influence (mood)	vr	vr	vr	vr	vr	vr	vr	vr
Harmonise	vr	vr	vr	r	r	i	i	i
Generate good-will	vr	vr	vr	i	r	i	i	r
Influence behaviour	vr	vr	vr	i	r	i	i	i
Influence performance	vr	vr	vr	vr	r	r	i	i
Change social attitude	vr	vr	r	i	r	i	r	r
Change moral attitude	vr	vr	vr	i	i	i	i	i
	i = irrelevant		r = relevant			vr = very relevant		

Table 6: The Applied Relevance of Specific Characteristics of Functional Music[189]

In the early 1960s there was already criticism regarding background music in shops,[190] whereas in recent years there have been some authors who tend to have a more favourable opinion. The (in-)effectiveness of background music is not limited to a workplace environment, but should be investigated specifically in the context of shopping and advertising, which might be a different setting opposed to work related topics altogether. This has also been done over the last 40 years, and in 1966 there was already a study that examined the effects of background music on purchasing behaviour.[191] To assist traditional retailers in survival and the achievement of successful differentiation from other 'bricks-and-mortar' retailers, the in-store atmosphere created with means such as music may increasingly generate an important contribution to retail strategies.[192]

[189] cf. Stromeyer (1992), p. 98
[190] cf. Uhrbrock (1961)
[191] cf. Smith & Curnow (1966). They reported that shoppers shopped for a shorter period of time when loud music - compared to soft music - was played.
[192] cf. Vaccaro (2001), p. 3

According to a survey by the *Gallup Organisation* in the mid-90s, 91% of retail customers said that music affected their behaviour while shopping, 86% of the customers believed that music enhanced a shop's atmosphere and 33% of the shoppers felt that music influenced their purchase decisions. In addition, 70% of the shop managers thought that music made their customers feel more relaxed and increased the time spent in the store.[193]

Previous research on music effects specifically in a retail environment has indicated that structural characteristics of music (such as tempo) can encourage to spend more time – as assumed by the store managers – and may stimulate more unplanned purchases – at least in such retail environments as supermarkets.[194] Furthermore, music category type (i.e. Top 40 music or instrumental background music) was found to influence perceived time spent in a department store.[195] This experiment involved systematically varying the music played in departments, and apart from the music, the other two causal factors were the age and the time period when people were shopping. Therefore, with the knowledge of the relative ineffectiveness of music – according to the mentioned studies – it was at least possible to show that shoppers (consumers) do respond psychologically and behaviourally to environmental factors such as music even though few of them consciously noted the presence of music. However, it cannot be said that one type of music will be appropriate for all situations. It was shown that age determined how shoppers (consumers) responded to the music even though the customers' range of age in the particular store was relatively small.

Further results showed that in terms of methodologies song-specific measures may be more appropriate than general music involvement measures in determining consumer responses to new music. This experientially-based involvement measure had a significant and stronger relationship to the evaluative and purchase intention measures.[196] It was also revealed that it might be a reasonable consideration to vary the music between mornings, afternoons, and evenings, as well as during the week and the weekend.[197] In this respect it might be helpful to understand the differences between the message attributes

[193] cf. Vaccaro (2001), p. 9, results cited from a study by Rubel (1996)
[194] cf. Milliman (1982). For a study in which music was an accompaniment of an independent stimulus variable (personalised online shopping website), see Genin (2001). Here, the assumption that such a website would further increase the level of satisfaction and the intention to buy products online was supported. Therefore, music has its share in the combined ability of playing a significant role in the success of an online-retailer. It makes clear that the relevance of the Internet as a marketplace should not be underestimated.
[195] cf. Yalch & Spangenberg (1990)
[196] cf. Mizerski et al. (1988)
[197] cf. Yalch & Spangenberg (1990), p. 61

70

contained in TV advertising, especially regarding daytime and primetime. In one study a content analysis examined the frequencies of a variety of message attributes including demographic data and structural cues such as length, number of cuts, settings, and scenes.[198] Furthermore, types of products advertised and emotional overlays were studied. The study included commercials from a constructed week that included three key television day parts, daytime, daytime fringe, and primetime. Daytime and primetime data generally reinforced historical findings. Women played a greater role during daytime TV advertising. Men dominate primetime TV advertisements. Products seem to coincide with these stereotypical roles. During the daytime, body and home care products are advertised. Primetime promotes services. In both parts of the day, ethnicity reflected current patterns in the general population. Daytime fringe advertising revealed that products and portrayals were biased towards males and Caucasians, and featured traditionally male products. This occurred despite an expected female and significantly black audience. Across day parts, emotion was found to have an inverse relationship to persuasiveness. That might indicate that emotional commercials do not attempt to include persuasive message attributes; emotionally neutral commercials may employ more persuasive techniques. Music was found to predominate, without contributing in any consistent way to the emotional dynamic. Sound effects were generally found to be ineffective. Settings were often unclear or limbo settings, which may lower cost and not commit a product to a particular setting.

In other experiments effects that had previously been measured could not be replicated. So one of the most remarkable studies of the 1980s on the effects of music in advertising on choice behaviour, in which it was found that there obviously is evidence that product preferences can be conditioned through a single exposure to appealing or unappealing music,[199] could not be replicated in a later study.[200] In three experiments the authors of that later study tried to replicate the previous finding, but none of the experiments supported that result. As well as those of other researchers, their findings rather suggest that the single-exposure conditioning of product preferences is an elusive phenomenon.[201] They assumed that previous results were contributed to the possible unique conditioning power of music, but showed in their own experiments that there was no apparent effect on subjects' preferences, when they heard music of widely differing appeals. What can be said is that by

[198] cf. Dahlberg (1999)
[199] cf. Gorn (1982), p. 99
[200] cf. Kellaris & Cox (1989), p. 117
[201] cf. e.g. Park & Young (1986) and Blair (1990). The latter is a study in which the role of context as a moderator of an unconditioned stimulus (a piece of music) was examined.

playing appropriate music for specific departments[202] more purchases were made and shoppers spent therefore more money. An additional analysis suggests that store music interacts with age rather than with gender, and that moods do not explain the effect of music. Music may influence shopping by stimulating cognitive associations rather than altering emotional states.[203] Shoppers perceived the departments to have more desirable characteristics when certain types of music were played.

Conflicting results from empirical research regarding the possibly optimal set up and design of a store show that "...there are likely to be many high order interactions among these factors. It appears that designing store atmospheres may remain an art rather than a science for many more years",[204] which makes it even more difficult to generalise findings.[205] New research shows the development of a 'Music-Retail Environment Model',[206] where pre-test results found a consensus amongst respondents on that music was perceived as consistent, neutral or inconsistent with a retail environment. The main experiment for this new model was a 3x2 factorial laboratory study with a between-subjects design with music-retail environment consistency (consistency, neutrality and inconsistency), and music mode (major and minor mode), plus a no-music control group. Groups (comprising a total of 161 undergraduate students) were randomly assigned to the treatments. Respondents were shown a videotape of a sporting goods shop with a particular treatment and completed a self-administered survey that adapted the Music-Message Integration (MMI) construct.[207] Correlation analyses indicated 'Music Mood-Consumer Prior Mood Consistency' was significantly related to shop mood, music mood, product mood, shop image and behavioural shopping intentions. Regression analyses showed that these perceptions were significantly moderated by consumer screening levels of environmental stimuli and by gender. 'Music Mood-Retail Mood Consistency' significantly influenced perceptions of product mood and shop image when the factors screening ability and gender were considered. Unexpectedly, neither ANOVA's[208] comparing consistency levels nor the control group produced any significant differences in responses, only

[202] The experiment was done for two department stores in the US, three types of music, and a 90-minute segment during a two-week period.
[203] cf. Yalch & Spangenberg (1993)
[204] ibid., p. 635
[205] cf. Timmerman (1981) and his study in which he investigated the effect of crowding (in a shop) and temperatures on consumers' attitudes or feelings about a retail outlet and found that they might be mediated by the environmental characteristics of sound and temperature.
[206] cf. Vaccaro (1999)
[207] cf. Kellaris et al. (1993). Other new measures were based on the PAD mood scale and the Mood Short Form.
[208] ANOVA = Analysis Of Variance

some directional support. In-store music in a major mode consistent with a shop significantly influenced music mood and had a directionally supportive impact on product mood, shop mood and behavioural shopping intentions. The no-music control group was directionally more effective than inconsistent music and neutral music for shop mood, product mood, shop image and behavioural shopping intentions. In summary, some support was found for this first test of the new model.

Evaluating the effects of music on responses is often intuitive, largely because of the difficulties of obtaining data uncontaminated by the visuals, and other consumer-related factors. That is why in recent studies the effects of music on responses in television commercials were measured empirically, using criteria like recall, recognition, and reactions to the music in a special TV advertisement.[209] One recent study examined recall for advertising messages that were presented via two musical formats, either as an instrumental version of a popular song or as a vocal version.[210] Consumers that were familiar with the song in the commercial were more likely to sing along with an instrumental version of a popular song in an advertisement than a vocal version of popular song. Consumers unfamiliar with the song in the advertisement could not realise the memory benefits of being able to generate lyrics, because they were unable to access the lyrics. Recall for this group was better when exposed to the vocal version, which at least provided the lyrics to listen to, rather than the instrumental version, from which they probably derived little information about the brand.

Different ways of presenting music can produce different levels of memory enhancement. Memory is enhanced to a higher degree when music invites to actively sing along compared to music that encourages passive listening. In one case original and alternate music versions of three different TV commercials were utilised. In all three commercials the music was different between versions, and also differed in levels of musical stimulation. The alternate (experimental) versions were deemed to contain a greater amount of musical stimulation than the original or control versions. The author composed the music for the alternate versions of the three test commercials after completing a detailed musical analysis of 33 award-winning music tracks, written for commercials shown on Australian TV. The analysis focused on the music's tonality, tempo, rhythm, melody, harmony, form, instrumentation, texture, intensity, mood and style.[211] The size of the sample consisted of more than 2300 subjects, aged between 18 and 65. Responses to four dependent variables were compared, in the two

[209] cf. Springer (1992) for an examination of advertising music practices.
[210] cf. Roehm (2001)
[211] cf. Watson (1992)

musical versions of the test commercials. The four dependent variables were

- reactions to the music,
- reactions to the visuals,
- desire for the product
- and intent to purchase.

In addition, the intervening variables of gender, age and level of education were assessed for the significance of their mediating effects.

The results showed that a change of the music significantly affected responses in all three commercials, and that the liking for the commercial was positively associated with the fondness of the music. Increased musical stimulation resulted in an increased acceptance of the commercial only when the music was liked. Increased musical stimulation had the opposite effect when the music was disliked. As in the previously mentioned study, age was found to be a significant factor affecting responses, in all three commercials. The trend showed that favourable responses increased with age. The effects of gender and level of education were not found to be significant in this study. Owing to the fact that the repeated exposure of TV commercials is an integral part of the marketing process, responses to the two music versions were also compared after the repetition of the commercials. The evidence provided some support for the notion that more complex music can delay commercial wear out, and by so doing, affect purchase intentions.

Another study demonstrated the importance of the imaginable and sensorial response in a hedonic consumption experience, such as listening to music. It could be shown that constructs like sensorial, emotional, imaginable, and analytical responses had significant direct effects on both the overall affective and the experiential response.[212] The need to re-experience the music had the greatest effect on an individual's purchase intention. The liking of the music, however, was not found to be a strong indicator of purchase intention. Similar results were found in another study, where background music was suggested to possibly interfere with viewer processing of advertising messages in TV commercials. However, the influence on affective responses was not overwhelming.[213]

Summarising one can say that the peripheral role of music in advertising was quite often in the focus of research. It has been extended by the examination of the potential of music to assume a central role and influence the viewer's perception of the advertised brand. Based on a model of meaning transfer the extent to which the meanings embedded in music can influence the viewer's

[212] cf. Lacher (1991)
[213] cf. Yoon (1993)

74

perception of the advertised brand could be investigated. The results of this research suggest that music in TV advertising has main and interactive effects on brand perception. Similarly, pictures in a commercial also have significant effects and play a moderating role in the influence of music on the viewer's perception of the advertised brand. [214]

3.7. Music and Media: TV, Radio and Print

Up to this point, music in advertising has been discussed as music by definition, as music that is acoustically audible to its audiences. Therefore, it was supposed that the described effects on emotions and the changes in buying patterns were directly due to the heard and processed sound of music. The question remains, whether optical aspects in connection with acoustics also influence the investigated effects.

The investigation of pictures has a certain tradition in research. In particular, research has concentrated on the question, in how far pictures may have a stronger influence on consumer behaviour than pure text. Therefore, the discussion has mainly concentrated on the analysis of pictures versus text elements of an advertisement. Especially in the 1980s there were quite a few investigations on how consumers react on visual stimulants in advertising. Picture-word and picture-text consistencies together with the processing of such information were a significant research area. Research in this area was divided into two parts: one part concentrated on the effects of pictures in the memories of the spectators, whereas the other part dealt with the impacts of attitude-related criteria. Especially the latter were and are very important as they influence buying patterns. Various tests have shown that an interactive picture creates certain expectations regarding the content of the accompanying text.[215] If the recipients realise deviant verbal information, the effect of a more elaborative processing and recall will be reached. Specific verbal elements or product attributes make an advertisement consistent or discrepant, lead to a higher recall and recognition in case of a greater consistency.[216]

[214] cf. Hung (1996)

[215] cf. Houston et al. (1987), p. 366

[216] cf. Stewart et al. (1990) for an investigation of the ability of music to improve recognition with a musical cue that either substitutes for, or complements to a more traditional verbal product cue. These musical cues seem to be more sensitive than verbal cues, both as absolute measures of memory and as means for detecting changes in awareness over time. Furthermore, such a cue appears to elicit different types of commercial playback from that obtained with a verbal product cue, and it elicits more imagery responses.

These findings may be due to the redundancy of information in consistent advertisements. However, the processing of information, which is caused by the variations of consistent or inconsistent picture-text-combinations, is only one dependent variable.[217] Furthermore the effect of the viewing time of advertisements has been investigated. It could be shown that advertising content explained the viewing time, and that these effects are partially mediated by the emotional dimensions and components of attitude towards the advertisement via two 'routes': feelings and uniqueness with pleasure and hedonism, and uniqueness and arousal and interestingness.[218] Beyond these mediating effects, there remains however a significant direct contribution of the advertising content to the explanation of viewing time. This effect comes from the non-monotonic influence of uniqueness, and it also depends on the negative contribution of facts and the positive contribution of feelings. Advertising that appeals to feelings exerts a positive influence on variables such as hedonism, pleasure, and also viewing time. Content analyses turned out to be feasible of studying communication phenomena across objects (like messages) to supplement findings from analyses conducted across subjects (i.e. receivers).[219] It can therefore be said that based on common copy-testing applications content analysis has a relatively strong track record in regard to TV commercials as well as print advertising.

There is a long list of content variables that have been analysed in previous studies. Research regarding the use of humour, fear, puffery, and message complexity has produced ambiguous findings. For example, a study on the use of humour in advertising concluded that 'sometimes it works, sometimes it doesn't'.[220] Music or musical instruments do not seem to have ever been the topic of investigation in print media,[221] since the general understanding seems to be that it is just another subject that is used in the context of an advertisement, whereas in commercials with their ability to use the actual sound of music, effects have been analysed. While characteristics of headlines, graphics, and

[217] cf. Finn (1988) for information-processing-based models that provide a substantially better fit to data (for printed advertisements) than hierarchical models.

[218] cf. Olney et al. (1991), p. 451

[219] cf. Naccarato & Neuendorf (1998) for an overview of studies in which content analysis was used as a predictive methodology; in their case for business-to-business print advertising, where they point out that in previous studies content-style variables that have been most often studied in the realm of consumer advertising do not generally apply to industrial advertisements (e.g. celebrity endorser, sex appeals).

[220] ibid., p. 20

[221] cf. Theberge (1993) for the role of musical instruments, notation and sound recording in the formation of the concepts and practices of music making, the industries that supply new (microprocessor-based) technologies and their influence on the ways in which popular music is produced, and finally the various media that promote them.

copy as compositional form variables in print advertisements have been examined, and also colour and size were the centre of studies, other evidence is either mixed or missing. Regarding TV commercials, there are at least some comprehensive studies available, where the usual variables recall, comprehension, and persuasiveness were influenced by brand performance characteristics, such as a brand-differentiated message, or convenience of product use, and attention and memory factors, such as humour, mnemonic devices, front-end impact, or brand sign-offs.[222] Omnipresent music was one of the variables that were found to be characteristic for award-winning commercials in the mid-80s, apart from variables like humour, children, animals, and male characters.[223]

The question remains whether these variables can possibly be transferred and applied to other types of media. For radio e.g. the typical research would have focussed on variables such as recall and its effectiveness in general.[224] There is also research on the type of music that is used in radio advertising. In a specific case (mid 1980s) folklore and popular music were tested.[225] For print media one extensive study is available. In this study 3600 printed advertisements were analysed regarding characteristics that contributed to readership, i.e. that the advertisement was noticed. Factors in this respect were the colour and the use of spread or bleed format. Since the study was limited methodologically, the significance of the findings remains doubtful.[226]

In another study four approaches were distinguished to measure the role of imagery in shaping consumer responses. In the archival tradition studies gather large samples of advertisements and conduct analyses that describe the frequency in which various types of visual elements appear.[227] These studies may also report correlations between the presence of certain elements and specific audience responses. The rather descriptive approach is a weakness for the finding of causal effects.

Another type of study is the experimental one where the presence or absence of pictures per se and the nature of some particular visual elements is varied. The processing conditions under which subjects encounter particular visual elements are analysed. The reader-response approach emphasises the meanings that consumers draw from advertisements. Causal analysis is limited, and the links

[222] cf. Stewart & Furse (1987)
[223] cf. Gagnard & Morris (1988)
[224] cf. Sewall & Sarel (1986)
[225] cf. Julien (1985)
[226] cf. Naccarato & Neuendorf (1998), p. 21 and their criticism
[227] cf. McQuarrie & Mick (1999), p. 37

between specific types of an advertisement's elements and different kinds of consumer meanings are rather vague. The text-interpretive approach finally draws on semiotic, rhetorical, and literary theories in order to provide an analysis of individual elements that make up the advertising. Visual and verbal elements are treated equally in their capability of conveying relevant meanings. Rhetorical figures have emerged as a general principle of text structure that can be embodied in visual as well as verbal texts. It could be shown that the artful deviation characteristic of figures, and the over-/under-coding that produces schemes and tropes, can be constructed of pictorial elements in advertising.[228]

While verbal figures appear to deserve a place among the executive devices available to advertisers with a consistent and reliable impact on consumer response, there is additional prove that pictorial elements comprise a variety of rhetorical forms (rhyme, antithesis, metaphor, and pun) and different types of signs (iconic, indexical, and symbolic) to evoke a diverse set of meanings about the brand or in the user (e.g. sophistication, beauty, safety, fun).[229] Additional empirical support could be found for the theoretical taxonomy that all figures are located at a given node sharing certain formal properties. These properties are the key determinants of consumer response to figures. The rhetorical figures are an artful deviation, relative to audience's expectation that conform to a template independent of the specifics of the occasion of occurrence. The top level, which includes all figures, is characterised by the property of artful deviation. The degree of deviation present in specific instances of figures may vary widely and systematically across types of figures, with a corresponding difference in impact on consumers. At the second level schemes are distinguished from tropes as two different modes of figuration. They deviate with an excessive regularity. Tropes like metaphors and puns deviate by an irregular usage. At the third level, specific rhetorical operations serve to construct schemes or tropes. Repetition and reversal are the simple and complex operations that construct schemes, while substitution and destabilisation are the simple and complex operations that construct tropes. All four rhetorical operations provide four different opportunities for adding artful deviation to an advertisement.[230]

[228] Tropes are figures of speech that deviate from consumers' expectations through the non-literal use of words. They deviate because they involve an unexpected juxtaposition of words that causes one or more of the words to take on an unusual or unexpected meaning; cf. Toncar & Munch (2001) for a study on consumers' responses to tropes in print advertising.

[229] cf. McQuarrie & Mick (1999), p. 51

[230] cf. ibid. for a re-inquiry that examined the robustness of research and showed that rhetorical figures can have a positive impact on consumer response to advertising. Those figures were more often effective regardless of processing conditions, whereas verbal figures only performed better when subjects were directed to process the advertisements.

The boundary condition that was uncovered in studies up to that point was the question whether or not customers are sufficiently acculturated to the rhetorical and semiotic systems within which the advertising text is situated. This leads back to the question about the possible universality of music in an advertising context. For visual tropes it was found out to be true, it did not condition responses to visual schemes. The theory that advertising visuals should not be conceived as photocopies of a pan-cultural reality was confirmed. Furthermore it is said that they are often highly stylised representations that compel consumers to engage advertising as meaningful texts that require an active reading in accordance with an existing stock of sociocultural insights. Therefore, visual tropes require complex semantic knowledge structures concerning the objects, activities, and products artfully depicted in the advertisements.

In a contrary study it was analysed that all subjects and informants – foreign nationals as well as native Americans – seemed to appreciate the schematic visuals that are constructed by similarities and/or differences in such surface features as shapes, sizes, and/or colours. It appears to be correct that the role of cultural competency in processing advertising rhetoric with respect to tropic rhetorical operations strongly depends on sociocultural semantic knowledge but may be less compatible to schematic rhetorical operations determined by structural regularities.[231] The consumers who were less culturally attuned to the American society and advertising are less likely to appreciate the visual tropes, as compared to the visual schemes. Regarding the discussion about socio-cultural effects on the perception of music and advertising, in general, the questions remains as to the possible encounters of advertising in other cultures than the American culture, as to the possibility of structuring visual elements as rhetorical devices, and to the stock of cultural knowledge that might be required to interpret structures in which music and/or musical instruments play a role.

So far little can be said about the possible impact of musical symbols in print advertising, and whether positive consumer emotions that have been identified in connection with audio-visual parts of advertising would also exist with different types of presentation. The type of medium, which is defined as a 'system that carries the message'[232] should be considered regarding its effects on the perception and possibilities to use rhetorical figures. The medium under consideration in the investigation of the saxophone in advertising is print. Advertising on the Internet will also be referred to occasionally, since although it is not strictly speaking print the visual presentation is very similar, provided that no sound or movements are used along with the visual presentation. Outdoor advertisements will also be considered.

[231] cf. McQuarrie & Mick (1999), p. 51
[232] cf. Koeppler (2000), p. 14

4. The Saxophone – a Musical Instrument

After now having given some background on the topics of advertising, music, and their interactions, an introduction to the saxophone as a musical instrument is given below. This is not intended to be a complete historical overview of the saxophone, but rather a focused extract with some background information, to make clear what image the saxophone has acquired during its development. Particular information about the saxophone in Germany will be given, underlining the instrument's status in the country, which is in the centre of this investigation.

4.1. General Information

The saxophone is a reed instrument and thus belongs to the family of wood wind instruments. The whole saxophone genus consists of seven main types: Sopranino tuned in E^b, Soprano in B^b, Alto in E^b, Tenor in B^b, Baritone in E^b, Bass in B^b and Contrabass saxophone in E^b. There are some rare other versions as well, but these are not important for this study. Today, Soprano, Alto, Tenor and Baritone saxophones are the most commonly used instruments. Figure 3, an advertisement for the saxophone manufacturer *Selmer*, shows from left to right: a Sopranino, Bass, Alto, Soprano, Tenor and Baritone saxophone.

DIE FAMILIE DER SAXOPHONE

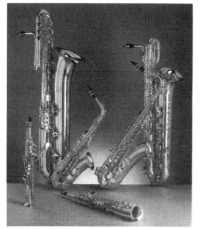

SELMER
DÜSSELDORF

Alleinvertrieb für Deutschland
Selmer GmbH & Co KG · 40035 Düsseldorf
Postfach 10 44 21
Tel. (02 11) 37 04 88 · Fax (02 11) 38 10 98

Figure 3: Selmer Saxophone Family[233]

The body of the saxophone is made out of brass and consists of a conical tube. Mouthpieces are made out of plastic, ebonite or metal; a single reed needs to be attached. Body and mouthpiece are connected via a gently curved detachable crook, which is, like the body and the bell, made of brass. As the bigger instruments are quite heavy, the player puts a sax strap around his or her neck so

[233] in: Juchem (1996), cover page inside

that the weight of the instrument only partly lies on the right thumb. The usual colour of a saxophone is gold, but silver and other colours exist as well. Sopranino and soprano saxophones are built either straight or in a U-shaped form, whereas the bigger saxophones are usually made in the characteristically folded version.[234]

Today, important manufacturers are *Keilwerth* in Germany, *Buffet-Crampon* and *Henri Selmer* in France, *Yamaha* and *Yanagisawa* in Japan, *Amati* in the Czech Republic and *Conn* and *H. A. Selmer* in the USA,[235] although in today's global world, most brands are available almost everywhere.

4.2. History

4.2.1. Invention

The Belgian instrument manufacturer Antoine-Joseph Sax (1814–1894), later called Adolphe Sax, invented the saxophone around 1840.[236] The exact date of invention is as unclear as the reason for its invention, although there is much speculation.[237] The most probable reason for the invention seems to be the then still missing link between clarinets and tenor brasses in military bands. Hector Berlioz first used the name 'saxophone', so called after its inventor, in an article on 12 June 1842 in the *Journal des Débats*.[238] According to Liley, "The word saxophone means 'the sound of Sax' – specifically that of Adolphe Sax...The saxophone is similar [to the human voice] in its potential to move people, both viscerally and emotionally." [239]

By the time Sax applied for a patent for the saxophone he was living in Paris in France and was a hated foreigner, who had to fight hard against his competitors and opponents who tried to harm him and his manufacture of musical instruments by means of various intrigues. In June 1846 (usually given as the

[234] In the New Grove Dictionary of Music and Musicians (1980) the author Philip Bate says under the topic *Saxophone*: "As the larger saxophones are of some considerable length they have from the beginning been made more manageable by introducing a U-bend (...) This folding has often been regarded as a characteristic and attractive feature of the instrument to the extent that for uniformity both the soprano and sopranino sizes have sometimes been so made.", p. 334

[235] cf. Ventzke et al. (1994), pp. 143-144

[236] cf. Dullat (1995), p. 9

[237] cf. ibid., pp. 14-15

[238] cf. ibid., p. 15

[239] Liley (1998), p. 1

year of invention) Sax was finally granted a patent on the saxophone for 15 years, which was extended by a further five years in 1861.[240]

4.2.2. 19th Century

Adolphe Sax had developed two different sets of saxophones, one set for military use and one for orchestral use, each consisting of the seven main types of saxophones. Owing to Sax's efforts the saxophone was made an obligatory instrument in French infantry music in 1845. This was no long-lasting success, as it was soon withdrawn. However, a come back was to follow a few years later. The instrument only had the chance to make its way and not disappear again like many other new instruments of that period because of its hard-fighting and devoted inventor Adolphe Sax. He was bankrupted three times and his competitors harmed him and the saxophone immensely. However, with the help of some influential friends and benefactors, he always managed to get back on his feet again and keep the saxophone in manufacture and use.[241] Nevertheless, until the end of the 19th century, the saxophone was not used in German or Austrian military bands, whereas French, Belgian, Dutch, Italian, Spanish and Japanese military bands all used saxophones to a greater or lesser extent.[242] In classical music the saxophone was hardly used at all, with the result that the set of orchestral saxophones dropped out of use, and only one set of all-purpose saxophones remained.

In the USA, John Philip Sousa was one of the leading musicians at the end of the 19th century. He used the saxophone in his band and therefore made American concert audiences familiar with the instrument. By doing so, he made possible its later wave of popularity and success in the USA.[243] The main way of presenting the saxophone to a bigger audience was that the "Travelling of saxophone ensembles, originally and offshoot from the Sousa Band, demonstrated virtuosity and instrumental possibilities to audiences across the USA and beyond".[244]

[240] cf. Kool (1931), p. 218
[241] cf. Kochnitzky (2001), cited in http://saxgourmet.com/adolph-sax.html, 13 August 2001
[242] cf. Habla (1990), p. 236
[243] cf. Bate (1980), p. 539
[244] Ingham (1998), p. 126

4.2.3. 20th Century

In the late 19th century the company *Conn* became the first American saxophone manufacturer. As American musicians preferred American made saxophones, combined with the great demand and popularity of the instrument, the 1910s and 1920s were a period of great innovations and saxophones were built in almost every conceivable size and key. According to Ashton "C. G. Conn's manufactory was, from 1921, encouraged to increase its production threefold until the Wall Street crash signalles an end to this phenomenal boost to the saxophone's popularity." He further speaks about an "unprecedented saxophone 'craze' of the 1920s in America" [245] and that "this 'craze' was not matched outside America".[246]

In the early 20th century the serial manufacture of saxophones developed mainly in France, Germany and the USA, although the use of the instruments was still limited. In Europe, the saxophone mainly remained a military instrument, with limited use in classical music. As already mentioned, the saxophone was first used in military band music, and then in classical music. Liley puts it this way: "To those who associate the saxophone primarily with jazz it is often a surprise to learn that the instrument is a late edition."[247] An important year regarding the instrument's use in classical music was 1928, when Maurice Ravel wrote his *Bolero*, which is still one of the most popular classical pieces using the saxophone.

However, the instrument's real success only began when it was discovered by jazz musicians. It is often said that the ideal instrument for jazz – a very emotional kind of music of which improvisation is the main characteristic – is an instrument which is as agile as the clarinet and as expressive as the trumpet. Thus, the saxophone was and is this ideal instrument. Ingham even says: "A history of the saxophone in jazz is in many ways a history of jazz itself, inasmuch as many of the essential protagonists, those who took style and aesthetics forward, were saxophonists".[248] Although nowadays jazz is played and enjoyed worldwide, originally it was the music of a minority. Jazz was born in the southern USA, principally in New Orleans in the late 19th century, where many immigrants from all over the world lived and played their own music and thus influenced culture. From there mostly black musicians, who remain the dominant force in the jazz world, took it north in the US.[249] This statement

[245] cf. Bro (1993)
[246] Ashton (1998), p. 21
[247] Liley (1998), p. 18
[248] Ingham (1998), p. 125
[249] cf. Berendt (2000), pp. 17 et seq. and Buchner (1985), pp. 347-348

regarding jazz in general is also true for the saxophone. Whereas the saxophone was unknown in New Orleans Jazz (about 1900), it began to become an important, if not the important instrument during the 1920s, the 'Chicago Jazz Era'. Before the saxophone appeared, the clarinet was one of the main instruments in jazz. Berendt says in his book *Das Jazzbuch* that the soprano saxophone goes ahead from where the clarinet ends, mainly, because it is louder and because it offers a greater ability for expression.[250] But not only the soprano saxophone made its way in jazz, the alto saxophone jazz history started at the end of the 1920s, the tenor instrument in the 1930s, and the baritone saxophone in the middle of the 1920s.[251] From then on the saxophone gained more and more popularity, to which famous jazz saxophone players like Charlie Parker, Branford Marsalis or Sidney Bechet contributed significantly.[252] This US-American success, which is still apparent today, also crossed over to Europe. However, this was a bit later in the history of the saxophone and not to the same extent, due to racial problems, which will be further examined in the section "The Saxophone in Germany". Despite this success in jazz, one can discover the difficulties in the saxophone becoming a proper instrument by the fact that Marcel Mule, in 1942, was only the second appointed Professor of Saxophone at the Paris Conservatoire, "after Adolphe Sax who left in 1870 without a successor being appointed." [253]

Another kind of music in which the saxophone was used to a considerable extent is the 'light music' that was played mainly in the 1930s and 40s. At the end of the 1950s this kind of music was pushed aside by a new kind of music: the rock era was about to begin, and with it new instruments such as the keyboard, percussion instruments and the electric guitar began to obtain importance. Saxophone players were not needed to the same extent as in big bands anymore, they mainly found employment in theatres and studios (and still in jazz of course), but not much on stage. A new decline of the saxophone was noticeable.[254]

In the late 20th century, however, the situation for saxophone once again changed radically. The saxophone gained a lot better image, being enforced by the first 'World Saxophone Congress' in Chicago in 1969. Further regional meetings, proper teaching at the Paris Conservatoire and other conservatoires and musical schools, saxophone journals with articles and reviews, and saxophone societies among other institutions helped to make the saxophone

[250] cf. Berendt (2000), pp. 298-299
[251] cf. ibid, pp. 305-334
[252] cf.ibid., pp. 297-338
[253] Dryer-Beers (1998), p. 44
[254] cf. Lewin (1998), pp. 114-115

better known, recognised and accepted by the public.[255] A new saxophone boom had begun.

4.3. The Saxophone in Germany

Until the end of the 19th century the saxophone was hardly known in Germany. There were articles about the saxophone in musical journals, but some of these articles were inaccurate or seriously incorrect, so that they did nothing to inform the German readership about the saxophone. During the 1880s, however, the saxophone was discussed as a possibility for military bands, but it was ultimately not accepted.[256]

Since about 1900 saxophones were built in Germany but, due to little demand, these instruments were mainly built for export. Richard Strauss was the first composer for classical saxophone in Germany with his composition *Symphonia domestica* in 1903. Unfortunately there was a shortage of saxophone players who could perform the saxophone parts, and whether this helped or even damaged the image of the saxophone at that stage of its development is disputed in literature.[257]

Before World War I saxophones were virtually unused in Germany. They were considered from time to time for military music, but ultimately not used for reasons of cost. After World War I the situation had changed completely. In the 1920s, which saw huge changes in society and its values, the saxophone became the enigmatic instrument symbolic of new attitudes to life and of an expansion of possibilities of musical expression.[258] After its failure to become a success in symphony orchestras, military bands and concert bands (Harmoniemusiken), the saxophone became **the** instrument in dance music and jazz. From that time onwards the saxophone has also appeared in paintings and cover pages of musical compositions. The only remaining difficulty was the shortage of good saxophone players, due to a lack of education on the instrument, which was still seen as a secondary instrument to the flute or oboe.

[255] cf. Dryer-Beers (1998), pp. 47-48
[256] cf. Ventzke et al. (1994), p. 147
[257] cf. ibid., p. 147
[258] cf. ibid., p. 148; the German original text says: "...während der 20er Jahre wurden die Saxophone zum schillernden Symbolinstrument neuer Lebensauffassungen und erweiterter musikalischer Ausdrucksmöglichkeiten".

Real problems for the instrument began at the end of the 1920s, when the saxophone came to be regarded as Anti-German: it was already closely linked to the jazz world, which in the developing Nazi-Germany represented decadent, inferior music and a bad influence. The jazz image was transferred directly to the saxophone and its sound was described as perverted.[259] A Nazi propaganda poster, a crude exaggeration of the poster for the opera *Jonny spielt auf*, became the visual symbolisation of *Degenerate Music* (Entartete Musik). In this picture, which was well known in Germany, the saxophone represents the lowest rung of the instrument ladder, a Belgian invention with exaggerated bends, which is only played by foreigners.[260]

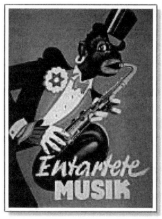

Figure 4: Jonny spielt auf[261]

There were attempts to promote the saxophone to be a proper concert instrument, but the voices that condemned the instrument were stronger and louder.[262] Musicians even became afraid to play the saxophone. They tried to pretend that their instruments were metal clarinets, or simply decided to play another instrument. Other famous saxophone players, like Sigurd Rascher, who was born in Germany in 1907 and is one of the central figures in promoting the classical saxophone, left Germany "as a result of Nazi prejudice against the saxophone".[263] Eventually, it came to an open boycott of the saxophone, which brought well-established German instrument manufacturers into trouble, so that

[259] cf. Ventzke et al. (1994), pp. 149-150
[260] cf. Philipps (1998), pp. 92-93; for the original poster advertising the opera by Ernst Krenek and Dümling & Girth (2003), http://www.duemling.de/EM-Info.htm, for further information about the caricature and the topic of Degenerate Music.
[261] No author identified (2001), in: http://fcit.coedu.usf.edu/holocaust/arts/musDegen.htm, 15 July 2001
[262] A quotation in Ventzke et al. (1994), p. 150 reads: "(...) versuchten die einen, das Saxophon zur Würde eines Konzertinstruments zu erheben, so zögerten die anderen nicht, es als Symbol totalen geistigen Verfalls und Schrittmacher zum Untergang des Abendlandes zu deuten und abzulehnen. Die in Amerika gelegentlich erfolgte Verwendung des Saxophons in der Kirche wurde geradezu als Gotteslästerung empfunden (DibZ 1931, S. 295)." Translated into English it is: „(...) while some people tried to lift the saxophone's image up to a proper concert instrument, others proclaimed it as a symbol of mental decay and an instrument able to destroy the occident, therefore denying the saxophone. They even judged the use of the saxophone in a church, which was sometimes done in America, as blasphemy. (Translation by the authors.)
[263] Dryer-Beers (1998), p. 42

the *Reichswirtschaftsministerium* (Reich Ministry of Trade and Commerce) had to save the saxophone's reputation by declaring that the instrument could be used after all, but only for proper German dance music. In 1940 the band of the German *Luftwaffe* included a full set of saxophones. Thus, one hundred years after its invention the saxophone was used, even if it had not yet achieved the status of a proper instrument.[264]

Due to its historical background the saxophone was in a difficult position in Germany and, until the late 1970s, was not allowed to show its potential. In the foreword to the first edition of his book *Die Saxophone* in 1978, Ventzke even said:

> Hierzulande stehen die Saxophone meist noch im Ansehen einer instrumentalen Zutat ohne eigentliche Eigenständigkeit. Sie werden – auch literarisch – als halbgeschwisterlicher Anhang der Klarinetten betrachtet und so behandelt. Sie sind Neben- und Zweitinstrument oder genießen die Einschätzung einer belustigenden Gagmaschine. (...) Nur im Jazz haben sie die Anerkennung eines vollwertigen Musikinstrumentes.[265]

This shows that, even in 1978, the saxophone was (apart from its use in jazz) not fully recognised or emancipated as an instrument. Subsequently however, more and more films were shown which featured saxophones. These, and the growth of American influence in Germany contributed to the establishment of a myth about the instrument, which developed rapidly and made the saxophone the instrument of the 1980s.[266] The number of saxophone students increased from only 330 in 1976 to 2,250 in 1984, representing the highest increase in wind instrument students.[267]

In the year 1979 a new kind of music was born in Germany: the *Neue Deutsche Welle* (NDW), a kind of independent music which tried to make or play everything in a different way from existing musical arrangements. It can be categorised somewhere between punk and pop music, with the most important features of being independent and new. Wind instruments played a special role in this era, and especially the saxophone, mostly because of its attractive

[264] cf. Ventzke et al. (1994), pp. 145-151

[265] ibid., p. 9; Translation: In this country the saxophones are considered as a musical accessories without proper independence. They are – even in literature – considered as half-sisters of the clarinet, and this is how they are treated. They are a secondary or deputy instrument and they enjoy the image of a funny gag machine. (...) Only in jazz they enjoy the full recognition as proper musical instruments. (Translated by the authors)

[266] cf. Hentz (1991), p. 53

[267] cf. Ventzke et al. (1994), p. 10

appearing. In its history, the saxophone had already been used in classical music to substitute a human voice: the alto saxophone for a female and the tenor instrument for a male voice. The musicians of the *Neue Deutsche Welle* used the saxophone not only as a solo instrument but also for accompanying the lead vocals, as it had already been done in free jazz and the Rock 'n' Roll of the 1960s. The most important factor of using the saxophone in the *Neue Deutsche Welle* is, however, that people were proud of using an instrument on which they had not had any lessons. They just took it and played it. Their motto was: Do exactly what you cannot do – for example play the saxophone.[268] The image that the saxophone gained in Germany during this era, did probably a lot of good to young people and made the instrument famous in their eyes, but must have damaged, once again, the saxophone's reputation as a proper concert instrument.

In the introduction to the 1994 edition of Ventzke's book *Die Saxophone*, the author states that the saxophone is now a very popular instrument. It appears to be youthful and more vibrant than ever before, and that it might even be called a cult instrument.[269] So even an intensification or improvement of the image is perceptible.

4.4. Use of the Saxophone in Music

The saxophone is one of the most popular and versatile instruments of our time. It is such a versatile instrument, that it can be used in almost any kind of music. In an article advertising a concert by the *Kasseler Saxophonquartett* it is said:

"Wie kein anderes Musikinstrument steht das Saxophon für den Brückenschlag zwischen unterschiedlichsten musikalischen Welten: mit seiner Herkunft aus der Militärmusik, seiner dominierenden Rolle in allen Spielarten des Jazz und seiner Emanzipation zum veritablen Orchesterinstrument in der Kunstmusik des 20. Jahrhunderts prädestiniert, die engen Grenzen der einzelnen Genres immer wieder in Frage zu stellen."[270]

[268] cf. Görlich (2003), pp. 44-46
[269] cf. ibid., p. 11
[270] Cine (2002), p. 6; Translation of the quotation (by the authors): Like no other musical instrument the saxophone symbolises the bridge between the most diverse musical worlds: with its descent in military band music, its dominating role in all kinds of jazz and its emancipation to become a veritable instrument within the orchestra for the *Kunstmusik* of the 20th century it is predestined to question the tight borders between the particular genres.

This can further be stressed by the fact that the saxophone still appears in military band music (which was indeed its original purpose), circus music, dance music, wind bands, and in saxophone ensembles, mostly quartets. It is used in modern music such as Rock, Pop, Latin, Soul and Funk as well as in film music, musicals, dance music, symphonic wind bands and of course, in Blues, Swing, Big Bands and Jazz, where the saxophone is sometimes just called *the instrument*. The saxophone is also used in opera and orchestral music, but here it is still an exotic instrument.[271] This limited use in orchestral (or classical) music is partly due to the relatively short history of the saxophone, as a lot of orchestral music was written before the saxophone had been invented. Nevertheless it has to be said that there is music for classical saxophone and that more and more orchestras now include saxophone concertos in their repertoire in order to become more attractive or make their music more accessible.[272]

4.5. Image of the Saxophone Based on Historical Development and Present Situation

From the above summary of the saxophone's development, it can be seen that the saxophone has never had an easy position and that it needed much commitment by those who believed in the instrument, for it to become used and for it to develop in the musical world. The saxophone was not accepted right away, and some musicians and audiences do still not accept it as a proper instrument. Its position in the world of classical music is still difficult. It is still the target of accusations such as being an instrument so easy to play, that it cannot count as a proper instrument in its own right. Thus it is still being seen as inferior to 'proper' instruments such as the violin. The rumour that it is much easier to learn to play the saxophone than any other instrument, which was already mentioned by Kool in 1931,[273] is still circulating. In 1994 Friedrich wrote in an article on studying the saxophone as main instrument at a German University, that the saxophone is no easier or more difficult to play than any other instrument, if it is to be played properly, but the problem is, that the saxophone is mainly defined through the media, whereas the violin defines itself.[274]

In 1995 Bensmann wrote in an article on the same topic that the demand for saxophone players is high, as the audience has discovered or at least accepted

[271] cf. Klimek (1998), p. 174
[272] cf. Bensmann (1995), p. 27
[273] cf. Kool (1931), Vorwort
[274] cf. Friedrich (1994), p. 50

the saxophone as an instrument for serious or classical music.[275] Therefore, even though the saxophone has gathered a lot of respect and recognition in the jazz world, classical music audiences and their attitudes towards the saxophone are still divided. Older generations still associate the saxophone with something of ill repute, or something sinful. This harks back to the 1930s and the phenomenon of *Degenerate Music*. In an article about an international saxophone workshop, which took place in a monastery, Hilkenbach writes that towards the end of the workshop week, a group of female teachers visited the monastery. They were obviously scandalised, that something as flashy as a horde of saxophone players was allowed to operate within the walls of a monastery. The saxophone players invited the ladies to listen to their music, as a result of which they admitted that they needed to reconsider their opinion.[276]

Haberkamp pointed out in 1993 that many people, when asked what they think of the saxophone, wrongly (but understandably) believe that the saxophone was imported from the US and came to Germany when jazz came to Europe, and therefore is often associated with the 'American Way of Life'.[277] Most people, who want to learn to play the saxophone, consider it to be the most important jazz instrument. Habla calls the saxophone the 'dream instrument' that everybody wants to play or, if one had been given the chance to learn to play an instrument, it would have been the saxophone.[278]

Vogl found out in a study called *Instrumentenpräferenz und Persönlichkeitsentwicklung*[279] that saxophone players are lively, extroverted people who are usually well balanced and rather masculine in their self-perception.[280] Furthermore, she found out that saxophonists usually start to learn the instrument about seven years later in their lives (at the age of 17.5 years on average) compared to violinists or pianists. Apart from physiological reasons she explains this phenomenon with the fact that the piano and the violin are instruments with a tradition, parents often recommend to their children, whereas the saxophone is still a young, not that well accepted instrument, therefore not so often recommended to children by their parents.[281] This goes along with the

[275] cf. Bensmann (1995), "Die Nachfrage bei Veranstaltern in groß, denn das Publikum hat die Saxophone als Instrumente der 'ernsten' oder Kunst-Musik entdeckt oder zumindest weitgehend akzeptiert.", p. 27; Translation: The demand by promoters is big, as the audience has discovered, or at least accepted the saxophones as instruments of classical music. (Translated by the authors)
[276] cf. Hilkenbach (1993), p. 181
[277] cf. Haberkamp (1993), p. 23
[278] cf. Habla (1996), p. 14
[279] This translates as: preference for musical instruments and development of personality
[280] cf. Vogl (1993), p. 44
[281] cf. ibid, p. 68

fact that the saxophone is often chosen by the players themselves and not by their parents. Saxophonists prefer to play in a free and self determined way and therefore often do not have such a strong wish to become a professional saxophone player as they might then be restricted in their freedom of playing the instrument in the way they like.[282] Saxophonists enjoy their instruments and playing their instrument a lot more than violinists or pianists do. Fun is one of the central factors why people play the saxophone.[283]

Bearing all that in mind, one may conclude that two very different perceptions of the saxophone exist in Germany today. People who are old enough to remember the 1930s and the phenomenon of *Degenerate Music*, and those who are classical music orientated, tend not to appreciate the saxophone. Something dark, dirty and rude seems to have stayed on their minds. On the other hand, for young people and those who like jazz or dance music, the saxophone is the most fascinating instrument. Many people think the saxophone is a sexy instrument, which leads to plays on words like *sexy sax* or *saxy*. Ferenc Geiger even composed a piece of music for wind orchestra, which he called *Sexy Sax*.

Taking all that into consideration one can see that the saxophone has quite an extraordinary history and links into various fields, which would not necessarily spring to mind. One nowadays comes across the saxophone in many unexpected places or situations, e.g. in films from the 1970s featuring Bud Spencer with a baritone saxophone and many other (often American) films, in *Donald Duck* comic strips, saxophone-playing Lisa Simpson, a *Barbie* doll equipped with a saxophone, the *Saxophone Smurf*, on birthday and friendship cards, posters, stickers, bed linen, wrappings, covers of cookery books, as watch hands, candle holders, shop-window decorations and – in advertisements.

[282] cf. Vogl (1993), pp. 93-94
[283] cf. ibid, p. 72

5. Iconography/Image of the Saxophone in Advertising

This chapter presents a detailed examination of the saxophone's use in printed advertisements. It will show how the saxophone has been used in advertising in Germany, Austria and Switzerland from 1990 until today. Advertisements featuring the saxophone were found in journals, magazines, newspapers, brochures, leaflets, sales folders, posters, catalogues, in the *Jahrbuch der Werbung*, and in a few cases via the Internet. Before getting down to the actual topic, musical instruments in general will be looked at in order to see what they represent and how they are perceived, as it is important to show differences between the saxophone and other instruments. It will also be interesting to see how the saxophone itself is advertised.

In the main part of this study it will be shown how the saxophone has been used to advertise a huge variety of products and services. A selection of advertisements will be described and analysed according to certain characteristics. As criticism has already been voiced, a short paragraph will be dedicated to criticism of the saxophone's use in advertising. Together, this will help to find an answer to the main question of this investigation: What does the saxophone try to tell us or represent when it is used in advertising?

5.1. Musical Instruments and their Associations and Perceptions

Every instrument has its own history and fulfils its own function within its particular cultural background. Some instruments have a very long history, such as the flute or pipe, which is one of the oldest musical instruments, dating back as far as the Stone Age. In mythology the flute (or pipe) is a very important instrument. It is the instrument of the gods and has always been said to have supernatural or magic forces.[284] The probably best-known example to support this theory is Mozart's popular opera *The Magic Flute*. In addition, it is linked to shepherds, whistling their pipe on lonely hillsides with their sheep, which gives the instrument a rather romantic but also lonely character. In Sergej Prokofiev's musical tale *Peter and the Wolf* the bird is played by the flute. The flute is also used in advertising, usually the traverse flute, and mainly in cultural brochures, concert programmes, or local newspapers.

The clarinet, thought by some to be the predecessor of the saxophone, is still quite a young instrument. Johann Christoph Denner invented it about 1700. It is used in classical music as well as in jazz. The clarinet is a very agile instrument

[284] cf. Buchner (1986), p. 247

and makes a smooth and mellow sound, which, since Prokofiev's *Peter and the Wolf*, has unmistakably been associated with the cat. However, not only in this musical tale, the clarinet represents the cat; there are many other examples in musical literature that confirm this link. It was used for a long time by the German TV broadcasting station HR3 that showed a group of cats playing amongst a pile of boxes, to a composition for the clarinet called *Wild Cat Blues*, by T. Waller and C. Williams.[285] The clarinet's ability to be sweet and cuddly in the lower registers and shrill and shrieking in the higher registers like a cat reinforces this link. Not many examples of the clarinet in advertising could be found and, if so, it was together with other instruments rather than on its own.

Another group of very old and charismatic instruments are brass instruments. Early trumpets date back to at least Egyptian times. Trumpets were found in the grave of Tutankhamen, who died in 1352 BCE.[286] The trumpet was known as the instrument of the kings and was given to a new king together with the imperial orb. Later on in history it represented the proud cavalry.[287] Apart from this 'strong and mighty' image, the trumpet nowadays also has a classical and a jazz image. The trumpet, like the saxophone, is one of the front instruments in jazz. All these images are used when the trumpet appears in advertising. Brass instruments in general symbolise strength and force. They can be played at a very high volume, and they can be heard over long distances. Therefore, in the Middle Ages brass instruments, especially hunting horns, were used for hunting signals or fanfares.[288] The post-horn still symbolises the post office in many countries, whereas a postman blowing a horn is long out of date.[289] The brass instrument, which is always associated with church and biblical scenes, is the trombone. Today, trombones are still apparent in church music, in Germany grouped with trumpets in 'trombone choirs' (Posaunenchöre), which are – strangely enough – not known in England, where brass bands are a more common band form. The German image of the trombone is a rather solemn one. The trombone therefore, when used in advertising, indicates a connection with church or, like the clarinet, is depicted together with other instruments.

Another instrument with a long mythology is the harp, often seen in connection with angels and thus linked with biblical stories. However, the harp is also the heraldic figure of Ireland and, returning to advertising, represents the well-

[285] For a detailed report about the link between the cat and the clarinet cf. Krüger (1994): *Von Katzen und Klarinetten*, pp. 64-73
[286] cf. Buchner (1986), p. 257
[287] cf. Kool (1931), p. 1
[288] cf. Buchner (1986), p. 257
[289] cf. Habla (2001), p. 156

known Irish brewery *Guinness*. The harp also appears on the reverse sides of the Irish Euro coins.

One really does not have to say much about the classical string instruments violin, viola, and cello: they have always represented classical music and they probably always will. String instruments used in advertising are symbolised by their characteristic form. The best-known advertisement in this category is probably *Mozartkugeln*. The violin and *Mozartkugeln* are closely linked, as shown in Figure 5. In general, string instruments are only used in advertisements that represent a classical, formal or serious style.

Figure 5: The Violin in Advertising - Mozartkugeln[290]

Even though many people associate the violin with Mozart and *Mozartkugeln*, the instrument is also closely linked to classical music in general. An example visualising this link is shown on the right. The violin and a French horn, two instruments that represent classical music very well, are used to advertise the *Volkswagen Orchestra*. The text, which expresses "A classic by Volkswagen" even mentions the word 'classic'. And it further has the advantage that people will automatically think of the old *Beetle* or *Bulli* as well.

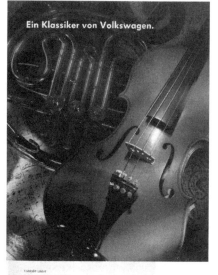

Figure 6: Volkswagen Orchestra[291]

[290] Packaging of Mozartkugeln
[291] Clarino 10 (2002), p. 15

There are only two exceptions regarding the image of string instruments. The first one is the double bass since, in addition to being used in classical music, it is the main bass instrument in jazz and Latin American music. One example that shows the use of the double bass in advertising is the *Petit* advertisement, shown in Figure 7. In this example the double bass is shown exclusively but usually it is seen as an accompanying instrument that remains in the background and does certainly not appear in advertisements as often as the other 'classical-only' strings.

Figure 7: The Double Bass in Advertising[292]

The other exception is the guitar that, with its young and stylish image, is a stringed instrument, but does not really belong to the string family. The guitar is, like the saxophone, used in classical music, but it is not its main musical style. It is also used in almost every kind of modern music, Latin American music, and dance music. The guitar is often seen in advertisements, symbolising rock music. In addition, it personifies youth and has a young and trendy image. A typical advertisement with a guitar is the advertisement shown in Figure 8.

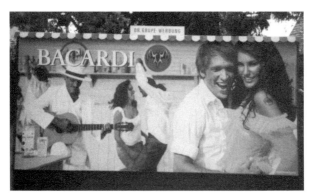

Figure 8: The Guitar in Advertising – A Bacardi Hoarding[293]

[292] in: Süddeutsche Zeitung (2001); the text of the advertisements says: My music has always had Cuban roots. Now I enjoy *Petit* cigars with fine Havana tobacco.
[293] Bernhard Habla photographed this hoarding, and kindly put it at the authors' disposal.

Keyboard instruments used in advertising are the piano and the accordion. The accordion is usually associated with three countries or images: with Austria for its *Volksmusik*, with France for its musette waltzes and with Argentina for the tango. These three images are also used in advertising. The piano, although it can be found in almost any kind of music, symbolises a very classical style. It is seen as an accompanying instrument that always seems to stay in the background, even if it has its own solos. All examples of the piano used in advertising that could be found were in connection with an extremely classical, high-class style.

All these instruments have been used in advertising, and this general survey cannot cover every instrument or detail, although it can give an idea of their images and associations in general, as well as their use in advertising. But where does that take us as regards the saxophone? Without carrying out an empirical study to prove this assumption, it seems as though the saxophone is the instrument that is most often used in advertising. As the historical overview at the beginning of this paper shows, the saxophone is still a very young instrument. It is not well established in classical music and thus not a regular member of classical orchestras. However, the saxophone is associated with

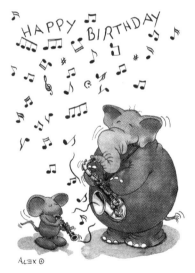

animals and other figures, but not as specifically as some of the instruments described above. The saxophone is sometimes shown with an elephant, probably due to the similarity of shape of the elephant's trunk and the saxophone. On the other hand, this is a strange connection as elephants are said to trumpet with their trunks; please also note the mouse (usually the cat's victim) in Figure 9 playing the clarinet (the cat's instrument as illustrated above). Other associations and characteristics of the saxophone will be dealt with later on.

Figure 9: Saxophone-playing Elephant[294]

[294] Verkerke Greeting Card #38389

5.2. Advertising the Saxophone

Before proceeding to the description and analysis of the saxophone in advertising, it will be briefly outlined how the saxophone is presented in advertising when the instrument itself is being advertised. Although this is only a side aspect it is necessary insofar as it will show if there is a difference between advertising the saxophone itself and using the saxophone to advertise other products and services, which is the main topic of this study. It seems clear that the saxophone itself has been advertised since the beginning of the 20th century, whereas the use of the instrument to advertise other products started some 80 years later.

Of course there are more than two kinds of designs in which the saxophone is advertised, but there are two groups of saxophone advertisements, which show obvious and characteristic features. Although only a small selection of advertisements can be discussed here, these seem to represent saxophone advertisements very well.

The first group consists of advertisements for retailers or wholesalers who sell other instruments in addition to the saxophone and possibly other equipment and services. Figure 10 shows a characteristic example. The half-page advertisement is designed in black and white and was printed in a journal for wind music in 2001. It indicates via pictures which instruments are sold, without any detailed information about the instruments, and without giving or showing any brand names. None of the instruments stands out. There is further information about the shop and contact details including its homepage on the Internet. The objective of this kind of advertisement seems to be to let consumers know that a certain shop exists, what their business is, how the shop can be contacted and how to find it on the Internet.

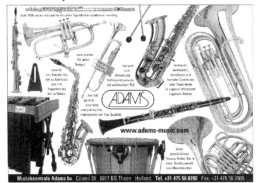

how to find it on the Internet. The instruments are depicted iconically, which is more effective than simply naming them, as analysed above. There are many of these advertisements for music shops and, generally speaking, these advertisements are nothing spectacular, although an improvement over the last few years seems to be visible.

Figure 10: Adams Advertisement[295]

[295] in: Clarino 5 (2001), p. 39

98

The second group of advertisements for saxophones are those advertising a specific brand, as the examples in Figures 11 to 15 show. Before examining the differences between these advertisements, some similarities may be noted: all the advertisements were printed in music journals or saxophone study books and, apart from Figure 15, they were all A4-size. All these advertisements portray either the alto saxophone and/or the tenor instrument. The saxophone covers a considerable portion of the advertisement. There is no hint that saxophones in other pitches are available as well; this is taken as self-evident. All the saxophones in the colour pictures are depicted in the original and traditional saxophone colour of gold. Even if some saxophones are also available in other colours, the traditional version still dominates the market. The background of the colour advertisements is always designed in cold colours (blue, black, white), which allows the warm-coloured saxophone to draw the viewer's eye. Apart from Figure 13, these advertisements promote a brand image rather than a particular instrument.

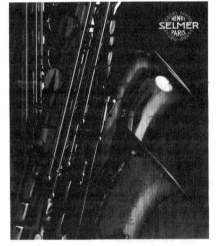

The *Selmer* Advertisement in Figure 11 shows two saxophones, but only partly. The attention is directed towards the brand name *Selmer* and to contact details about where you can buy or get more information about *Selmer* Saxophones. Exclusive distribution rights in Germany are with *Selmer GmbH & Co. KG* in Düsseldorf, the company that commissioned this advertisement. Please note in this context Figure 3, which is also a *Selmer* advertisement, but this time showing six different saxophone sizes in colour.

Figure 11: Selmer Advertisement[296]

[296] in: rohrblatt 10 (1995), cover page at the back

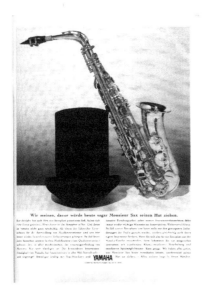

This *Yamaha* advertisement, showing an alto saxophone and a top hat, expresses excellence in picture and word. The top hat symbolises style and a high-class image. The instrument's only task is to show that a saxophone is advertised. The slogan below the picture, which translates as "We believe that for this, even Mr Sax would nowadays take off his hat", creates a link between picture and text. The small print further stresses the excellent quality of a *Yamaha* saxophone. The organisation that commissioned this advertisement is *Yamaha Europa GmbH*. The only contact detail given is a telephone number.

Figure 12: Yamaha Advertisement[297]

Figure 13 is the only example out of the five examples discussed which advertises a specific instrument besides the brand image. What is striking about this advertisement is that it stresses its American aspects: *Conn* is an American saxophone manufacturer, the slogan is in English, and so is the coin or seal in the top right hand part of the picture. The picture on the left also looks typically American, which is further stressed by the text underneath. At the bottom one can find a little US flag and contact details in the USA.

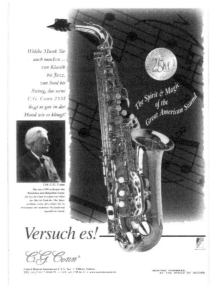

Figure 13: Conn Advertisement[298]

[297] in: rohrblatt 8 (1993), p. 25
[298] in: Clarino 11 (2000), cover page at the back

The two *Jupiter* examples are from different years: Figure 14 from 1995 and Figure 15 from the year 2000. The most important word in the earlier one is "spielen(d)" which translates into English as "play(ing)", making use of the ambiguity of the word. "*Jupiter* connects playing" is shown in the whole advertisement, not only in the slogan at the top, but also in the images. The saxophone in front seems to connect the man and the woman by capturing the important elements with its whole body, showing that the saxophone's shape also contributes to the connection. There are three saxophones in the picture, two altos and one tenor. The woman is playing an alto, and the man the tenor saxophone. The man's thoughts, which tell the story behind the picture, are printed in words below the picture; contact details and some further information are given at the bottom of the advertisement.

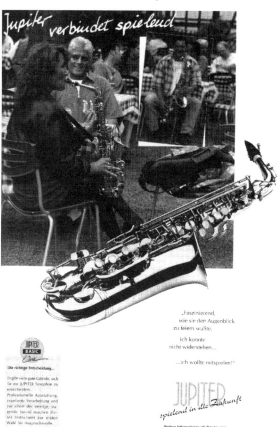

Figure 14: Jupiter Advertisement 1995[299]

[299] in: Juchem (1996), cover page at the back

The later *Jupiter* advertisement presents a testimonial by Carolin Hild, the saxophonist of the band Ca-Roh. It is not clear who commissioned this advertisement, but it is most likely that it was *Jupiter*, as they use Carolin Hild as a spokesperson for their instruments.[300] Contact details of both are given. The slogan has changed since the appearance of the older advertisement and now reads: "*Jupiter* – be inspired", which is once again prominent in the whole advertisement. The future is mentioned in both *Jupiter* advertisements, in the old one in words and in the new one by the dynamic presentation of the keys.

Figure 15: Jupiter Advertisement 2000[301]

To sum up how saxophones are advertised, it can be said that retailers do not seem to spend large amounts on advertising. The manufacturers, who usually advertise their brand by advertising an image rather than a specific instrument, do the main advertising for the saxophone.

5.3. Use of the Saxophone to Advertise Other Products and Services

There is a great variety of advertisements in which the saxophone has been used. Therefore a categorisation seems to be necessary in order to get some idea for what kinds of products and services the saxophone has been used in advertising. Subdividing the advertisements into various subjects and points of view will help to identify the different roles that the saxophone plays in advertising. Some advertisements will be found in more than one subdivision, which emphasises the similarities in some areas, as well as differences in others. When discussing the advertisements, elements that are not crucial to the understanding of the saxophone's role will be neglected.

[300] cf. No author identified (2001), in: http://www.ca-roh.de/inhalt.htm, 19 September 2001
[301] in: Clarino 11 (2000), p. 21

As the saxophone has been used quite frequently in advertising, there is a collection of at least one hundred and sixty German, Austrian and Swiss advertisements from the last thirteen years, depicting a saxophone. Unfortunately not all available advertisements can be discussed in this context and therefore the authors of this study made a selection of interesting and representative examples. The selection was made by choosing the advertisements deliberately according to criteria that would help to identify the saxophone's role in advertising. The criteria of examination can be found in the headings of the following sections. Within the sections only characteristic or interesting examples will be discussed. Due to similarities in the use of the saxophone in advertising, a description of all available advertisements seems neither useful nor necessary.

5.3.1. Categories of Products and Services

The range of products, services and other items advertised with the aid of the saxophone is immense. In order to get an idea and overview of the different advertisers that use the saxophone, two tables have been drawn, which divide all known advertisements featuring the saxophone into different groups. The authors chose the headings and groups, as they seem to build a useful and clear structure. A first rough subdivision is the division into products and services. As most advertisements showing the saxophone are made for consumers and not directed at businesses, a further division into advertisements for businesses and consumers does not appear to be necessary. Products can then be further subdivided into the broad categories Furniture and Household, Food and Drink, Fashion, Vehicles and Other Products. For services the categories Events, Travel, Media, Shops and Businesses and Others seem appropriate. The tables, which give an overview of examples and a further subdivision, are shown in Appendix 1. In the following sections these categories and their saxophone advertisements will be looked at more closely.

5.3.1.1. Products

5.3.1.1.1. Furniture and Household

It can be seen that in furniture advertising, the saxophone seems to appear quite a lot, but only a few different styles have been used, always presented as colour photographs. The picture shows the furniture of a living room, bedroom or kitchen and the saxophone appears as an accessory. In the first kind of furniture advertisements the saxophone is placed somewhere in the room, e.g. leaning in a

corner, stored in a cupboard, lying on a sofa or on a table, etc. Usually, there is no text accompanying the picture that mentions the saxophone at all. The saxophone is simply part of the décor of the room or furniture presented. Figure 16 shows a typical furniture advertisement of a living room. Various examples of this kind were found. In this figure, in addition to the alto saxophone in the corner, a jazz band has been put on the cupboard on the left and the saxophonist on his own once more on the cupboard with the drawers.

Figure 16: Typical Furniture Advertisement[302]

A little different are the advertisements where somebody plays (or pretends to play) the saxophone. The person may be lying on a sofa, standing or sitting in the 'room' that is advertised.

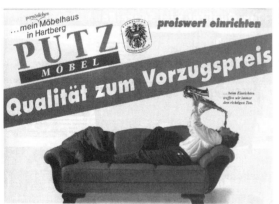

Figure 17: Putz – Furniture Advertisement[303]

[302] in: Brigitte (1996), p. 22
[303] in: *Möbelhaus Putz* Leaflet (1993)

In the second case, there is sometimes some indication, of why there is a saxophone in the picture. One collection of furniture is called *Jazz* and portrays a saxophonist in black and white in the foreground of the picture, whereas the furniture stays in the background in full colour.

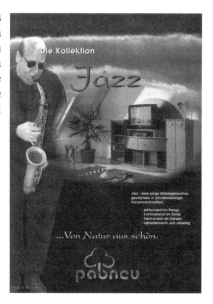

Figure 18: Kollektion Jazz[304]

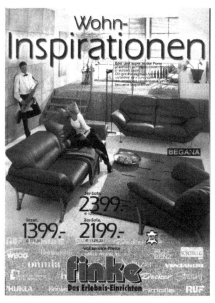

In the case of the *Finke* advertisement, the saxophone, together with the stylishly dressed people and the red leather sofas, seems to emphasise quality. The slogan printed in bold letters "Edel und super in der Form", which translates as "noble and in great shape" could apply for both the set of sofas and the saxophone and thus creates a link.

Figure 19: Finke Advertisement[305]

[304] in: HBZ (1997), p. 40
[305] in: *Finke* Catalogue (2001), cover page

The advertisement by *Möbel Bolte*, which advertises the shop's 49th anniversary, is completely different. No furniture or product information is shown in the advertisement, but a prominent headline announcing the last day of a

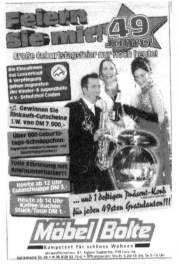

celebration, on the left giving some information about prize draws, food and events which take place during the day, and three people (a man and two women), partying and enjoying themselves. The man is holding a saxophone in his hands, not playing but laughing.

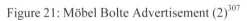

Figure 20: Möbel Bolte Advertisement (1)[306]

Another advertisement by *Möbel Bolte*, which was printed in the same local newspaper as the first one, also makes use of the saxophone. This time two saxophones are visible, positioned decoratively on the left and right hand side of the armchair. This is a typical furniture advertisement with a saxophone as decoration. It is interesting to note that a furniture retailer called *Gröbl Möbel* used exactly the same picture in November 1999 in Austria.

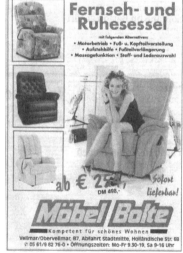

Figure 21: Möbel Bolte Advertisement (2)[307]

[306] in: HNA Melsunger Allgemeine (2001a), p. 3
[307] in: HNA Melsunger Allgemeine (2001d), p. 15

A recent furniture advertisement by *Daube Wohnwelt* differs from the others significantly, as it is one of two saxophone advertisements that were found, in which a child is playing the saxophone. The child is standing on the advertised sofa. The slogan that translates into English as "Jazz breakfast with dad ... dumdidumdidum ... fantastic" builds a link between the saxophone-playing boy and his guitar-playing dad. It creates a nice young family atmosphere, whereas the picture does not give any evidence of a breakfast to be had. The instruments seem to have been used to create this nice atmosphere, without having any specific use or deeper meaning. Apart from also showing a red sofa, this advertisement's use is similar to the *Finke* advertisement insofar, that they were both published on the cover page of the respective brochures.

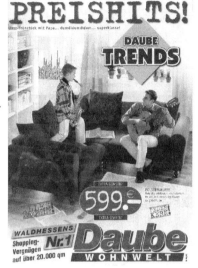

The other saxophone advertisement with a child also shows a boy wearing his dad's pullover and playing his saxophone. It is an advertisement for *Bueckle*, a manufacturer of knitted jumpers for men.[308]

Figure 22: Daube Wohnwelt[309]

The saxophone seems to be particularly attracted to flooring or floor coverings. There is more than one example advertising carpet or parquet, with a saxophone lying on the floor, without any further explanation or indication given, as to why

it is there. Figure 23 at least goes along with the text: "Das **innovative Modulsystem** ermöglicht eine vielfältige Bodengestaltung", which translates into English as: "The innovative module system allows a varied flooring arrangement."

Figure 23: Flooring Arrangements[310]

[308] cf. No author identified (1996), pp. 342-343
[309] in: *Daube Wohnwelt* catalogue (2002)
[310] in: Wohnen (1999)

Apart from advertising living rooms and their equipment, flooring, children's rooms and bedrooms, the saxophone is also used to advertise for kitchens. One example for a kitchen being advertised with a saxophone is shown in Figure 24. What is interesting about this *Kortina* advertisement is that the slogan means "Diversity of colours – the kitchen in the trend of the time". From the slogan one would expect a lot of different colours in the kitchen, but the kitchen shown is a white one with silver parts and a little brown wood. The floor is shiny and silver, the chair is made of aluminium and so is the table. Even the saxophone lying on the table is a silver one – and not a golden one as in almost all other advertisements showing a saxophone.

Kortina Küchen

Vielfalt der Farben – die Küche im Trend der Zeit

Figure 24: Kortina Advertisement[311]

In all these furniture advertisements the saxophone seems to be just some kind of decorative element, not even an eye-catcher, as it is not especially placed where the eye will focus when looking at the advertisement. The advertisements depicting people communicate at least some kind of atmosphere or mood, whereas the ones in which the saxophone is just positioned somewhere in the room do not have this strong emotional aspect.

[311] in: *Kortina* Catalogue (2002)

108

A recent example for a saxophone advertisement within the area of household appliances is a vacuum cleaner advertisement by the German company *Miele*. They have two very similar vacuum cleaners on offer, which are called *Tango* and *Jazz*. Both are advertised in the same brochure. The front page shows a very typical picture symbolising tango: a dancing couple in a position that is known to everybody. The colours in that picture are black and red, very warm and emotional colours. Red is also the colour of the vacuum cleaner called *Tango*. Next to the red tango dancing couple, there is a tenor saxophone player with black skin. This picture is kept in blue and black colours. There is smoke in the background. Altogether this is an emotionally very gripping picture, symbolising the idea of Jazz very clearly. In addition, *Jazz* is the name for the silver vacuum cleaner. The *Jazz* cleaner is further described in the inside of the leaflet by the slogan: "*Miele Jazz*. Precision and stile", which is a further link between the visualisation and the product. Therefore, there is a whole concept behind the *Tango* and *Jazz* ideas, which has been visualised in a very emotional way, and which allows potential buyers to get an emotional idea about the product and therefore gives these *Miele* vacuum cleaners the leading edge compared to other cleaners that are advertised in a less gripping way.

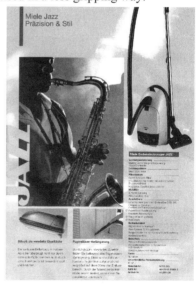

Figure 25: Miele Advertisement (1)[312]

Figure 26: Miele Advertisement (2)[313]

[312] in: *Miele* brochure (2002)
[313] in: ibid.

5.3.1.1.2. Food and Drink

In the area of foodstuffs, the saxophone has seen frequent use although, mostly advertising drinks rather than food. For food only two examples could be found, both in the group of packaging for sweets. Both depictions were paintings and not photographs. The first example was a packaging for *Haribo* sweets, which shows a saxophone-playing bunny. In a second advertisement the saxophone appeared on a packaging for *Lieken Urkorn* sweet bread snacks, which shows a saxophone-playing fox.

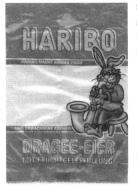

Figure 27: Haribo[314]

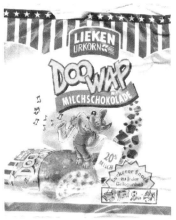

Figure 28: Lieken Urkorn - DooWap[315]

However, as regards drinks advertisements a wide variety is covered: from mineral water to tea, wine, beer and spirits; the saxophone advertises them all. The most interesting product within this group seems to be beer, as here a variety of different advertisements can be compared. In Chapter 2, the *Villacher* advertisement has already been discussed. *Gräflinger*, another Austrian beer brand, used a picture with a young man holding a glass of beer in his left hand. He is standing casually and looking straight into the viewer's eyes. Next to him a saxophone is standing. The only difference between the two advertisements is the slogan. The slogan in the first and second line of Figure 29 means "*Gräflinger* soft Pils. For strong guys/for the strong type". In Figure 30 this is reversed: "Strong types/blokes drink soft Pils". The picture itself is in black and white, and so is the saxophone. Only the advertised product, shown by a bottle and a glass of beer, is shown in its original colours. Clearly, the tenor saxophone helps to make the young man look strong.

[314] Packaging *Haribo*
[315] Packaging *DooWap*

110

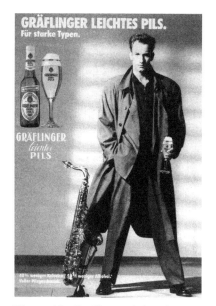
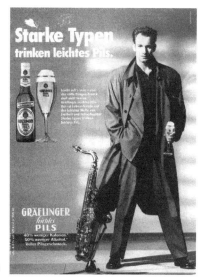

Figure 29: Gräflinger Advertisement (1)[316]

Figure 30: Gräflinger Advertisement (2)[317]

Herforder Pils, a German beer brand, also portrays a man with a tenor

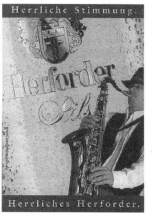

saxophone. Here the young man is dressed like a stereotypical Bavarian. The man is leaning slightly backwards playing his tenor saxophone. The background consists of beer. The colour of the beer is very close to the 'normal' colour of the saxophone, but the saxophone portrayed here is black with golden keys. The slogan means "Great Mood. Great *Herforder*", suggesting that the saxophone will help to put people in a good mood – just like *Herforder*.

Figure 31: Herforder Pils Advertisement[318]

[316] in: *ADAC* Motorwelt (1991), p. 31
[317] in: *ADAC* Motorwelt (1990), p. 18
[318] in: Bielefeld Veranstaltungen 2001, p. 5

A most interesting beer advertisement with the saxophone is the Swiss *Heineken* advertisement, which is shown in Figure 32. It shows a melting tenor saxophone and uses an English slogan. The same idea has been used with a guitar, which provides an indication therefore, that the saxophone and the guitar have to a certain extent a similar image. The text parallels the idea and helps to convey the 'feel' of the message: trips to hot festivals can be won, where one can then cool down with *Heineken*. The text, which gives further information about the advertisement in the *Jahrbuch der Werbung* in which the picture was found, says that here a simple promotion centred on an idea which, coupled with an attractive promotion, helps to enhance the *Heineken* brand image.[319] Apparently, there is also a German *Heineken* advertisement with a saxophone, which is completely different in style from the Swiss one. It shows a jazz band, all in black and white.

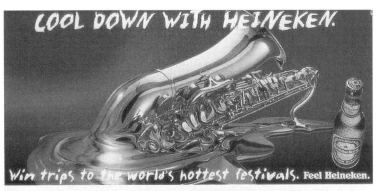

Figure 32: Heineken Advertisement[320]

[319] cf. No author identified (2000), p. 171
[320] in: Jahrbuch der Werbung 2000, p. 171

Another noteworthy example of a beer advertisement is shown in Figure 33. It is partly painted and partly photographed, similar to the *Villacher* advertisement shown in Figure 2. The bottle is photographed whereas the saxophone made out of beer has been painted. This makes sense in so far as the bottle of beer is a real object, and a photograph, which is a reproduction of reality, can better show this realism. The saxophone made out of beer and foam is a product of the imagination and is therefore painted. The association of the saxophone with jazz is clear from the slogan: Keep on swinging.

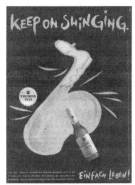

Figure 33: Trumer Pils Advertisement[321]

A further example of brewery advertising with a saxophone is *Köstritzer*, a brewery in Thuringia in Germany. The company has various pictures and posters in which a young man plays a saxophone. He is always shown in a youthful gathering, including a woman sitting at a piano or happy young people surround him. However, the saxophone seems to play a more important role for *Köstritzer*. *Köstritzer* founded their own jazz band and is a sponsor of jazz festivals. Therefore the saxophone appears repeatedly on their Internet homepage and other publication material. The jazz image is embodied into the company's marketing strategy.[322]

There is also an entire marketing strategy for a collection of wines from a wine-growing society called *Weingärntergenossenschaft Stuttgart-Untertürkheim*, for whom the advertising agency called *Die Crew Werbeagentur GmbH*, Stuttgart created a wine range for young people. The umbrella brand name *Weinedition Jazz* was developed for a complete marketing campaign including packaging, radio jingles, events and leaflets. Four different wines are called *Swing, Ragtime, Blues and Soul*. Each wine has its own painted image. The wine represented by a saxophone is a white wine called *Swing* and shows a male tenor saxophonist on the label of the bottle. The *Ragtime* label bears the figure of a pianist and the *Blues* wine that of a guitarist. *Soul*, a red wine, shows a female soul singer.[323]

[321] in: News (1995), p. 49

[322] cf. No author identified (2001), in: http://www.koestritzer.de, 17 October 2001; one advertisement (picture) was seen in the Ratskeller in Heiligenstadt in a collection of *Köstritzer* advertisements by Melanie Vockeroth on 14.10.2001; a collection of posters and other marketing material was kindly put at the authors' disposal by the brewery *Köstritzer*.

[323] cf. No author identified (1994a), p. 458

113

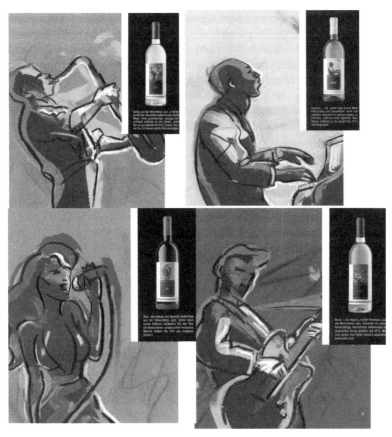

Figure 34: Weinedition Jazz – Labels and Bottles[324]

Figure 35 shows an advertisement for *Southern Comfort*, which is clearly all-American. The product is American, the black saxophone player symbolises the origins of jazz, and the steamboat is also a symbol of the southern USA. Even the text is mainly in English to emphasise the American associations. Only the small print on the left hand side of the bottle's neck is in German, giving details of the advertised cocktail night.

[324] in: Sales folder *Weinedition Jazz*

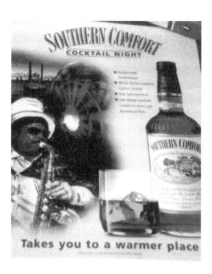

Figure 35: Southern Comfort Advertisement[325]

As already mentioned, the saxophone has also been used to advertise anti-alcoholic drinks, namely mineral water and tea. The *Lipton* advertisement, which is an example from Austria, shows a young man, holding his alto

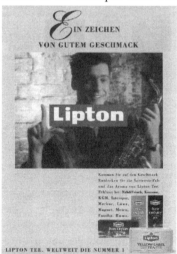

saxophone in his left hand. The slogan, which means "A sign for good taste" is visualised by the man's right hand, forming an L for *Lipton*. There is, once again, no obvious reason for showing the saxophone in this advertisement. The intention may have been to show that young and trendy musicians are not too cool to drink tea, and if they do, they will go for the Number 1 worldwide. But the saxophone might also be just a symbol for youth and its appearance in the advertisement not linked to any deeper wisdom.

Figure 36: Lipton Advertisement[326]

[325] Collection B. Habla (2001)
[326] in: Fernseh- und Radiowoche (1992)

The tenor saxophone-playing man in the *Rosenberg* advertisement is well dressed, but still looking cool and trendy while playing his instrument. This advertisement is kept in white, grey, black, red and blue colours. The important message *"Rosenberg*. So fresh, so good" is printed in red, a warm colour, drawing to the front, whereas the saxophone player with a blue background is intended to look cool, emphasised by cool colours. This advertisement is an image advertisement, as most mineral water advertisements are. There are only slight differences between different mineral water brands concerning the product. Therefore, mineral water companies try to establish an image, which makes people believe that their water is healthier, cleaner, etc. *Rosenberg* must have tried to give their water a trendy, sporty and cool image by showing this advertisement.

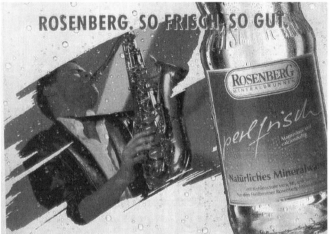

Figure 37: Rosenberg Advertisement[327]

This detailed description of where and how the saxophone has been used to advertise drinks shows a strong association between drinks and music, particularly jazz. The saxophone is an indicator of music, linking the two. This link is not far-fetched, as people often have a drink in the company of others, accompanied by background music, in a pub, club, or at a party, etc. The saxophone in the pictures serves for creating this kind of atmosphere on the viewer's minds, although they cannot actually hear the music, but have to imagine it through the saxophone and the associations linked with the instrument.

[327] in: Jahrbuch der Werbung 1994, p. 173

5.3.1.1.3. Fashion

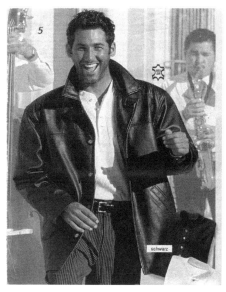

Fashion is also an area, in which the saxophone has been widely used to advertise clothes for men and women. Examples of its use for advertising children's clothes have not been found. It is interesting to see how many styles can be promoted with the saxophone by communicating certain features. There is, for example the 'cool style, happy man' image as shown in Figure 38, where a person looking Mexican plays the saxophone in the background. On the left, there is also part of a double bass, and therefore the general atmosphere is jazzy deep Southern American or Mexican. The saxophone helps to underline this image.

Figure 38: Advertising a Leather Jacket[328]

Another style of fashion that the saxophone underlines is a wacky, freaky, young style. At the same time the saxophone is used to advertise fashion of a more traditional or even legendary style, such as that used by *C&A* in 1995, shown in Figures 39 and 40. In both advertisements the saxophone stays in the background, but it is nevertheless portrayed in different ways. In the advertisement for men a saxophone can be seen in the background only, whereas in the advertisement for women there is somebody with black skin pretending to play an alto saxophone. It is not totally clear what associations the saxophone is supposed to evoke in this context.

[328] in: Alba Moda (1999), p. 125

117

Figure 39: C&A New Legend '95 (For Women)[329]
Figure 40: C&A New Legend '95 (For Men)[330]

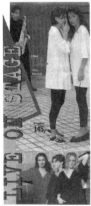

Another advertisement, in which a tenor saxophone played by a man has been used in the background, is shown in Figure 41. It is similar to Figure 39 insofar as women's clothes are advertised, shown in the foreground of the picture, with a male saxophone player in the background, but differs inasmuch as the slogan "Live on stage" at least links the saxophonist with the advertisement. The saxophone seems to have been pushed to the background by the clothes that deserve to be 'live on stage'. However, the saxophone is necessary to indicate the stage.

Figure 41: Live on Stage[331]

[329] in: Kleine Zeitung (1995a), p. 33
[330] in: Kleine Zeitung (1995b), p. 36
[331] Original source unknown; access through Collection B. Habla (2001); also printed in Habla (2001), p. 171; further Figures from the Collection B. Habla, for which the original source is unknown, will be marked as 'Collection B. Habla (2001)'

118

The high quality clothes manufacturer *Peek & Cloppenburg* published a catalogue advertising men's clothes in 2002, in which three pages were designed with the same men of about 40 years of age with an alto saxophone, once holding it in his right hand, once playing it, and once it is just lying next to him in the concert hall. Although in the first and second example the background colours are blue and black (cold colours) and in the third example red (a warm colour), the same high quality and style is clearly visible. The musician seems to symbolise the target group of the type of clothes that is advertised.

Figure 42: Peek & Cloppenburg Advertisement (1)[332]

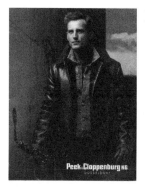 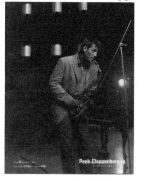 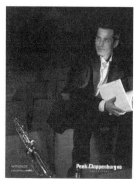

Figure 43: Peek & Cloppenburg Advertisement (2)[333]

Figure 44: Peek & Cloppenburg Advertisement (3)[334]

Another use for the saxophone is to advertise shoes. There are only two examples known in this category. One of them is very peculiar and does not seem to make a lot of sense. Therefore its details will not be discussed here.[335] The other one is a recent advertisement from *Comfort Schuh GmbH*, Germany. It will be further discussed in Chapter 5.5., which deals with criticism of using the saxophone in advertising.

[332] in: *Peek & Cloppenburg* brochure (2002)
[333] in: ibid
[334] in: ibid
[335] Interested readers can find this advertisement in Habla (2001), p. 166

5.3.1.1.4. Vehicles

In this chapter, vehicles such as cars and motorbikes shall be looked at a little more closely. Therefore it is necessary to understand the communication policy in the automobile industry. The automobile industry is the industry with the highest advertising spending in Germany.[336] An automobile is a typical high involvement product. A costumer spends a long time finding out information before making the decision of buying a car.[337] This is a serious difference to most of the other products that are advertising with a saxophone. Dietz further explains in his book *Automobilmarketing* that the communication policy creates one of the central success factors in the automobile industry: building the image of a company, brand or product. The image helps to create a unique selling proposition in the market as it helps to distinguish from other companies or brands.[338]

Therefore it is not surprising that the saxophone has also been used to advertise cars and motorbikes. Within this group of advertisements, the saxophone has been used differently. The first example to mention is the campaign that launched the *Citroën Saxo*. *Citroën* gives its cars fantasy names that are sometimes created via internal brainstorming and sometimes by specialised agencies, added by suggestions from fans or employees of the company. The criteria considered when looking at a possible new name are those of morphology, to establish whether the name looks good, is easy to read and to remember; semantic criteria in order to make sure that the associations evoked by the name are positive; and further marketing criteria such as whether the name of the car fits its image, size of car and brand name.[339] Even if *Saxo* is a fantasy name, the allusion to the saxophone is undeniable. And a car with a name so similar to the word 'saxophone' was naturally advertised with a saxophone when it was launched in 1996. In the picture, a smartly dressed man is standing behind his new *Citroën Saxo*, obviously trying to attract the woman who is standing in front of him. She seems to be almost blown away by the wind that comes out of the saxophone. This wind might indicate the force of the new car. The car is still in production, but *Citroën* now advertises the *Saxo* as a young, sporty and dynamic car, without reference to the saxophone.[340]

[336] cf. Dietz (2001), p. 491
[337] cf. ibid, p. 489
[338] cf. ibid, p. 489
[339] cf. Fax by *Citroën*, received on 12.10.2001
[340] cf. *Citroën Saxo* Catalogue M 5300101

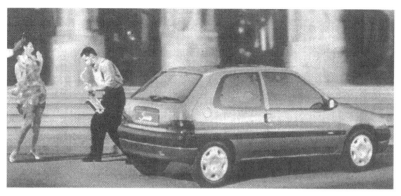

Figure 45: Citroën Saxo Advertisement[341]

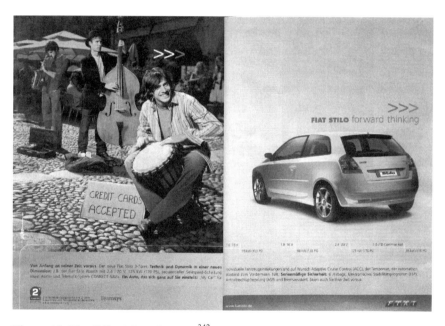

Figure 46: Fiat Stilo Advertisement[342]

A recent car advertisement showing a saxophone is an advertisement by *Fiat*, advertising the *Fiat Stilo* with a group of young male musicians. The band is playing in a street, with the drummer in front of the picture, followed by a

[341] in: Kleine Zeitung (1995c), p. 43
[342] in: TV Movie (2002)

double-bass and alto saxophone player. The three young men have a sign saying, "Credit cards accepted". On the right hand side of the advertisement the *Fiat Stilo* is shown with *Fiat's* slogan "Forward thinking". One can see the link between the two parts of the advertisement: The musicians must be playing their instruments in order to be able to buy a *Fiat Stilo* in the near future. Therefore they are forward thinking, which is further stressed by the fact that they accept credit cards. This advertisement was not only used in Germany, but with minor changes or adaptations, also in England.

Ford also used the saxophone to advertise their *Ford Fiesta Blues* in 1994. The difference between this advertisement and the three examples discussed above is that in the *Ford* example it is the dealer who advertises with the saxophone and not the producer or company in general. The saxophonist is painted and depicted in a strange position. His back is bent back very strongly, obviously on the one hand as this is a typical position to show that this man is playing a solo in a very excessive way, and on the other hand, because this way of showing him fits in the whole concept of the advertisement: The *Blues* seems to come out of his saxophone directly. It is an emotionally gripping advertisement although the design of the saxophone player has been a bit overdone with his unnatural position.

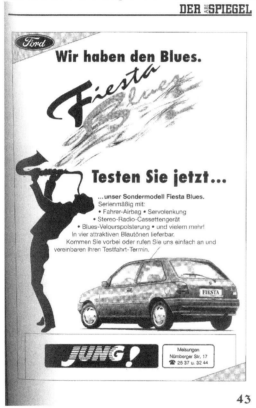

Figure 47: Ford Fiesta Blues Advertisement[343]

[343] in: Der Abi Spiegel (1994), p. 43

Whereas *Citroën, Fiat* and *Ford* are considered lower-to-middle class cars in the countries of this investigation, automobile companies with a high-class image such as *BMW* and *Audi* have also used the saxophone in their advertisements. It must be a coincidence that in the advertising year 2000, in which most companies of the automobile industry reduced their advertising budgets, *BMW, Citroën* and *Audi* belonged to the few companies who increased their advertising expenditure.[344]

Audi used the saxophone in a recent campaign. There are two saxophones in the background of the advertisement for the new *Audi A4 Avant*. The colours of the advertisement, which was printed in a local newspaper, are limited to black, white and red. Even the car is limited to shades of grey; only the background with the two very smartly dressed saxophone players is shown in red, a warm colour which directs the attention to the foreground, thus to the car and gives it a warm and pleasant image. The words chosen underline the sensual appeal of this advertisement. Furthermore, there is another important element of advertising in the automobile communication mix linked to this advertisement: a marketing event. The saxophone is used to convey the jazz image by inviting customers to a jazz morning/lunchtime drink, which is a typical German custom on special occasions, usually – as in this case – taking place on a Sunday morning.

Audi Zentrum Kassel präsentiert: **Audi**

Kommen, Sehen und Erleben Sie den **neuen Audi A4 Avant**

JAZZ Frühschoppen
Sonntag 23.9.01
um 10.°° Uhr

Samstag, 22.09.01*
von 10.°° - 16.°° Uhr TESTDRIVE

Heute haben Sie die Möglichkeit, den neuen Audi A4 Avant live bei einer Probefahrt auf Leistung, Sicherheit und Komfort zu testen.
Es stehen verschiedene Motorvarianten für Sie bereit.
Feiern Sie mit.
Wir freuen uns auf Sie.

Sonntag, 23.09.01*
von 10.°° - 17.°° Uhr FAMILIENTAG.

Heute feiert der neue Audi A4 Avant so richtig seinen Einstand. Los geht es um 10.°° Uhr mit guter Laune und vielen netten Menschen bei unserem JAZZFRÜHSCHOPPEN.
Ab 11.°° Uhr swingt für Sie die BAND GROOVE JUICE, die mit ihrer Live-Performance den Hot-Jazz aus New Orleans in Ihre Herzen spielt. Für die Kids beginnt um 11.°° Uhr und 14.°° Uhr die Show von Karl-Eugen Läberle - „dem Mann für alle Fälle".
Sein Programm wird alle Kinder begeistern. Außerdem... ohne Worte: Charly Chaplin als Karikaturist.

Audi Zentrum Kassel
Dresdener Straße 5 • 34125 Kassel
Am Kreisel • Telefon 05 61 / 57 44-0
Telefax 05 61 / 57 44-102

Figure 48: Audi Advertisement[345]

[344] cf. Vornhusen (2000), p. 57
[345] in: HNA Melsunger Allgemeine (2001c), p. 15

123

In Austria, *BMW* advertised a series of its cars with a saxophone. The cars called *BMW Compact* are equipped with a special sound system. The tenor saxophone player in Figure 49 takes up almost half of the space of the advertisement. The bell of his saxophone leads towards the text explaining the advantages of this new sound system, which gives the passengers in the car the feeling that they are at a concert. This advertisement makes good use of the saxophone's shape. The tenor saxophone, being slightly longer than the alto saxophone and with a very soft shape, is especially suitable to announce the positive message from its bell. A baritone saxophone could not have been used in this picture, as that is bent once more at the top of the instrument, which would distract from the straight, but clear and soft transmission of the good news. The saxophone acts as a spokesman, which again underlines the appeal to the senses while bringing the news of an innovative product to its customers.

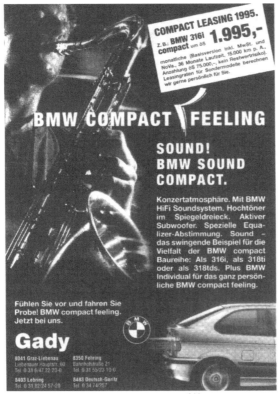

Figure 49: BMW Compact Feeling[346]

[346] in: Programmheft *Die Grazbürsten* 1995/1996. *In Ehren versaut!*, p. 11

In addition, *BMW* in Germany used the saxophone in an advertisement for its motorbike *BMW R 1200 C*. Like the car advertisement, it is designed to appeal to the senses. It even mentions the word 'emotions' on the right hand side of the advertisement. On the left side there is a saxophone player, lovingly playing his instrument, with other instrumentalists in the background and the question written on top: "What inspires people who inspire others?" The answer is given on the right hand side, where the motorbike is shown: "Emotions". The text below the two pictures also underlines the feeling that the advertisement is designed to convey. The saxophone in the left picture is as shiny as the motorbike in the one on the right, which provides a further link between the two. This advertisement was part of an advertising campaign featuring at least three different designs of visualisation. All three are divided in two, with someone asking a question on the left and the advertised product providing the answer on the right.[347]

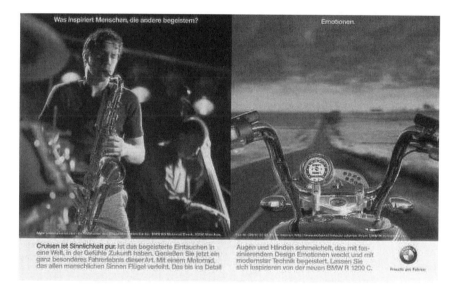

Figure 50: BMW R 1200 C[348]

It is interesting to see that in all the advertisements in the motor industry, a man in his late twenties to mid-thirties plays the saxophone. This suggests, that all these advertisements are targeting men in their mid-twenties to mid-thirties. A car advertisement with an alto saxophone is the *Chevrolet* advertisement, shown

[347] cf. No author identified (1998), pp. 224-225
[348] in: Jahrbuch der Werbung 1998, p. 225

in Figure 51. In the picture one can see the same American symbols as in the *Southern Comfort* advertisement (Figure 35): a Mississippi steamboat and an alto saxophonist. It is, once again, an all American advertisement, this time underlined by a slogan, which refers to the American way of life.

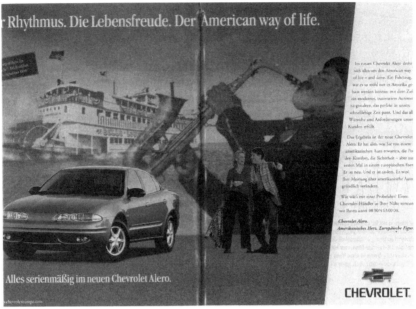

Figure 51: Chevrolet Advertisement[349]

Even if the saxophone has been used in different ways and for a variety of brands, it seems to make sense to use the saxophone to advertise products of the automobile sector. Cars are very important for Germans. They are even called 'a German's dearest child'. They carry feelings, moods and lifestyle and act as a mirror of the Zeitgeist.[350] In this respect, a car and a saxophone are very close to each other, as a saxophone can express or symbolise the characteristics of a car.

[349] in: Stern (1999), pp. 30-31
[350] cf. Schulte-Döinghaus (2001), p. 8

126

5.3.1.1.5. Other Products

The saxophone has also been used to advertise other products like sound systems, cosmetics, stationery, books, electronic coating systems and accessories of various products. A list of these other products, which have been advertised with a saxophone, is included in the table of Appendix 1.

Five cigarette advertisements shall be in the focus of this section. The three brands *HB*, *Memphis* and *Camel* use the association between smoke and the saxophone. As the saxophone is played in many jazz bands that tend to perform in dark, smoky clubs and because of the smoky sound of the saxophone (especially the lower instruments like tenor and baritone saxophone), the saxophone is often associated with smoke and linked to cigarettes. Thus it is logical for the tobacco industry to make use of this image.

Figure 52 portrays the typical smoky, jazzy saxophone image. Apart from what can be seen in the picture, the atmosphere is emphasised by the colourless presentation of the picture. Only the two boxes of cigarettes appear in full colour. Figure 53 is an advertisement for the same brand, *Memphis*, and also shows two men smoking, but this time the saxophone is not played but only shown in the picture. It is a baritone saxophone, as distinct from Figure 52, which shows a tenor saxophone. While Figure 52 uses both smoke associations, Figure 53 only makes use of the association of the smoky sound a saxophone can produce. The latter advertisement is shown in full colour, but unmistakably portrays a club atmosphere as well. In this

advertisement it is assumed that the consumer already knows that *Memphis* is a brand of cigarette, as can be deduced from the absence of any specific mention or direct reference apart from "Real Tennessee Tobaccos".

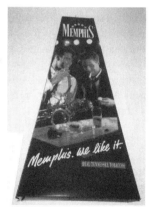

Figure 52: Memphis – Smoky Bar[351]

Figure 53: Memphis – Club Atmosphere[352]

[351] Collection B. Habla (2001)
[352] ibid; according to B. Habla this cardboard folder was used as shop window decoration.

Figure 54 shows cool *Joe Camel*, smoking a cigarette, with a tenor saxophone in his lap. The smoky image is equally evident from this picture, even if it is a drawing and not a photograph as are all the other pictures. Figure 55 makes a rather strange use of the saxophone. The clip, which normally holds the music for a marching band, now holds a cigarette. The slogan "Open for sound and smoke" tries to build a connection. This advertisement is not really convincing,

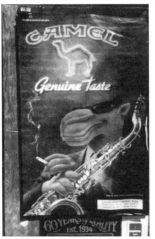

as anyone who knows how the saxophone works also knows that it is not possible to smoke a cigarette through it. The saxophone as a cigarette holder appears neither very entertaining nor clever.

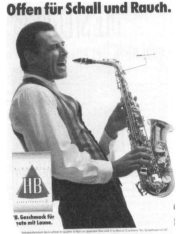

Offen für Schall und Rauch.

Figure 54: Joe Camel[353]
Figure 55: HB Advertisement[354]

The first three examples of cigarette advertisements are linked with the American image of the saxophone *and* the smoky image. The *HB* advertisement does not have the American image, but the smoky one. Example number five is of a completely different kind of style and idea. The French make *Gauloises*, a brand that always advertises with the slogan "Liberté toujours", uses another typical saxophone image: liberty. The saxophone symbolises the freedom to be different, independent and to be able to do whatever one feels like. This is shown in the advertisement as displayed in Figure 56. A man in his early thirties feels free to play his alto saxophone on a French train to a couple, about the same age, who are dancing to his music. It is interesting to note, that this is only the second example of a French product in Germany that is advertised with a saxophone.

[353] Collection B. Habla (2001); it is not certain if this advertisement was published in the German speaking countries under consideration
[354] ibid.

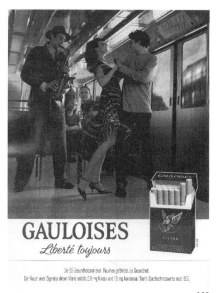

Figure 56: Gauloises Advertisement[355]

Into another category of advertisements one could group sound systems or digital equipment advertisements. Two examples of this category are shown in Figures 57 and 58. The company *sdsystems* manufactures microphones for instruments. As shown in Figure 57, their advertisement shows a man holding a saxophone in his hands, (even with a sax strap around his neck!) to which a microphone is attached. Their logo, that can be seen on the Internet when following the Internet address given in the advertisement, also contains a saxophone bell, although they do not only produce saxophone microphones but also microphones for a range of other instruments.

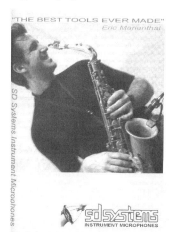

Figure 57: sdsystems Advertisement[356]

[355] in: TV Movie (2002), p. 139
[356] in: Clarino 10 (2002), p. 57

The young man in the *Sony* advertisement shown in Figure 58 is also holding a saxophone in his hands, playing, or pretending to play the instrument. The picture on TV is shown in yellowish colours, which belong to the warm colours, and the background is shown in blue, a cold colour. The actual items that are advertised for are shown in silver, once again cold colours. This design of the *Sony* advertisement with the chosen colours, and the saxophone picture on the TV screen emotionalises the situation, draws to the foreground, and gives the technical products a warm, young and trendy image.

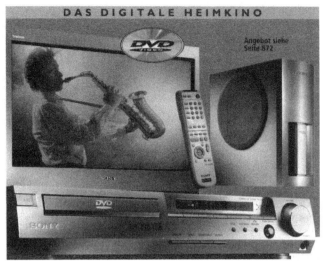

Figure 58: Sony Digital Home Cinema[357]

5.3.1.2. Services

5.3.1.2.1. Events

The next four sections will deal with services, which have used the saxophone in advertising. This first section takes a closer look at publicity material for events. Of course there are lots of bands and saxophone soloists who advertise for themselves, their concerts, CDs etc. with photographs of the band, also showing their instruments and among these, saxophones. Theses advertisements have been left out of this discussion, as it would lead too far.

The saxophone is used very often to promote events of different kinds. It advertises concerts and concert series, festivals for wind bands, jazz festivals, workshops, circuses and many more.

[357] in: *Otto* Katalog (2000), p. 844

It seems clear that within the category of events publicity, which uses the saxophone in advertising, more paintings or drawings (as opposed to photographs) are used than in product advertisements. This can be explained by the ability of photographs to reproduce real life situations. As already discussed above, photographs are more 'real' than drawings or paintings. Their more realistic nature means that they are more likely to sell effectively than are paintings and drawings, as they seem more believable.[358] So why are there more drawings and paintings when it comes to advertising events? One explanation is that an event is a service, which is invisible and intangible. An event, like every other service, can only take place at one particular moment and therefore cannot be depicted as easily as a product.[359] For this reason services such as events are advertised by paintings, which are made up and leave more room for the imagination than a photograph. The event will become real when attending the concert, workshop, etc. and then everybody can make up his or her own image of the event. An example of such a painting is shown in Figure 59, where the saxophone is depicted in its characteristic shape and colour. The rounded shape seems to be such an important characteristic that even in painted or drawn advertisements featuring a saxophone the rounded shape of the instrument is clearly visible.

Only two drawn advertisements could be found, in which the saxophone was depicted as angular.[360] One of them is shown in Figure 60, which is a sticker showing the logo for the *Hessentag 1993* in the state of Hesse in Germany.

Figure 59: Esslinger Kultursommer Advertisement[361]

Figure 60: Hessentag in Lich[362]

[358] cf. Oller & Giardetti (1999), pp. 43-44
[359] cf. Meffert (2000), pp. 1170-1171
[360] cf. rohrblatt 8 (1993), p. 27
[361] in: Jahrbuch der Werbung 1994, p. 587
[362] Sticker from the event in Lich, Germany

Of course photographs are also used to advertise events. In 2001 the *Maiwoche*, an open-air festival with bands, food and drink, which takes place in the centre of Osnabrück every May, displayed a photograph of an alto saxophone on the front page and again on the first inside page of the leaflet. In the background of the front page one can see the dome and a carrousel, a picture all in green, which seems rather unreal. There appears to be no obvious reason why the saxophone has been depicted twice, nor is there reference in the text. What seems to have happened is that, being a popular instrument, the saxophone was used to denote music. However, there is no suggestion whatsoever as to why the saxophone was chosen rather than any other instrument. Its only function seems to be its eye-catching nature. It is then even more interesting to see that, on their homepage on the Internet site,[363] a tenor saxophone appeared, this time not as a picture but as a drawing.

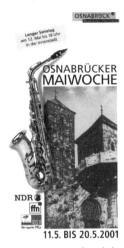

Figure 61: Osnabrücker Maiwoche 2001[364]

Another example from Osnabrück is the poster that can be seen in Figure 62. It is an advertisement for a special event taking place in 25 bars in Osnabrück on a Saturday night, each bar having life music. One has to pay an entrance fee for one bar, but can go to all the other participating bars as well without having to pay again. This kind of event and similar schemes are often advertised with a saxophone. Examples were also found in Kassel and Münster (both Germany).

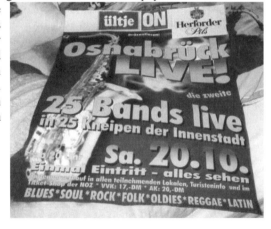

Figure 62: Osnabrück live[365]

[363] cf. No author identified (2001), http://www.osnabrueck.de, 10 May 2001
[364] in: Festival leaflet *Osnabrücker Maiwoche 2001*, cover page
[365] The Poster was seen in Osnabrück, autumn 2001

The saxophone has also been used to advertise the festival known as "A festival/party with cider and jazz". Figure 63 shows the advertisement. It makes use of the jazzy image of the saxophone, which has already been mentioned. There are many more examples of events being advertised using the jazz association by portraying a saxophone, some appearing as drawings, others as photographs. Sometimes these advertisements show a saxophone without a person, and at other times with a player. Occasionally, the saxophone is not even shown in its entirety, but only in part, as e.g. the S-shaped crook and a player are sufficient to represent the instrument and its image.

**Ein Fest mit
Most + Jazz** Figure 63: Most and Jazz Advertisement[366]

There are many more examples of the saxophone advertising festivals, workshops, concerts, etc., which seems logical as the saxophone can symbolise music and is therefore highly suitable for advertising in this area. One of these examples is shown in Figure 64. It is a poster advertising the *Sommer-Samstagskonzert* (Summer Saturday Concert) Series in Melsungen. One cannot only see a big saxophone with its bell to the right, 'spitting out' the bands that participate in the concert series, but also saxophones held by the members of the bands shown in the smaller pictures. The text in the top right hand corner means "On Saturdays in a happy mood into the weekend". So apart from the ability of spitting out the bands the saxophone also communicates the good mood people shall get into by listing to the concerts.

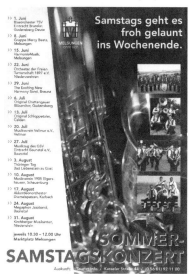

Figure 64: Sommer-Samstagskonzert[367]

[366] in: Kleine Zeitung (2000), p. 32
[367] The poster was seen in Melsungen, Germany in summer 2002

In October 2002 an advertisement showing a saxophone was seen in Hanover: the example is shown in Figure 65. It is a hoarding that was also published as poster and handout, advertising for the *Kinder Info-Tage*, which stands for 'children's info days'. It was a fair taking place in Hanover, offering a range of attractive events for children or families, taking place in the *Hanover Congress Center*. The poster shows, apart from the text explaining the event in a very colourful way, three very sporty people on inline skates, one of the women playing a saxophone while skating. The saxophone seems to have been used to symbolise activity in general and creativity as one of the main factors of the event. Furthermore it may have been included in the picture because of its ability to attract attention – both of the children and their parents.[368]

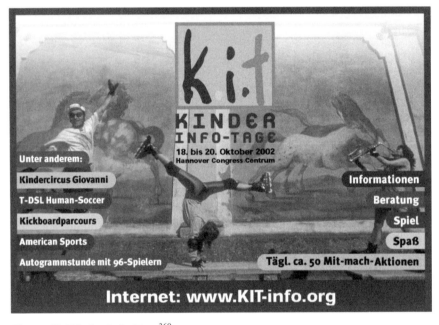

Figure 65: Kinder Info-Tage[369]

[368] cf. No author identified (2002), http://www.kit-info.org, 9 November 2002
[369] The hoarding was seen in Hanover and kindly put at the authors' disposal by Gabriela Samland.

134

5.3.1.2.2. Travel

Regarding tourism advertisements with the saxophone, it can be seen, that these often promote journeys to the USA, especially to the South. As mentioned above, the birthplace of jazz is in New Orleans and jazz is still linked with the southern states of the US. The travel agency *Bel Mondo* in Austria used the American image of the saxophone to advertise journeys to the USA. Figure 66 shows an example of this type of advertising: a very dark-skinned young man wearing a hat, playing his alto saxophone. It seems as though he is playing the saxophone just for himself, but the lady in red is obviously taking an interest, looking as if her dreams are carrying her far away – on a journey to the USA.

Figure 66: Travel Agency Bel Mondo Advertisement[370]

Other destinations also try to become attractive by advertising themselves with a saxophone. There are two examples of this kind of advertisement. In the first, the place trying to become more attractive by advertising itself with musical instruments including a saxophone is a Youth Hostel, which offers rehearsal weekends for choirs, orchestras and bands. The picture shows an electric guitar, a trumpet and a saxophone, three instruments, which are quite popular with young musicians.

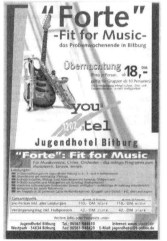

Figure 67: Youth Hostel Bitburg Advertisement[371]

[370] Collection B. Habla (2001); photograph of a hoarding, seen at the airport Wien-Schwechat by B. Habla in July 1995
[371] in: Clarino 10 (2000), p. 5

On the other hand, there is Ried, a town in Austria, which has developed a brochure especially for musicians. On the cover there are three photographs, one of which shows a woman, who is probably supposed to look very trendy and cool with her tenor saxophone. The slogan announces that Ried provides everything musicians need. Figure 68 shows the front cover of this leaflet, which contains very little information about the place itself, but carries several advertisements of service providers for musicians and bands. One of the advertisements in the leaflet is an advertisement by *Fox Holz*, specialists in designing rehearsal rooms for musicians, who have already run at least three advertisements featuring a saxophone. One of these is shown in the leaflet and part of it can be seen in Figure 69.

Figure 68: Ried im Innkreis[372]

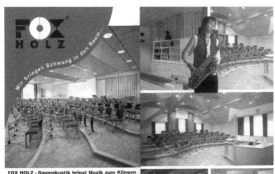

Figure 69: Fox Holz[373]

[372] in: Leaflet *Ried im Innkreis*, cover page
[373] in: ibid., pp. 3-4

DFDS Seaways, a ferry company, showed a male tenor saxophone player on the

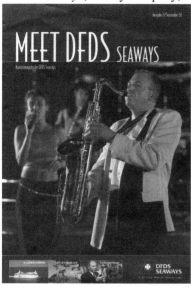

cover page of the customer magazine in August/September 2002. In the background more musicians can be seen. Showing this picture on the cover page of their magazine seems to be rather effective, as the emotions transferred are quite strong. The reader feels like being on board of the ferry, it conveys a very leisurely atmosphere, and the reader might be tempted to actually book a trip with *DFDS Seaways*.

Figure 70: DFDS Seaways[374]

One last example that shall be discussed in this context is an advertisement for Jamaica. By showing six different, very emotional photos of Jamaica, this location tries to attract attention. In one of the pictures, a part of a band can be seen with two saxophones in the front. Once again, showing, among other images, well-dressed men with a saxophone, creates emotions.

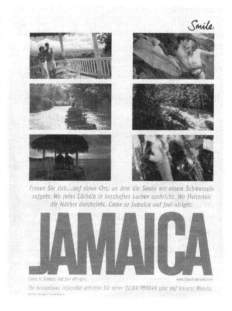

Figure 71: Jamaica[375]

[374] in: Meet *DFDS Seaways* (2002), cover page
[375] in: TV Movie (2002)

5.3.1.2.3. Media

A third category regarding advertising services that has made use of the saxophone is the area of media. The saxophone has been used in advertisements for and within newspapers and broadcasting stations. Within this section of advertising it is not always clear whether advertisements should be categorised as media advertisements as they may, at the same time, belong to another category, since for example some advertisements by newspapers were for events they organised.

Two interesting newspaper advertisements featuring a saxophone will be discussed here. Firstly, there are small ads. Apart from one advertisement without a picture, in which a woman advertises herself in the lonely hearts section describing herself as a wild saxophonist, there is Figure 72. The man in the picture states that he could have sold his saxophone twenty times. The way he holds his saxophone resembles the way one would hold something very precious, such as a baby. In addition, this advertisement was printed in black and white, which is quite normal for printing small ads in newspapers anyway. However, it once again makes clear and shows that black and white advertisements can also have a very gripping content, emotionalise and bring across the intended message.

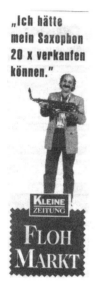

Figure 72: Flea Market Advertisement[376]

Secondly, there is an advertisement by the newspaper group *WAZ*, which advertises a jazz festival by showing a performing black saxophonist. The advertisement is designed in black and white; the only two coloured parts are red. The text next to the saxophone player is about the melting pot Moers (a town near Düsseldorf in Germany) and the fact that times have changed. It also gives the formula for a successful jazz festival: musicians from all over the world, a bit of exoticism, some classical elements, etc. Thus, this advertisement in addition to its actual function of advertising the festival carries an anti-racism message as well.

[376] in: Kleine Zeitung (1998), p. 40

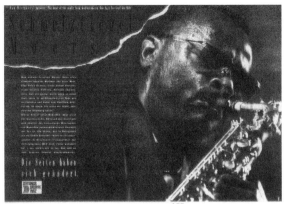

Figure 73: WAZ Advertisement[377]

In the broadcasting category, the saxophone is sometimes shown with other instruments, sometimes with players, at other times without. This question of depiction will be considered further in section 5.3.1.4. Recently there have been two advertisements for an Austrian radio station called *Life Radio Oberösterreich*. They clearly make use of the sexy image of the saxophone, combined with a woman's eroticism. Figure 74 was used on the Internet homepage of the broadcasting station, Figure 75 as a hoarding in Austria. Both advertisements are very yellow – a warm colour as analysed above. The saxophone is used as a seat, and it is not totally clear, whether the saxophone or the scantily clad woman is supposed to be the eye-catcher in these pictures.

Figure 74: Life Radio Oberösterreich – Internet[378]

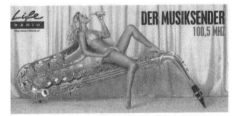

Figure 75: Life Radio Oberösterreich – Hoarding[379]

[377] in: Jahrbuch der Werbung 1994, p. 435
[378] No author identified (2001), in: http://www.liferadio.at, 8 September 2001
[379] Collection B. Habla (2001)

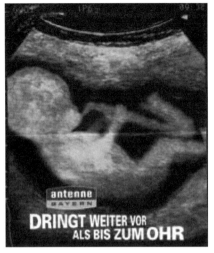

Another very interesting example is the one of *Antenne Bayern*, a Bavarian radio station: an unborn baby playing the saxophone can be seen on an ultrasound scan in its mother's womb. The slogan says: Gets closer than to the ear. The picture is already an eye-catcher because of impossibility shown. In addition, an ultrasonic picture of a pregnant woman usually creates big emotions with the parents of the unborn child. Therefore, this picture is, also because of its ridiculousness, a very emotionally gripping eye-catcher.

Figure 76: Antenne Bayern[380]

5.3.1.2.4. Shops and Businesses

The two business categories that make most use of the saxophone in advertising are banks and insurance companies. Austrian banks particularly make use of the saxophone to advertise clubs. *Bank Austria* advertised their club with a whole

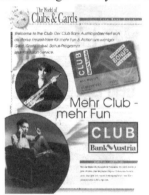

series of pictures, and although the style of the advertisements is very different, whereas Figure 77 is in black and white, Figure 78 is in full colour. The one feature they have in common is the presence of a saxophone.

Figure 77: Club Bank Austria Advertisement (left)[381]

Figure 78: Club Bank Austria Advertisement (right)[382]

[380] No author identified (2002), in: http://www.saxophoniker.de, 9 November 2002
[381] in: Magazin Österreich (1994), p. 30
[382] in: News (1997), p. 128

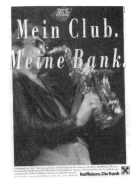

Its competitor, the *Raiffeisen Bank* also has a club, which it advertised with a saxophone picture. The text accompanying the pictures is very similar in style, content and wording. Both advertise their clubs in short sentences and appear directed at young people. Figure 79, which shows the advertisement for the *Raiffeisen Club*, is the older advertisement. It was used as long ago as 1990.

Figure 79: Raiffeisen Club Advertisement[383]

It is interesting that *Bank Austria*, the German *Sparkasse* and the British private bank *Singer & Friedlander* on the Isle of Man all used the same picture, which is shown in Figure 80. *Bank Austria*[384] used the picture to advertise its club for young people, printing the club logo on top of the picture and giving further

information in small print underneath the picture. The German *Sparkasse*, saying "the reasonable and fair credit programme", used the picture in black and white[385] and the British Bank used the picture in full colour with the slogan: "A private bank in tune with you? Singers will be music to your ears",[386] with the text, printed below the picture, making use of musical terms.

Figure 80: Multifunctional Picture[387]

Insurance Companies also use the saxophone in advertising. The company *Nürnberger Versicherungen* ran an advertisement in 1996 in Austria with a young man, leaning back with his tenor saxophone, advertising life insurance policies. His posture and the way he is standing, playing his saxophone, is very

[383] in: SportBlick (1990), p. 3
[384] Collection B. Habla (2001), also printed in Habla (2001), p. 174
[385] in: No author identified (2001), in: http://www.saxophoniker.de/erbarmen.html, 13 April 2001
[386] cf. *London Philharmonic Orchestra* Yearbook 1997-1998, p. 119
[387] in: ibid.

similar to the man in the previous advertisement, who is sitting and holding the woman and the saxophone in his arms.

The German insurance company *Sparkassenversicherung* advertised a car insurance policy called *SUPERkasko* (a full comprehensive insurance policy) with the picture of an approximately 30-year-old man, dressed casually, leaning against his trendy red car, which seems to have had an accident, playing his saxophone as he waits for help. As he has the *SUPERkasko* insurance policy, he does not have to worry

Die Formel 1 in der Kfz-Versicherung does not have to worry but can use the waiting time in a pleasant and entertaining way – playing the saxophone.

Figure 81: Sparkassenversicherung[388]

IBM tries to attract possible new employees by advertising their vacancies showing a blond female with short hair and a tenor saxophone. Compared to the other advertisements discussed, this is extraordinary insofar as the woman is not the typical, longhaired, alto saxophone-playing woman, but a shorthaired tenor saxophone-playing female. The text below the picture refers to *IBM*'s innovativeness and the fact that they are looking for young, creative people, like the saxophonist. The slogan "Good vibrations" also builds a link to the picture. The target group for this advertisement are College and University students. The advertisement is part of a campaign consisting of four advertisements with very emotional pictures and well-fitting accompanying texts.[389] In a similar case, the *University of Applied Sciences Osnabrück* shows the picture of a saxophone player when giving information about its music courses in the 2001 brochure, designed to recruit new students.[390]

[388] The *Sparkassenversicherung* sales folder was kindly put at the author's disposal by Marc Freudenstein
[389] cf. No author identified (1998), p. 635
[390] cf. University of Applied Sciences Osnabrück (2001), p. 16

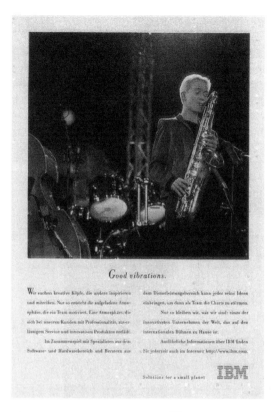

Figure 82: IBM Advertisement[391]

The *BigBand der Bundeswehr* (Big band of the Federal Armed Forces), Germany, has a most amazing way of advertising with a saxophone. Thomas Ernst, responsible for Management/Promotions/Press, had the idea of displaying a saxophone on the truck, the band transports its equipment with. Said and done – the idea was put into reality, as can be seen in Figure 83 which was kindly put at the authors' disposal by Thomas Ernst. According to Ernst the saxophone represents the band perfectly. It has a young image, it stands for the kinds of music the band plays, and the saxophone is a lot more attractive and better to visualise than a trombone or any other instrument. Ernst chose a *Keilwerth* saxophone to be presented on the truck. This brand is used in other publications as well, as this is the make that was presented to Bill Clinton by the *BigBand der Bundeswehr*. Because of this background, there is a strong link between the band and *Keilwerth*, which is also communicated to the public. Furthermore, the truck has become such a popular means of communication that *Wiking*, a company this is known for its tradition and quality of building model cars and

[391] in: Jahrbuch der Werbung 1998, p. 635

143

trucks, was very keen to build a toy truck under an exclusive right, size 1:87, which has become a bestseller to children and collectors. And, in addition, this truck also advertises for its builder, *Iveco*. The company is, according to Ernst, of the opinion that this is the greatest truck they have ever built.[392] The truck with the saxophone has become a very powerful symbol that represents the *BigBand der Bundeswehr* with its youthfully presented music.

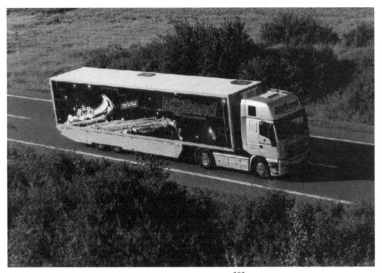

Figure 83: BigBand der Bundeswehr Truck[393]

Describing and cataloguing advertisements featuring a saxophone according to the sort of items they advertise has shown a variety of saxophone advertisements and that, within some categories, similarities between the styles of the advertisements are obvious, whereas in other areas the advertisements are designed in many different kinds of styles.

5.3.2. People Portrayed with the Saxophone

The previous section has already given quite a good overview of how and by whom the saxophone has been used in advertising. However, it is not the only interesting point of view from which these advertisements can be examined. Therefore, in the next section, advertisements will be looked at in connection with the people shown.

[392] Phone call between Thomas Ernst and Melanie Vockeroth on 28 October 2002
[393] Photograph: Der Truck der BigBand der Bundeswehr, © by Thomas Ernst

5.3.2.1. No Person

The first case consists of the advertisements where there is no person shown with the saxophone. Usually the saxophone is shown with people but, as has been seen from the description of the saxophone as room decoration in furniture advertisements, the advertising of events or as in Figure 23, there are also saxophone advertisements featuring just the instrument itself.

An unusual example is the marketing campaign of the company *Arosa Bergbahnen* in the Swiss winter sports holiday town Arosa. For a period of at least the two winter seasons of 1994/1995 and 1995/1996, and the intervening summer, they showed no person in their advertising campaign but instead personified[394] the saxophone, thus telling a story.[395] These pictures appeared as hoardings or on advertising columns, as shown in Figures 84 and 85, posters, ski-passes and other marketing material. As this campaign continued for such a long period of time, it was able to build a strong image and allowed people to really associate the saxophone with Arosa.

Figure 84: Arosa (1) – Winter[396]

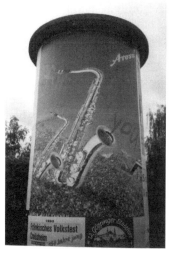

Figure 85: Arosa (2) – Summer[397]

[394] For further information about the personification of symbols, subjects used in pictures and cult objects or ritual symbols see Dieterle (1992), pp. 149-153

[395] cf. Habla (2001), pp. 175-176; Habla makes up a love story of the saxophone advertisements, which could indeed have been intended the way he tells it.

[396] Collection B. Habla (2001)

[397] ibid.

5.3.2.2. Player or Not

A second category regarding people portrayed in advertisements with saxophones, distinguishes between those who are playing (or at least pretending to play) the saxophone and people simply portrayed with the instrument.

When a person is shown playing the saxophone, the picture assumes a high level of activity. There appears to be a process, a visual story is being told. People are shown to be in a good mood, or even making romantic advances, as can be seen by studying any of the Figures above. Almost always the saxophonist is on the left hand side of the picture, playing the saxophone towards the middle of the photograph.

However, there are also those advertisements, which show a saxophone and people, without anyone playing the saxophone. These advertisements are a great deal more static. They do not show the enthusiasm and liveliness of the pictures, in which the saxophone is being played. Within these pictures there are two categories again: in some, the person is shown holding the saxophone, whereas in others the saxophone is simply positioned somewhere in a corner, as for example in Figure 16. In either case the saxophone does not transmit signs of energy or action. When a person is holding the saxophone without playing, as in

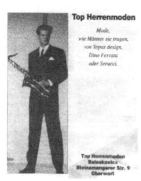

Figure 86, the picture gives a rather solemn, classical, tough or 'cool' impression, in spite of the presence of the saxophone. Alternatively, as in Figure 72, the saxophone resembles a precious museum piece. If these pictures were imagined without the instrument, the mood would be different. Therefore its presence and the image it communicates must be intended. This also becomes clear when looking at Figures 25 and 26, two emotionally very gripping images.

Figure 86: Balaskovics Advertisement[398]

5.3.2.3. Man or Woman

Another interesting aspect is the question whether it is a man, a woman or even both who are portrayed with the saxophone in advertising. There seems to be a tendency to show men with tenor saxophones and women with alto saxophones. This may be due to the different sizes of these instruments: the alto saxophone is

[398] in: Burgenland plus (1994), p. 24

146

smaller and must therefore seem more appropriate for a woman whereas the tenor saxophone which, with its bigger size and deeper sound, seems more suitable for a man. Thus the size and gender of people match the size and type of saxophone. Of course this is true for advertisements only as, in reality, there are many women playing the tenor saxophone and men playing the alto saxophone.

Advertising theory talks of an ideal type of man or woman, an ideal of beauty. Broad shoulders, a large chest, a flat stomach, slender hips, long legs and a long base of the skull indicate the ideal man.[399] This type of man, aged in his twenties or thirties, is used in all the saxophone advertisements showing white men. The depiction of black men will be dealt with in the next section. Regarding the feminine ideal of beauty one has to distinguish two kinds: one where the woman is shown as a symbol of fertility, and the classical Venus with her sexually attractive features, characterised by a slender waist, broad hips, full, well-

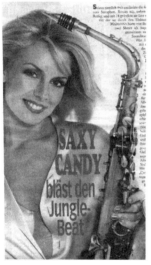

rounded breasts, red cheeks and red lips.[400] When looking at the women portrayed in advertisements featuring a saxophone, it is usually the classical Venus model one finds; an exception is woman with her short blond hair in the *IBM* advertisement discussed above. One woman, who uses this knowledge to her advantage, is Candy Dulfer, a female jazz saxophone player. Wherever she appears to advertise her music, she appears in a sexy or seductive pose together with her alto saxophone, as shown in Figure 87. In addition, she called her debut album *Saxuality*.[401]

Figure 87: Candy Dulfer[402]

[399] cf. Dieterle (1992), p. 74
[400] cf. ibid., pp. 75-76
[401] cf. No author identified (2001), Biography, in http://www.candydulfer.nl/history/content. html, 4 November 2001
[402] in: Die ganze Woche (1999)

Whenever a man, a woman or both appear in an advertisement with a saxophone, then they almost always represent the stereotypical ideal of beauty, indicated by the secondary sexual characteristics described above. In all the advertisements discussed, attractive men and women in their twenties or thirties are portrayed in connection with the saxophone. A typical example of young, good-looking, happy people is shown in Figures 88 and 89, which show advertisements for an oven. In Figure 88, the man is playing the saxophone on the right hand side of the picture and turned towards the middle; the woman is shown on the left side. In Figure 89, man and woman have been exchanged in a double sense, but the general idea stays the same. The people shown in the picture do not have to worry about their oven, as they have the *Neff EasyClean* model.

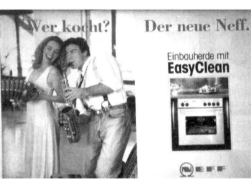

Figure 88: Neff Advertisement (1)[403]

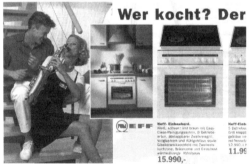

Figure 89: Neff Advertisement (2)[404]

The method of displaying ideals of beauty is not exclusive for saxophone advertisements, but it is widely used in advertisements designed to appeal to the senses and emotions.[405] The importance of this has already been mentioned above in connection with images in advertising. The people portrayed with a saxophone are almost always in their late twenties or thirties; only very few

[403] Collection B. Habla (2001)
[404] ibid.
[405] cf. Dieterle (1992), p. 77

advertisements could be found that featured a saxophone and a child, as discussed earlier. Otherwise, advertisements with the saxophone and children seem to be extremely rare. This makes sense, as a little child with a saxophone certainly looks cute, but it does not help to evoke the appropriate emotions and associations necessary to sell any of the advertised products. The use of children with a saxophone might only make sense for products that are to be thought of as being soft, cute or cuddly, such as the sofa and jumper discussed above.

5.3.2.4. Black or White

The next aspect that affects an advertisement is the skin colour of the people portrayed with the saxophone. In general it seems to be the case that there are more advertisements featuring white people in the three countries under investigation. How these white people are shown with the saxophone and the image they communicate has been described in the previous section.

However, there are also advertisements with the saxophone and black-skinned people or, in particular, Afro-Americans. All of these are male, women could not be found. This is because one wants to convey the southern US-American image, and at the beginning of the 20th century, when jazz was born in the southern states of the US, saxophone players were male. Therefore the depiction of a woman would not fit the historical facts or carry the intended associations. In contrast to the ideal white man described above, black saxophonists have a rounder face, seem to be less tall than the white men portrayed and often wear a hat and sometimes sun glasses. Black men do not have to be as young as white ones to represent the desired image. Figures such as 35, 51, and 66 with their US-American image have already been discussed above. Further examples of black saxophone players, which have already been discussed above, are Figures 39, 72 and 77. These advertisements do not so much allude to the jazzy American image as to the atmosphere they create, or they may have an anti-racism focus. Another advertisement with a black saxophonist is the advertisement for a prize draw, shown in Figure 90, announcing two hundred trips to the USA to be won. The similarity between the two men shown in Figures 35 and 90 is striking.[406]

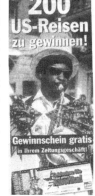

Figure 90: 200 Trips to the USA to be Won[407]

[406] Fore more information regarding the portrayal of African Americans in advertising see Harris (1999), pp. 50-54

[407] Collection B. Habla (2001)

5.3.2.5. Celebrities

Another aspect that will be taken into consideration in this context is the appearance of celebrities with the saxophone, which might be described as 'automatically included image advertising' for the saxophone. The following example is not specifically German, Austrian or Swiss, but rather an international example of political advertising, which was used, but not exclusively so, in Germany, Austria and Switzerland. As such it was felt, that this example could not be omitted. The example could also have been cited when dealing with advertising the saxophone itself but, as it also relates to people portrayed with the saxophone, it has been included in this section.

Probably the best-known amateur saxophonist is the former American president Bill Clinton. Clinton was shown with his saxophone in both presidential election campaigns in 1992 and 1996. He repeatedly emphasised his love for music and especially for his saxophone, so that a real boom (*"Sax Mania"*) came up in the USA. Apart from real photos, there are lots of caricatures showing Bill Clinton with a saxophone. One effect of these political advertisements was that, in 1993, *Boosey and Hawkes*, one of America's biggest saxophone retailers, announced an increase in turnover of between fifteen and twenty per cent. This boom in the USA also increased the sales of saxophones worldwide.[408]

However, what was the actual objective of Bill Clinton appearing with his saxophone all over the world? Definitely not to increase the sale of saxophones, but to create a better image of the American politician. During the time of his presidency Clinton and the saxophone increasingly belonged together. As shown in Figure 91, Clinton appeared in newspapers, magazines, etc. all over the world with his saxophone. The positive image of the saxophone was transferred to Clinton. It was an American image that Clinton's saxophone communicated to the world, as he played 'American music' like *Rhythm & Blues* and *Jazz & Blues*. He is probably the only white American who can present an image that is otherwise reserved for African Americans. As a result of the rise in popularity of the saxophone due to Clinton's endorsement, others made and make use of this connection to advertise (e.g. on the Internet) their shops, brands or museums.[409] It is hard to say whether Clinton himself or the instrument benefited more from his love for the saxophone. That said, ultimate benefit is often difficult to define in the case of products endorsed by celebrities, and therefore this case is not unusual.

[408] cf. Herbert (1993), p. 39
[409] cf. No author identified (2001), in: http://www.usd.edu/smm/clinton.html, 5 October 2001

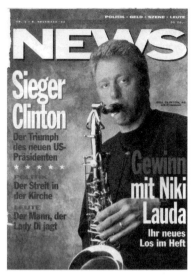

Figure 91: Bill Clinton[410]

Other celebrities equipped with or accompanied by a saxophone are comic stars such as Scrooge McDuck, Lisa Simpson and the Pink Panther. The positive image of the saxophone helps to popularise these comics and vice versa, without extra expenditure.

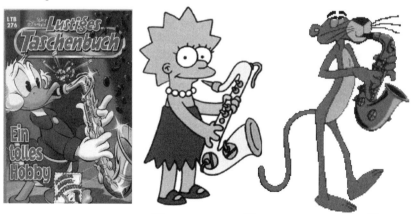

Figure 92: Scrooge McDuck[411], Lisa Simpson[412] and the Pink Panther[413]

[410] in: News (1992), cover page
[411] Lustiges Taschenbuch LTB 276, cover page
[412] Source unknown
[413] in: No author identified (2001), http://www.blasmusik-nrw.de/index.htm, 26 October 2001

151

5.3.3. Saxophone with Other Instruments

Advertisements using a saxophone can be categorised further according to whether the saxophone is the only instrument shown or whether it is shown together with other instruments. When it is shown on its own, its tasks must be different from when it is shown together with other instruments.

In most of the advertisements discussed so far, the saxophone was the only or at least the main instrument shown in the picture. But as Figures 93 and 94 show, the saxophone is also shown together with other instruments. In these two examples, which seem to be typical for advertisements showing several musical instruments, it is not the image of one particular instrument that seems to be important, but the general image of musical instruments. Even though in both advertisements the instruments are not being played, they still make a dynamic appearance, as they are held in an abstract way in Figure 93 and seem to be flying around in Figure 94. A single instrument could not have conveyed these ideas.

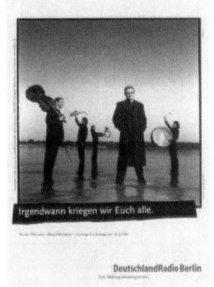

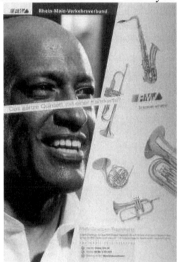

Figure 93: Deutschlandradio Advertisement[414]

Figure 94: RMV Advertisement[415]

Apart from these examples, it could be noted that the saxophone appears quite often with the guitar in the same advertisement, or that these two instruments

[414] in: Jahrbuch der Werbung 2000, p. 383; The slogan means: at some point we will get all of you.
[415] in: Jahrbuch der Werbung 2001, p. 444

substitute each other. Examples for this phenomenon are shown in Figures 22 32, 39, 59 or 67. The atmosphere that is being created because of these two instruments shown together is usually a very young and relaxed atmosphere. Both the saxophone and the guitar are instruments that appeal to the young generation. When the saxophone is shown together with a double bass, which is also quite often the case (e.g. Figures 38, 46, and 50), a southern American or also jazzy atmosphere are being created. When the saxophone is shown together with a piano, as in Figure 43, the atmosphere seems to be a lot more formal. Although in music the saxophone is often used in jazz, being accompanied by a piano, showing these two instruments together does not convey the easy-going atmosphere that a saxophone can establish together with a double bass or the rocky atmosphere it can create with a guitar. When a saxophone is supposed to represent jazz in contrast to classical music, one finds a range of advertisements in which the saxophone is shown together with a cello, as the example in Figure 95 shows.

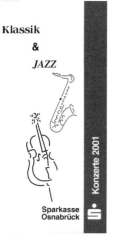

Figure 95: Klassik & Jazz Concert Series Advertisement[416]

5.3.4. Saxophone in Foreground or Background

Depending on where the saxophone appears in advertising, one can also examine whether the saxophone appears in the foreground or background of the picture. As in Figures 20 or 81, it is shown not only in the foreground, but also in the centre of the picture. When this is the case, the saxophone is obviously intended to catch the eye.

However, there are also advertisements that show the saxophone in the background. There are two types of advertisements with the saxophone in the background: the background is either shown in full colour, as in Figures 39, 40 and 41, or the background is shown as transparent, as in Figure 38 or 48. In these advertisements the saxophone is used in a more subtle way. It does not lead the viewer's attention directly towards the instrument, but rather gives the advertisement a certain kind of mood. In Figure 35 it is the Mexican or southern USA mood; in Figure 48 it is a jazzy and pleasant warm atmosphere, which is intensified by the red (warm) colour. As analysed above, warm colours have the ability to project other objects than themselves into the foreground. Thus even if

[416] in: *Sparkasse* Osnabrück Leaflet (2001)

the saxophone appears in the background, it can help other objects to come into the foreground or centre of the picture. In doing so, the saxophone may even remain unnoticed by the casual viewer of the advertisement, but it remains necessary for the saxophone to be there, as otherwise the effect would be lost.

5.3.5. Saxophone in Logos

Within advertising of the musical world, the saxophone is misused in some ways. One example of this misuse is to make the saxophone fit more easily into logos or use its shape to form letters. The saxophone can be used as a 'z', 'j' or 's' in words or names. Three examples are shown in Figures 96, 97 and 98.

All three examples are closely linked to the musical world. *Saxgourmet* is a homepage on the Internet, which gives information about saxophones and sells them and accessories for the instrument as well. *Zabos* is a shop where you can buy saxophones and have them repaired. The *Jazz Biergarten* is a beer garden in Bavaria, which used the saxophone as the 'J' in Jazz. Overall, it is surprising that this kind of use of a saxophone in advertising is rather limited and not seen more often.

Figure 96: Saxgourmet[417]

Figure 97: Zabos Advertisement[418]

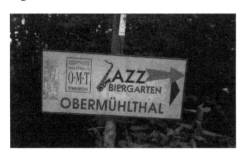

Figure 98: Jazz Biergarten[419]

[417] No author identified (2001), in: http://www.saxgourmet.com, 7 October 2001
[418] in: rohrblatt 9 (1994), p. 74
[419] Photograph taken by Melanie Vockeroth, August 2002

Furthermore, the saxophone's shape can symbolise a chimney, as in the logo for the *Musikhaus Kassel*, a shop selling musical instruments and further equipment. The idea of a house of music (which is the meaning of *Musikhaus*) has been incorporated in the logo of the company. According to the owner of the business, it was the size of the tenor saxophone that fitted perfectly into the picture and its additional ability to symbolise a chimney, which made him choose the saxophone.

Musikhaus Kassel Figure 99: Musikhaus Kassel[420]

Occasionally, the saxophone is used in logos for festivals, as the examples in Figures 100 and 101 show. Figure 100 shows the logo for a jazz festival in Homberg. Whereas in Figures 97, 98 and 99 the saxophone is easily visible, Figure 100 shows a deformed saxophone. It can just be made out as a saxophone, if one looks carefully. In semiotic language, it is an index. Figure 101 was the logo for the *3. Deutsches Bundesmusikfest* 2001 (Third German National Music Festival) at Lake Constance.

Figure 100: Jazz Swingin Homberg 2001[421]

Figure 101: Bundesmusikfest 2001[422]

[420] Thomas Boll, owner of the business *Musikhaus Kassel* and creator of the logo, kindly put the picture at the authors' disposal.
[421] in: HNA Melsunger Allgemeine (2001b), p. 8
[422] in: Festival leaflet *3. Deutsches Bundesmusikfest* 2001

Broadly, the use of the saxophone discussed in this section seems to be reserved for music-related businesses or events. The saxophone does not have one of the purposes discussed in the other advertisements, but it is used because of its shape, which happens to fit the various logos better than any other instrument.

5.3.6. Cultural Advertising

The last category that will be considered is the one which can be called cultural advertising. Many companies, when asked to advertise in brochures or leaflets of choirs, orchestras, bands, sports clubs, or local festivals, etc., use advertisements especially made for these purposes.

One example is an advertisement for the company *B. Braun Melsungen AG*. The company develops and manufactures medical products and services. Although the company operates worldwide, its headquarters are in a small town in the North of Hesse in Germany, where it is one of the most important employers and therefore needs to project a positive image in order to maintain close links with the local community. The advertisement shown in Figure 102 is intended to contribute to this purpose. It has to be said, however, that this advertisement does not seem to be carefully considered. The slogan that translates as "Overcome boundaries with good notes" could have been visualised in a better way, or conversely, a slogan that better suits the picture could have been found.

Figure 102: B. Braun Melsungen AG, Cultural Advertisement[423]

[423] in: Festschrift (2000)

Similar examples can be found especially in advertisements for saving banks and local newspapers where the advertisements are used locally. When brochures or concert programmes can reach a broader audience or readership other companies, such as car manufacturers or commercial banks, also make use

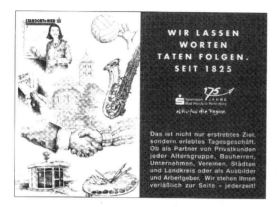

of cultural advertising. In general, this kind of advertising does use the saxophone in its pictures, but it also uses other instruments and there is no discernible reason why a particular instrument is used in any given advertisement. An example is shown in Figure 103.

Figure 103: Sparkasse Hersfeld-Rotenburg Advertisement[424]

This concludes the survey of the use of the saxophone in specific types of advertising. By categorising them and examining them from different points of view, a representative selection of advertisements with a saxophone has been presented and explained. In the following sections some more general aspects will be discussed, in order to identify the similarities and differences that are characteristic of the saxophone's use in advertising.

5.3.7. Comprehensive Analysis and Discussion

Generally, one feature frequently noted is that mainly alto and tenor saxophones tended to be used. This has also been noted in the advertisements for the saxophone itself. Altogether, in the study of the saxophone's use in advertising, there was only one example with a soprano saxophone[425] and one with a baritone saxophone (see Figure 53) among the approximately one hundred and

[424] in: Festschrift (2000)

[425] A straight soprano saxophone was used in one picture of a campaign by *Rotring-Werke Riepe KG* in Hamburg to advertise fountain pens in 1991. The soprano saxophone was probably chosen because of its straight shape with its similarities to a pen. In this exceptional advertisement the target group were persons interested in functionality and a clear, technical design. For further information and illustration see Jahrbuch der Werbung 1991, pp. 432-433

sixty advertisements available for examination. This seems to match the reality that alto and tenor saxophones are the best-known saxophones among the four major kinds in use today; in addition, the alto and tenor instruments have the characteristically curved shape that everybody can recognise.

5.3.7.1. Pictures and Text

In most of the advertisements discussed, the text or slogan that accompanies the picture is somehow connected with the use of the saxophone. Usually, this connection is easy to spot but occasionally it is less obvious or missing altogether.

As discussed in section 3.7.3., in the context of visual persuasion, even carefully considered and well-designed visuals need accompanying text in order to make sure that the reader understands the advertisement as it was intended. Furthermore, words can help the viewer to build a link, which he or she might not have done without the additional information contained in the text.

A play on words was only found once, in the advertisement of "Saxy Candy" (Figure 87). A second example, in which the name of the instrument was exploited, even though one cannot be sure that this was the original intention, is the *Citroën Saxo*. In all other examples, the text accompanying the advertisements with a saxophone makes the connection through the associations with the instrument itself rather than its name.

5.3.7.2. Features Associated with the Saxophone in Advertising

All the characteristics attributed to the saxophone in advertising, together with its associations and perceptions, are shown in Figure 104.

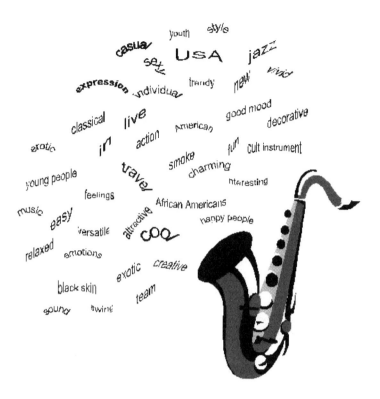

Figure 104: Messages of a Saxophone[426]

Of course these features are usually not used all at once, but in different advertisements and situations. The high number and diversity of associations evoked by the saxophone make the saxophone unique insofar as no other instrument seems to be able to express so many different ideas. No other musical instrument has such a wide range of associations or can visualise such a spectrum of moods, emotions and feelings. The tone chosen for all of the advertisements discussed above, therefore, is a positive one, which evokes happiness, good feelings and emotions, fun, action or simply a positive image in very relaxed situations. Because of its shape the saxophone has the ability to point towards something, i.e. the advertised object, the text, slogan or brand name – as in Figures 31, 48 or 52. All these qualities, as well as its versatility, help to explain why the saxophone has been destined to play such a prominent and diverse role in advertising.

[426] Melanie Vockeroth developed this compilation by looking at all available advertisements with a saxophone.

It is amazing to see the great role that the saxophone plays in jazz, as quite a few associations people make with the saxophone can be found in jazz music. Many people think the saxophone is at the same time a hot and cool instrument – what an interesting contrast! However, both these adjectives are also found in connection with jazz styles. Hot jazz, or the way of playing "hot" first appeared in New Orleans Jazz. One hardly plays the instrument, one rather speaks with it: One expresses feelings, especially showing the difference between one's own feelings and those of others.[427] Cool jazz is a style which came up in the 1950s and expresses the emotions of the people in these years: it reflects the resignation of people who lived a good life, but being aware of the hydrogen bomb being built.[428] Other jazz-related associations are that the saxophone often stands for swing, in a musical way as well as in a more common sense. In this context one can further add the adjectives free, individual and independent. When reading a book about jazz these must be the three most used adjectives, especially in connection with the saxophone and its players. Furthermore, the saxophone is also associated with dirtiness. This is due to the dirtiness saxophone players can intonate their instruments with, but also to the unhealthy lives of many jazz saxophone players who smoked and drank themselves to death (see Figure 104) and may, at least in Germany, go back to the bad image of the saxophone in connection with *Degenerate Music*. One could find even more examples in this field, but this range of adjectives shows the main idea.

...and too much sax can be bad for your health

THE saxophone is bad for your health, according to doctors. A team studied 813 musicians who played a variety of instruments and found those playing the sax were most likely to die earlier. The Devon-based researchers found of 230 saxophonists, 136 had died but of 113 percussionists, for instance, only 39 had died. Sax players have to inhale through the nose while inflating the cheeks and neck with air, which is more likely to cause cerebrovascular complaints – relating to the brain and its blood vessels. Playing in smoky clubs and the poorer background of many saxophone musicians were said to be contributing factors. The doctors added: 'We acknowledge all those famous jazz musicians who laid down their lives for the sake of a long-drawn solo.'

Figure 105: And Too Much Sax Can Be Bad For Your Health[429]

[427] cf. Berendt (2000), p. 27
[428] cf. ibid., pp. 18-20
[429] Source: Metro, London, issue unknown

The connections between the saxophone and its given characteristics are partly made by means of the visuals used, and partly through the accompanying text. The saxophone's round shape and its warm colour help to convey some of these aspects, such as the emphasis on a flirtatious or erotic situation, or the good mood that the people portrayed are clearly enjoying. However, the saxophone cannot make some statements on its own. To symbolise the USA or the American image, other visual elements like the steamboat, or an African American playing or holding the saxophone, are necessary. The saxophone on its own cannot show the trendy image of the clothes portrayed, but in presence with happy, young people; without people the advertisement cannot communicate this mood. Accompanying text is indispensable when services are advertised, as Figures 74 or 102 show. As one cannot take pictures of services before they are delivered; words have to be used to describe the advertised service or give further information. The musicians in Figure 101 cannot, on their own, communicate the qualities of *B. Braun Melsungen AG* as an employer, whereas most of the pictures advertising products can speak for themselves and thus only need a short slogan.

It is interesting to see that the saxophone has a clearly perceptible American image despite the fact that it was invented in France and the first and only Conservatoire teaching the saxophone in an official way was the Paris Conservatoire until the middle of the twentieth century. The only two French associations seem to be the *Citroën Saxo*, where there is a rather strong connection between the instruments name and the French company, and the French cigarette brand *Gauloises*, where the link is rather week, but anyway, these are only two examples against a large range of advertisements suggesting references to the American lifestyle and other American associations.

5.3.7.3. Style

One aspect mentioned above in the context of creative advertising is advertising style. According to Kotler, possible styles are *slice of life, lifestyle, fantasy, mood or image, musical, personality symbol, technical experience, scientific evidence or testimonial evidence.*[430] The prevailing style regarding advertisements featuring the saxophone seems to be the *mood or image* style, in which a mood or image is created around the product or service, without necessarily making any direct claims, as in Figures 29, 30, 50 or 52. Other styles used are the *slice of life* style, in which people use the product in their normal surroundings, for example shown in Figure 53. Advertisements presented in the *lifestyle* style show that the product advertised fits a certain lifestyle, as for

[430] cf. Kotler et al. (1999), pp. 801-802

example in the *Neff* advertisements shown in Figures 88 and 89 or indeed in the fashion advertisements discussed. Figures 74 and 75 show the *fantasy* style, they show unreal situations. Whereas the *personality symbol* (celebrities and their saxophones) and *technical experience* (examples were given in Figures 57 and 58) styles have at least been used occasionally, the *musical, testimonial and scientific evidence* styles do not seem to have been used.

5.3.7.4. Series or One-off

Another criterion to be examined is, whether an advertisement with the saxophone formed part of a series or advertising campaign, or appeared on its own, as a one-off. Most advertisements shown above were single pictures or used as such, rather than being part of a campaign. However, some advertisements did belong to advertising campaigns, as, for example, the *Herforder* or Swiss *Heineken* advertisements. The basic idea was used in similar ways. In the *Herforder* case the picture was adapted to the situation in which the advertisement was used via e.g. substituting the saxophonist with a sportsman, whereas the rest of the advertisement stayed the same. The *IBM* advertisement also belonged to a whole series of different pictures and texts. The text always went along with the picture, as in Figure 82 or, alternatively, showing a girl on her first school day, nature, etc.[431] A different type of series is the one where the advertising design changes, and where the only similarity is the repeated use of the saxophone, as in the advertisements for *Bank Austria* or *Memphis*. Alternatively, there are those advertisements using the same design in more than one picture with only minor changes, as the *Neff* or *Gräflinger* examples show.

The most useful kind of series was used in the Arosa example as shown in Figures 84 and 85, in which the saxophone was used in the same style and design over an extended period of time, using different backgrounds and thus trying to tell a story. The Arosa example seems to be the only advertisement in which the use of the saxophone was properly integrated into the marketing strategy and used over a longer period of time. *Weinedition Jazz* integrated not only the saxophone, but also the whole concept of jazz into the organisation's marketing strategy. *Köstritzer* is following a similar strategy with its jazz band. This well-considered integration of the saxophone would make sense for all advertisements, provided the saxophone is used thoughtfully and enables the viewer to build a link between the instrument and the advertised product.

[431] cf. No author identified (1998), p. 635

5.3.7.5. Target Audience

Every advertisement needs a target audience. If the advertisement is to be successful or even effective, it is very important to define the target audience properly and make sure that the right stimuli are used for the right people. Target groups can be defined through market segmentation. The advertiser has to understand the market, who his customers are and what they are like. Therefore an understanding of the sociocultural factors discussed above and a knowledge of lifestyle groups are important as, for example, not all people of the same age have necessarily the same interests.[432]

In order to see, if the right target audiences can be reached successfully through the media used, it would be necessary to study the media data regarding readership of the newspapers, journals, magazines, etc., in which saxophone advertisements were found. Unfortunately, this is not possible here due to the variety of publications with saxophone advertisements. Moreover, interesting as the results of such a media analysis might be, this would exceed the limitations of this study, which is concerned with issues of persuasion rather than measuring the effectiveness of advertisements with a saxophone. Generally, the outdoor advertisements reach an audience that is less focused than the readership of a magazine, journal, newspaper, or other publication.

In defining the target audience of the advertisements discussed above, it is not possible to generalise, but interestingly most advertisements studied seem to be directed at young people. The age range can roughly be set at between twenty and forty. Only one advertisement with a saxophone was found which was obviously directed at children and not a single one that was directed at older age groups. This seems logical, as those belonging to older age groups might still associate the saxophone with at least some of the negative reputation attached to the instrument in Nazi times. As it took the saxophone a very long time to establish a more positive image in Germany, the negative image seems to have prevailed for a long time and may still be present, as the example in section 4.5. proves. To young people, at whom the advertisements are directed, the 'dark' side of the saxophone is usually unknown. They see the saxophone as a trendy instrument.

Regarding the lifestyle of the target audience, a general statement cannot be made. Lifestyle groups are more difficult to define, as many areas have to be examined and taken into consideration, such as activities, interests, opinions, etc., apart from the sociocultural factors discussed above.[433] *BMW* targets a

[432] cf. Brassington & Pettitt (1997), pp. 637-638
[433] cf. ibid., pp. 177-180

much higher income class than *Citroën* for example, who sell cars in the lower to medium income groups. In most of the advertisements discussed, the people shown are dressed very smartly; the men often wear a suit and tie and the women a dress. This also points towards a higher income class. Whether the advertisements are directed at men, women or both depends on the product advertised, but mostly they are directed at both sexes.

5.4. Interim Findings

Having examined and discussed a representative selection of printed advertisements featuring the saxophone and before talking to those who create advertisements, a summary of the findings will be given. The theory described in Chapters 2 and 3 can generally be transferred to the saxophone directly. The saxophone is often used as a juxtaposed image. It is intended to change the viewers' opinions of a particular product and to make that product seem more attractive. This change of attitude is achieved by addressing the viewer's emotions. The saxophone as a musical instrument has the power to represent art, and therefore follows the arts' long tradition of conveying style and an upmarket social status in advertising.[434] The picture of a saxophone also has the power of transferring music to the viewer, although no sound can be heard.

Regarding the advertisements for the instrument itself, music shops or retailers do not give much attention to advertising the saxophone. The manufacturing companies design more carefully considered advertisements, usually by advertising their brand image rather than a particular instrument. There are some similarities between the advertisements of the saxophone as an instrument and the use of the saxophone to advertise other products or services. Firstly, the appearance of women with alto saxophones and men with the tenor instruments seems to be common in both areas. In both cases the text or slogan accompanying the image is crucial, as otherwise, for example, it would not be clear whether Figure 12 is advertising the saxophone or the top hat, or if Figure 63 is advertising a festival or the saxophone shown in the picture.

The general image and associations derived from a musical point of view can also be found in advertisements with the saxophone. Many advertisements featuring the saxophone have a 'jazz' link, and jazz is the biggest and most widely accepted area of use for the saxophone. However, jazz players are usually not dressed very well, whereas in many advertisements with the saxophone people are dressed extremely elegantly, which points towards a

[434] cf. Messaris (1997), p. 229

classical understanding and image of the saxophone. Thus in advertising there is a mixture of images, which in the musical world has not yet become common, even though there are some concerts in which jazz musicians perform with symphony orchestras.

It was further shown that the saxophone has been used to advertise a great variety of products and services. The product advertisements have been divided into several groups, in which the use of the saxophone is sometimes very similar, as, for example, in the furniture business, where the saxophone is usually used as a decorative accessory. It is also frequently used in advertisements for drinks, especially beer, where the saxophone is used to give the product the right mood and a young image. Fashion advertised with a saxophone can use a variety of images: it can be classical, stylish, trendy, casual and almost any other style of young fashion. The saxophone helps to emphasise the relevant image. In the automotive sector, the only French association of the saxophone could be found, but also American, young, trendy, and high quality images. Other products discussed were cigarettes, an area in which not only the smoky image but also a young and trendy image could be detected.

In advertisements promoting services, a tendency towards more paintings and drawings compared to product advertisements could be established. The saxophone is often used for advertising concerts or festivals, even if these are not particular jazz oriented. In travel and tourism there is an emphatic use of the USA image of the saxophone, which is emphasised by portraying African Americans or other American symbols in conjunction with the saxophone. Similarly, other places try to become more attractive by advertising themselves with a saxophone. Media such as newspapers or broadcasting stations use the saxophone is a highly diverse way, to advertise events planned by them, anti-racism advertising, and as an eye-catcher in small ads and radio advertisements. Shops and businesses use the saxophone to make their services look young and trendy or make themselves appear as attractive employers.

In the investigation of people portrayed with a saxophone, it was found that these were almost always people in their late twenties or thirties, as they also represent the target audience for most of the products or services advertised with a saxophone. Mostly men are shown with tenor saxophones, and woman with the alto instrument. This may on the one hand be due to the different sizes of both the instruments and the human beings, but may also find its reason in the fact that the alto saxophone has in its history often been used to substitute female voices, whereas the tenor instrument is usually used for male voices. Women with a saxophone are very often given a sexy or erotic image, whereas men are shown to be cool, well dressed and attractive. The type of saxophone

used in advertising is usually an alto or tenor saxophone, but in a few cases the baritone or soprano instruments are used as well. The saxophone is also used as a spokesperson, as shown in Figure 49, which is possible because of its shape. If the saxophone is shown without people, the image loses some of its dynamic power, but shown together with other instruments, this can be regained. Saxophones are mostly shown as icons, but they can also serve as letters, even though they may then have to be slightly deformed.

5.5. Criticism of the Use of the Saxophone in Advertising

There has been criticism of the use of the saxophone in advertising. This criticism is important insofar as it may give an indication of what improvements can be made in the future, when using the saxophone in advertising. It was therefore felt that it is important to insert this additional section into this paper in order to deal with the issue.

Criticism was found on the Internet, namely by a saxophone quartet called *Westfälische Saxophoniker*. Under the headline "ERBARMEN – wenn die Werbung das Saxophon entdeckt" which translates into English as "MERCY – when advertising discovers the saxophone", they show four advertisements with saxophones. Two of them are shown and discussed above (Figures 31 and 80). In addition, they mock advertisements for *Deutsche Postbank* and for a bar called *Dracula Cocktail Bar*. As concerns Figure 31, they first of all wonder whether this is the first saxophone for left-handed people, and then scornfully point out that the saxophone is, in fact, shown the wrong way round; the picture of the saxophone player is a mirror image. Regarding Figure 80, they draw attention to the mouthpiece being attached the wrong way round. In the *Postbank* advertisement the brand name *Jupiter* can be seen, which they would compare to the car brand *FIAT*, and they question whether this image was intended. In the *Dracula bar* advertisement they criticise the saxophonist's hand position.[435]

Many more such 'mistakes' can be found in the advertisements collected for this investigation and in the examples discussed above. Habla also makes fun of this carelessness in his slide show based on advertisements with a saxophone.[436] A very recent shoe advertisement, which uses a saxophone, also belongs into this category. As Figure 106 shows, the 35-40 year-old male alto saxophone player,

[435] cf. No author identified (2001), in: http://www.saxophoniker.de/erbarmen.html, 13 April 2001

[436] cf. Habla (2001), pp. 155-188

who is at least equipped with a proper sax strap, has his hands mixed up: The left hand is where the right hand belongs and the other way round. It is not clearly visible, if the reed on the saxophone has been attached properly.

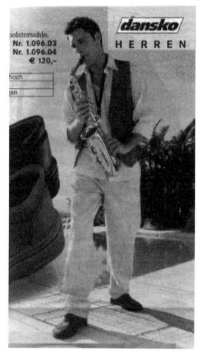

Figure 106: Shoe Advertisement[437]

Following Ogilvy's idea of subjects used to illustrate advertisements one could now say: 'Who cares? As long as there is a saxophone in the picture which can convey all the ideas intended by the creators of the advertisements, that's fine, isn't it?' It would only be a musician or perhaps only a saxophonist who knows these details. On the other hand, however, it should not be forgotten that the target audience might know these details and that people have a selective attention. Therefore, if that selective attention is already directed at the advertisement, it may well follow that the reader is someone who knows the instrument better than the creator of the advertisement. If the viewer is indeed so attentive, he or she could easily spot mistakes such as mirror images, hands in reversed positions, or a missing or wrongly attached mouthpiece. Consequently, instead of forming a positive image of the product advertised, the viewer may project the mistakes in the advertisement on to the product itself and may even reject that product as being faulty or of low quality.

[437] in: Katalog (2003) *Comfort Schuh GmbH*

6. Qualitative Research

The description and analysis of existing advertisements have already given a good idea of how and why the saxophone is used in advertising. In order to get a deeper insight into some of the advertisements, and to see if the interpretations made in this study match the intentions and ideas of the creators of the advertisements, primary research becomes necessary.

The type of analysis used will be a qualitative analysis. Qualitative research is a term that has been rather freely used to describe several specific kinds of marketing research. Qualitative research is diagnostic. Its findings cannot be analysed statistically and it is a very subjective method. However, it is able to provide valuable insights into a topic and help to get a fuller understanding.[438] It is therefore the most appropriate method of research in this context, as almost no research has been undertaken regarding the analysis of the saxophone in advertising. First, some basic information needs to be gathered and examined in a qualitative study, before one could conduct a quantitative analysis, maybe in a further study, in order to obtain quantitative data.

6.1. Objectives

The objectives of this qualitative analysis are quite straightforward: to underline, confirm, supplement or refute the statements made in the examination of advertisements featuring a saxophone. Practical experience may also expose areas that have so far been neglected in this study or can only be learned from practice. The analysis will help to answer the questions posed at the beginning of this paper. Why was the saxophone used in particular advertisements? What exactly were the objectives? Which image did the advertisers expect the saxophone to give to their products or services? Which target group(s) was/were selected? Was the effect of the advertisements monitored and checked? Were the assumptions and interpretations that have so far been presented in this study also so the intentions of the creators of the advertisements featuring a saxophone or were they different? A side effect is that one could discover other advertisements or campaigns using the saxophone or other musical instruments.

[438] cf. Chisnall (1997), p. 180

6.2. Methodology

Within the field of qualitative research various methods can be used. The most likely to achieve the objectives is to interview the creators of advertisements featuring a saxophone. Therefore expert interviews will take place. An interview is to be understood as a purposeful exchange of meanings, a conversation with a specific purpose. The purpose has to be more than only satisfaction in the conversation itself.[439] Interviews in general can be standardised, non-standardised or a combination of these.[440] In-depth interviews are non-directive interviews in which the respondent is encouraged to talk about the subject freely instead of having to answer 'yes' or 'no' to specific questions.[441] The interviewer asks open questions and makes sure the interview follows the intended direction. This kind of interview appears to be the most suitable one in this case because of its explorative character.

The interviewing technique of an in-depth interview requires a trained and qualified interviewer. As the interviewer is one of the authors of the publication, there is the danger, that the interviews might take a wrong direction or questions might be omitted accidentally. Therefore an interviewing guide has to be prepared and used to ensure that the vitally important questions will be covered. Questions in such a guide are not precisely worded, but key words make sure that important points are covered.[442] One great advantage of this method is that during these unstructured interviews, ideas can emerge and throw new light on the topic being surveyed. At the same time the interviewer must be able to resist the temptation of chasing too many new ideas so that the objectives of the interview are not lost.[443] Even if the topics talked about are not fixed, the interview should follow a logical progression. The language of the interviews is German. The advantage of the interviewer being a native German-speaker is that the respondents will be able to answer in their own language, which may encourage them to talk more freely compared to having to answer in English, the language of this study. The disadvantage is that the answers will have to be translated and that a verbatim use of the answers is not possible.

The possibility of a written survey was ruled out right from the start due to the danger of a low rate of response. Nor would a written survey allow questions to be formulated that would be appropriate for a particular agency.[444] As a written

[439] cf. Chisnall (1997), p. 161
[440] ibid., p. 162
[441] ibid., p. 181
[442] cf. ibid., p. 180
[443] ibid., pp. 128-129
[444] cf. Meffert (2000), p. 156

survey was therefore excluded, the interviews could either be conducted as personal face-to-face interviews or by telephone. Advantages and disadvantages of personal or telephone interviews in this particular case are shown in Table 7.

	Personal interviews	Interviews by telephone
Advantages	• High rate of success • Nicer atmosphere as interviewer and respondent get to know and see each other • Date can be fixed in advance to make sure, the respondent is prepared and has time for the interview • Possibility to elicit extra information like mimicry, gestures or emotions • The working atmosphere can be seen and felt	• Cheaper than personal interviews • Interviews can be conducted over a long distance (e.g. South of Germany, Switzerland and Austria) without expensive and time-consuming travelling
Disadvantages	• Very costly • Very time-consuming • Expenditures and results may be disproportionate compared with results obtained	• No personal contact • Interviewer might be shaken off more quickly with 'no-time' or other excuse

Table 7: Advantages and Disadvantages of Personal and Telephone Interviews[445]

Possible advantages and disadvantages of personal and telephone interviews were considered. Even though some organisations may refuse to take part in the survey, an advantage of both chosen methods of interviewing is that the no-response rate can be kept to a minimum. Unwillingness to take part in this survey might be caused by the interview partner's lack of time. Another reason could be that agencies may not wish to reveal their ideas and knowledge and thus they may not answer all the questions.[446] Furthermore there is a danger that some individuals may not be reachable via telephone and therefore a useful contact cannot be established. After having compared advantages and disadvantages of the two methods, such as expenditures and possible benefits from the interviews, a decision was taken in favour of the telephone interview, as it appeared to be the more appropriate method. Personal interviews were not

[445] Own table following Meffert (2000), p. 156
[446] cf. Chisnall (1997), p. 172

completely excluded but remained an option in case the interview partner preferred a personal interview or had enough additional information or material to make a visit worthwhile.

One advantage of the author of this publication also being the interviewer is that there is already a good insight into the topic and the objectives of the interviews are known very well. The three tasks to be undertaken before being able to conduct the interviews were to a) locate people who fulfil the requirements, b) establish contacts and arrange the time (and place if necessary) for the interviews and c) prepare the interviews carefully.[447] The careful preparation included studying the relevant advertising examples as well as gathering information about the agency or company. Internet research or checking publications such as the *Jahrbuch der Werbung* were effective ways to find out the required information. During the interviews themselves, leading the interviews into the right direction and accurate recording are the main requirements.

A survey, contacting all agencies that used the saxophone in advertising, would be very costly in time and expenditure, as all the agencies would have had to be located, which is neither feasible nor useful. Therefore it was decided to contact only a selection of companies and agencies, a sample size of five to ten was fixed. This sample size was thought to be most useful, on the one hand to get some idea of the answers to the questions asked at the beginning of this publication, and on the other hand this appeared to be a number feasible in terms of time and costs.

6.3. Selection of Interview Partners

Sampling has the possible disadvantage, that its results may not be representative.[448] This disadvantage can be limited by choosing the sample according to an appropriate method. Samples can be chosen either at random or deliberately. Because it was not possible to find out all the details (like advertising agencies, contact persons, creators of the advertisements, etc.) of all identified advertisements featuring a saxophone, because some advertisements with the saxophone are more interesting than others, and because some advertisements are very similar to each other, some kind of deliberate choice[449] seemed to be necessary. The decision was made according to the 'choice at

[447] cf. Chisnall (1997) p. 143
[448] cf. Meffert (2000), p. 149
[449] cf. ibid.

random' method, influenced by the respective difficulties or help in obtaining the relevant contact details.

The decision about which agencies or companies to contact also had to take into consideration the date of the advertisement, as advertising appears to have a relatively high staff-turnover. It is a fast-moving business and people tend not to work in an agency for long periods of time, i.e. more than two or three years.[450] The risk of not being able to establish a useful contact was therefore quite high, especially if the advertisement was developed several years ago. Therefore the advertisements chosen for discussion had to be relatively new.

The interview partners who were finally chosen and available are listed in Appendix 2. The figures in front of the name and contact details will be referred to in the discussion of the interviews (e.g. Interview 1 = interview about *Finke* advertisement, etc.). As interview partner, it was important to get hold of the person, who developed the concept of the advertisement, but unfortunately this was not always possible, as they were no longer with the relevant company or advertising agency. However, their successors, with whom the interviews were eventually conducted, were usually familiar with the advertisement in question, but not necessarily with all its details.

6.4. Description of Interviews

Altogether eight telephone interviews took place. This figure lies in the upper range of the number of planned interviews. Four more interviews were attempted, but contacts with the relevant persons could not be established in spite of repeated efforts. In any case, fundamentally new ideas could not be expected, and therefore eight interviews were thought to be sufficient. The decision for telephone interviews proved to be the right one, as all interview partners were prepared to talk about the topic straight away, did not need any preparation time, nor did they have any additional information, which would have required personal contact.

Dates and times for the interviews were fixed by telephone. A telephone call was felt to be a better and safer method of fixing dates than letters, faxes or emails, as a phone call establishes personal contact. Furthermore, the interview

[450] There is criticism concerning the ability of people in advertising agencies to understand the role of music in advertising, where those managers are said to behave adversarially, think that research paralyses creativity, and act primarily on intuition and custom; cf. No author identified (1994b), p. 6

partner could not ignore the question or leave the request for an interview unanswered. The time factor also played a part, as one can obtain an answer instantly instead of having to wait for a reply.

As five contacts were available and able to talk when they were first contacted, the majority of interviews took place straightaway. In three cases it was attempted to establish appointments for a telephone interview. In two of these, it was difficult to get hold of the contact person, as no firm appointment could be established, and five or six calls were needed before contact was eventually established. Out of the eight interviews, one took place with an association, one with a company and, in the other six cases, with the advertising agency who developed the advertisement.

The interviews were conducted following the interviewing guide, which is published in Appendices 3 (German original) and 4 (English translation). The sequence of the questions was not fixed other than at the beginning and the end, but depended on the answers given by the respondents. Questions, which referred to the individual situations or special features of the advertisements in question, had been added to the individual interviewing guides during the preparation of the interviews. The interviews were (with the consent of the respondents) recorded on tape in order to make sure that all details were recorded properly and can thus be referred to much more easily and more exactly than it would have been the case with hand-written notes.

6.5. Discussion of Results

In Interview 1, Figure 19 was discussed with Mr Wiesoleck from the furniture association *Begros*. He explained the general process involved in the production of furniture advertisements. The furniture association, together with its advertising agency, develops the pictures for the advertisements. A purchasing association then develops catalogues and leaflets for its members, the furnishing houses. In the *Finke* case, which can be regarded as typical of a furniture advertisement, *Begros* thought that it would be nice to have a musical instrument in the picture, as they had seen other furniture advertisements with instruments that, they thought, looked attractive. The instrument helps to ease the atmosphere of the setting and furniture portrayed. Wiesoleck said that the fact that a saxophone appeared and not a clarinet or a piano was completely incidental. Their advertising agency had proposed a saxophone, and they had not given the matter any further thought. They did not see or look for any deeper reasons and thus the saxophone does not fulfil a specific requirement in this

advertisement apart from conveying a relaxed atmosphere and creating a special mood, which is more than the display of sofas can achieve by itself. He added that there could also have been a piano, provided that it had looked sufficiently modern to match the modern set of sofas. Wiesoleck also said that the only objective of this advertisement was to increase sales. It is therefore emphatically not an image campaign. The product was to be presented in a way that interested the viewer, who then hopefully would take a closer look and, hopefully, buy the product. In this case, the atmosphere of the picture was considered more carefully than usual, as the picture appears on the front cover of the catalogue. The target audience is shown in the picture: men and women in their mid-thirties.[451]

This interview helped to understand how furniture advertisements are made. It also makes clear, why the picture shown and discussed in Figure 21 (*Möbel Bolte*) appeared in different catalogues. The statement about the piano implies, that the saxophone can fulfil the task of creating a modern atmosphere. That the saxophone was used more or less by chance explains why the saxophone appears without ligature and reed and with its mouthpiece upside down. These errors must be due to a lack of knowledge of the instrument.

Interview 2 with Mr Krüger revealed that the *Herforder* advertisement (Figure 31) appeared only in magazines, which he called 'Szene-Zeitschriften' (scene magazines). These include entertainment guides and brochures advertising events and festivals. The saxophone is used because it communicates a nice atmosphere, sociability, a sophisticated kind of music (by which he understands pop music as well as jazz), and a lifestyle shaped by *joie de vivre*. Krüger admitted that, even if the saxophone is supposedly associated with these characteristics, the choice of the saxophone did not take place purposefully. The picture of the saxophonist was stock material from the photo company with whom they work. Only the background of the picture was developed by their advertising agency and used with different themes on other occasions, e.g. a sports motive to advertise in sports media, etc. The advertisement was targeted at people between eighteen and thirty-five years of age who enjoy life. As this advertisement was part of a campaign of different themes, it is not possible to say whether this particular advertisement was effective. The campaign as a whole had positive results, which were not specified any further. The objective of the campaign was to create an image as, according to Krüger, such an advertisement does not help to sell a single additional bottle of beer.[452] This last statement seems to contradict what Wiesoleck said: the furniture advertisement

[451] cf. Wiesoleck (2001)
[452] cf. Krüger (2001)

was designed to sell more sofas by advertising with a musical instrument. Here the question remains: Why should this not be possible with beer?

Interview 3 also dealt with a beer advertisement: the Swiss *Heineken* advertisement shown in Figure 32. Ms Staufacher from the advertising agency *JWT+Hostettler+Fabrikant* in Zurich explained that it was her predecessor who developed the campaign rather than she herself. However, as she is now responsible for *Heineken*, she is familiar with the advertisement. She explained that the '*Heineken*-World' used to be presented as a world of music, especially jazz. This strong correlation with jazz was intended to be shown in the advertisement. Staufacher called the saxophone a symbol for jazz. The saxophone was also used to symbolise the sensual appeal of the slogan "Feel *Heineken*". This was similar in the case of the guitar. The campaign was conceived as an image campaign with a target audience of men aged between eighteen and thirty-five, or maybe even slightly older owing to the jazz idea. The target audience was therefore very similar to the *Herforder* advertisement, but the medium used was very different. The *Heineken* advertisement was only used as a print outdoor campaign. Staufacher said that she could very well imagine using the saxophone in advertising again (although not for Heineken, as the 'jazz world' is now history), as it is a very meaningful instrument whenever music and especially jazz are to be communicated visually.[453]

The *Weinedition Jazz* was the subject of Interview 4. Mr Bungert of *Die Crew* developed the concept of a whole new range of wine for what he calls a 'new generation of wine drinkers' (Nachwuchs-, Einsteigerzielgruppe), aged eighteen to twenty-eight. According to his statement, the idea of a jazz edition had never been translated into action in such a consistent way. The wine is only sold locally or can be ordered from the producer. This local aspect played an important role in the creation of the design, as he sees a very strong link between Stuttgart and its surroundings and jazz. He said that this campaign has been very successful insofar, as it caused quite a stir when it was launched about eight years ago. It has won several prices and is still continuing. The wine called Swing is the one designed with the saxophone, as Bungert associates swing with the music of the 1930s and 40s and musicians and bands like Glenn Miller, where the saxophone is an important instrument. But he also mentioned the trumpet in this context. So why a saxophone and not a trumpet? He explained that one reason was the space available in the picture. Because of its curves the saxophone fitted better into the picture and it looked more attractive: the way a saxophone is held and played is easier to portray in a striking way.[454]

[453] cf. Staufacher (2001)
[454] cf. Bungert (2001)

The fifth advertisement discussed is the one shown in Figure 50, the *BMW Cruiser*. The interviewee was Mr Zimmer from the advertising agency *U5 GmbH* in Düsseldorf. Zimmer is the successor to the creator of the *BMW* advertisement in question. The advertisement was aimed at precisely the type of person displayed in the picture: a creative young man who fulfils himself, who makes his dreams come true, somebody highly sensitive and emotional. The objective of the campaign was to increase sales. The image that is portrayed in the advertisement is intended to visualise the sensations one has when riding a cruiser: driving slowly on wide country roads, enjoying nature and feeling the freedom. It is a pleasure to be in harmony with one's surroundings and one can dream away. All this is equally true for saxophonists who also seem to dream away when they close their eyes and play a solo or improvisation. Moreover, they seem to be very calm and relaxed, enjoying the feeling. Therefore there is a very strong link between a saxophonist and the driver of a cruiser motorbike, and this has been visualised in the advertisement. The campaign only consisted of printed advertisements in motorbike magazines. Whether the campaign was successful or not is not known, as it has not been tested. However, as Zimmer put it, the fact, that the sales figures of cruisers at *BMW* are disappointing must be due to the product and not the saxophonist.[455] The other *BMW* advertisement discussed above (Figure 49) was not developed by this agency, even if the ideas expressed look very similar.

Interview 6 dealt with the advertisement for the *Sparkassenversicherung*, shown in Figure 81, and is the first of three advertised services that were discussed in an interview. Mr Billek from the advertising agency *Marketing-Vision*, who developed this advertisement, which was only used as a print presentation in sales folders, leaflets, posters, etc., said that this was not a big campaign, but rather a way in which customers of the *Sparkassenversicherung* could be addressed with an attractive motive. Most of the ideas expressed in the advertisement have already been described above, except for the fact, that the evening mood, which is shown in the picture, underlines the urgency of the problem for the man with his car that has had an accident. On the other hand the man has the possibility to relax, knowing his insurance company and *SUPERkasko* will help him. The picture intends to communicate a certain lifestyle, aided by the saxophone, which expresses calmness. *Marketing-Vision* is the only advertising agency of those interviewed who tried to evaluate the success of the idea. A minor project of marketing research was conducted on this campaign via a written survey. Unfortunately the response rate was very low and as such not significant. However, Billek instantly remembered one comment, as it concerned criticism by a customer who did not like to see the saxophone used in advertising in this context and almost insulted the advertising

[455] cf. Zimmer (2001)

agency with his comments.[456] This emphasises the point made earlier regarding criticism of the saxophone's use in advertising.

The seventh advertisement discussed in an interview is the one depicted in Figure 82, the *IBM* recruiting advertisement. Mr Eberle described the saxophone as a very emotional instrument, which is excellent for visualising anything that deals with feelings and emotions. He also mentioned the jazz association of the instrument. Eberle pointed out that a piano could not have been used in this context, as this is usually seen as a background instrument, which gives rhythm and support or stability, whereas the saxophone is a major focus of a band. The slogan "Good vibrations" provides a link between the text and the sensation one feels when either playing or listening to a saxophone. Furthermore the implication of these good vibrations is to be understood as an analogy of players in a band – which is shown in the background of the picture – who have to fit into the band and therefore subordinate themselves to the rest of the band but who also, at specific times, have to perform a solo. This represents exactly the relationship of an *IBM* employee with other employees of the organisation. The saxophonist and the band are the visualisation of this idea. That the female saxophonist does not conform to the typical image of a woman usually shown in advertising was also intended. Eberle pointed out that for *IBM* they usually try to find unusual pictures in order to attract attention. This advertisement, which was part of an advertising campaign including at least four different images, appeared in various publications, but always in magazines for students like *AIESEC* magazines, *Unicum*, or in publications connected with student or university conferences. The pictures appeared sometimes in full colour but occasionally also in black and white. The objective was to portray *IBM* as a very attractive employer. It could not be said for sure whether the campaign attained all its objectives, but there was definitely a good deal of positive response.[457] Altogether, this campaign was extremely well considered and produced an excellent visualisation, strongly connecting idea, slogan, text and picture.

The subject of Interview 8 was the advertisement shown in Figure 102. It was the hardest interview to conduct, as this advertisement had not been given a lot of thought during its development. Mr Slaby of the advertising agency *PAC Promotion* pointed out that *B. Braun* already owned that picture when they commissioned the agency to create some accompanying text. That there are two saxophones in the picture is a complete coincidence. It is more important, that there is a small band, which tries to achieve something in teamwork, much like the people who work for the company. The advertisement was only intended to appear in Melsungen and its surroundings as a cultural advertisement in

[456] cf. Billek (2001)
[457] cf. Eberle (2001)

178

anniversary brochures of choirs, orchestras, etc.: places in which one is not looking for an advertisement but encounters one by chance. When the interview was already thought to be over and Slaby had pointed out more than once that the use of the saxophone in advertising did not deserve much thought, he suddenly began talking about jazz and the saxophone's role in representing jazz, which he regarded as a connection between old and young people. He also mentioned the attractiveness of the golden shining instrument, which is very photogenic and for that reason a well-liked object for designers and photographers.[458] To Slaby, these aspects must have been self-evident, self-explanatory or just not worth mentioning earlier in the interview.

Slaby was the only respondent who could recall other advertisements with musical instruments developed by his agency. He mentioned a catalogue of carpet samples, in which different instruments represented different carpet colours, but could not give further details.[459] None of the other respondents could remember having used musical instruments in other advertisements. Only *Marketing-Vision* had tried to establish by means of a survey whether the objectives of their campaign featuring a saxophone had been realised although, as mentioned above, the low response rate yielded no useful results.[460] In the seven other cases, no monitoring of advertising effectiveness was undertaken or could be assigned to the advertisements with the saxophone. None of the agencies had an image analysis of the saxophone.

Even if the findings of the interviews should be treated carefully and not as firmly established facts, there are some points in which there seems to be agreement. For all the practitioners the saxophone is a very emotional instrument and linked closely with jazz and high-quality music. Interestingly, all those who took part in the interviews, think of jazz as something respectable or stylish, as upper class music, rather than the music played in dark and smoky bars. Nobody mentioned that the saxophone was used as an eye-catcher, whereas it may well have been the intention in the cases of Figures 19, 31 or 32. All those interviewed described the saxophone as an attractive, good-looking, handsome instrument. The saxophone also seems to provide a very popular subject or motive for photographers, as some advertisements featuring saxophones (e.g. Figures 31 and 102), were found in photographers' or company archives. In Figures 19, 31 and 102 the saxophone was said to have appeared by chance without having been given much thought. In general, however, the bigger and more prominent advertising agencies seem to have given the use of the saxophone more thought than the smaller agencies. This may also be due to

[458] cf. Slaby (2001)
[459] cf. ibid.
[460] cf. Billek (2001)

higher budgets assigned to these advertisements or campaigns. None of the findings above, deduced from advertising theory and the examination of the advertisements discussed, was proven wrong by the advertising experts, but it also became clear during the interviews that some processes were not questioned by the experts but simply put into action. The ideas that have been explained above all seem to be applicable, also to the advertisements discussed with the experts, and although the experts do not seem to have given much attention to the background of their advertisements and the power and associations that a saxophone has or brings along with it.

7. Conclusion

The explanation of some advertising background including important details have pointed out the importance of effective visual presentation in advertising in a world of over-stimulation and low-involvement products. The importance of a common understanding for signs used in advertising has become clear.

The discussion of music has shown in how far music has been given consideration in research until today. It could be made clear that, although the topic has been in focus of some studies, there is still plenty of room for further investigations. Most researchers have concentrated their studies on music in the electronic media, which makes sense at first sight, as one of the main features of music is that it can be listened to. According to their assumptions, only if music can be listened to, the desired reactions of the consumers can be achieved. A point that has so far been neglected in research is the question in how far the same emotions or reactions can be reached by transferring music to other media, which cannot make use of the main feature of music, sound. Although the medium in focus of this investigation has been print, media such as TV and radio have been given attention, as one needs to understand the differences in using a musical instrument on TV or on the radio, where one can actually hear the music of an instrument, compared to print advertising, where a picture or image has to transfer the intended meaning. In specific, it would be interesting to see, in how far 'music' works when it is used in printed advertisements that only make use of images of musical instruments – symbols that visualise music.

Over the last few years, the topic of emotion has increasingly been given attention. Products and services have to be emotionalised in order to attract customers. As music has the ability of arousing emotions, it has become of an even higher interest in advertising. It could be shown that research has not yet come up with a clear and common understanding regarding the power of music in advertising, but that different studies have shown different results. A topic that has been completely neglected in research is the question whether specific musical instruments carry specific potentials of creating emotions by evoking associations. The question that directly follows is whether these emotions can then be transferred to a product, service or brand to the desired extent. So far there has only been some research that has dealt with the different kinds of music, such as classical music, rock, pop etc., but none that examined musical instruments and their powers. Furthermore, in the context of the saxophone in advertising, the topic of the meaning of music has been examined. However, even here there is further research required. Topics, such as the process of how meaning is created and in how far it depends on particular elements, such as acoustics versus pictures, still need to be researched properly. As globalisation is

taking over more and more of our thoughts and daily lives, cultural aspects in advertising, and also the cultural differences of music needed to be given some thought within this study.

Closer looks at the history and the present situation have been given, including some special aspects about the saxophone in Germany. This reflection has led to an insight as to how the saxophone was perceived during its one-and-a-half-century history and the image it has in music today. A short study of the perception and associations of other musical instruments, and an examination of how the saxophone itself is advertised, have given an introduction to the examination of examples of the saxophone's use in advertising of other products and services. By doing so, the uniqueness and special features of the saxophone compared to other instruments became apparent. This field could be further researched, now that a detailed study exists at least for the saxophone in advertising. In the main field of the study regarding the saxophone's use in advertising, it can be seen that the saxophone is used to help advertise anything from furniture, to cars, cigarettes and festivals and from broadcasting stations to businesses like banks or insurance companies. Through qualitative research in form of interviews with advertising experts an attempt has been made to find answers to the questions that theory alone cannot answer, and to support the observations made previously.

The saxophone has the ability to symbolise a wide range of qualities, items, moods and emotions. The alto and the tenor instrument in particular have been widely used in a variety of advertisements and styles and in more ways than it seems to be possible for any other musical instrument. The saxophone is used as a symbol for music in general, and for jazz in particular. Jazz, in the context of the saxophone in advertising, is rather seen as an upmarket music that enjoys a higher regard in society than the music played in smoky bars. The smoky image could only be found in a cigarette advertisement. In addition, the saxophone indicates a good mood or atmosphere and a sophisticated lifestyle. Together with an Afro-American, a Mississippi steamboat or Bill Clinton it symbolises the USA, in the first two cases especially the southern states and a nostalgia for times gone by. When shown in connection with an Afro-American, it can nowadays also contribute to the fight against racism in a reversal of the symbolism of the saxophone in Germany under the Nazis.

To conclude, the main question of this publication will be answered: What role(s) does the saxophone play in advertising? The saxophone is first of all used as an eye-catcher. It tries to catch the attention and give extra value like emotional aspects or a special mood or image to products and services. It is used to change attitudes towards a product or service by giving them a positive

image. This is true especially in the case of low-involvement products. The target audience consists in most cases of an age group between twenty and forty, and those who identify with a young, happy and trendy lifestyle. Therefore the saxophone is shown very often in conjunction with sexy, good-looking, attractive, and smart young people and serves to make them appear even more attractive. Furthermore, the saxophone is seen as an attractive, good-looking instrument in its own right by photographers and designers and is therefore a well-liked photographic object. At the same time, in cases where the actual statements a saxophone can make because of its perception are not especially important, there appear to be no obvious reasons for its use. Advertisers say that it appeared by chance. But chance itself seems to have been influenced and the saxophone is often chosen because of its attractive looks or because it fits well into a picture, either because of its shape or because of its shining, warm, golden colour. Occasionally it may be used to simply 'jazz up' the picture. The saxophone also represents a certain cult, which was probably even more distinct in the late 1980s and which has developed into a more popular image or culture, which is now a part of our everyday lives and therefore no longer questioned. Objectives of the advertisements with a saxophone are sometimes product oriented and intended to contribute to an increase in sales, whereas at other times they are aiming at improving an image.

According to advertising theory the use of the saxophone in advertising makes sense. However, some advertising experts do not seem to take the subject seriously enough. There have already been complaints about the way in which the saxophone has been used in advertising, as well as ridicule. Coupled with the fact that the only statement of the failed survey done by *Marketing-Vision* that Mr Billek – one of the interviewed advertising managers – could remember was one of criticism shows that those working in advertising agencies or companies developing advertisements with a saxophone should, if they decide to use it, give it more thought and make every effort to show the saxophone correctly. Otherwise the incorrect representation of the saxophone might lead to a denigration of the advertisement, which may then also lead to a loss of image of the advertised product, rather than to an improvement. An advertisement with a saxophone shown correctly in all details (where the player has his/her hands in the right places, a mouthpiece is attached correctly to the saxophone, etc.) could then also appeal to saxophone players or lovers, instead of turning them away from the product, brand or service.

Furthermore, advertising theory has raised ideas to which the people who developed the advertisements featuring saxophones have not given much thought. If the results of an advertisement featuring a saxophone are not satisfactory, that can of course have many reasons. Just one of these could be

that some aspects analysed in this publication were not given sufficient thought, and thus the advertisement could not become fully effective. Regarding the link between the visualisation and the accompanying text, there is room for further studies. It could be investigated whether previous findings regarding the information processing of pictures in printed advertising can be confirmed when musical instruments are displayed.

The saxophone has not only been used in German, Austrian or Swiss printed advertisements, but examples can be found in many countries. So far, examples were found in England, Finland, France, in Africa, the USA, and the Czech Republic, but there are definitely more examples in more countries to be discovered. The examination of this study has concentrated on the German speaking countries, therefore it would be interesting to see in the future to what extent the findings can be transferred to other cultures. As it makes sense to use the saxophone in advertising and, as it is such a communicative instrument and attractive motive, the saxophone can, should and most probably will continue to be used in advertising in the future. Although the right target audience seems to have been found, some research should be done in order to find out in how far consumers really understand the intentions of the creatives of advertising agencies and if the positive attributes of a saxophone are also realised by the onlookers of an advertisement. If advertisers or companies want their customers not only to see the link between their product and the saxophone but to absorb the association, the saxophone must be used for a longer period of time rather than in just one advertisement or as part of a campaign; the Arosa example and advertising theory show that only then there will be long-term effects, that can be made use of. The saxophone is not yet associated with only one particular product or service, and therefore there is still a chance for at least one company, brand or product, to make use of it in such a way that everybody will one day associate the saxophone with all its positive connotations with this company in the way the violin is linked with the *Mozartkugel* and the harp with the Irish brewery *Guinness*.

List of References

Encyclopaedia

Bate, P. (1980), *Saxophone*, in: Sadie, St. (Ed.), New Grove Dictionary of Music and Musicians, Macmillan Publishers, London, pp. 334-339

Books

Adams, B. (1994), *The effect of visual/aural conditions on the emotional response to music*, Ph.D., Florida State University

Belch, G. E. & Belch, M. A. (2001), *Advertising and promotion: An integrated marketing communications perspective*, 5th Int. Ed., Irwin/McGraw-Hill, Boston

Berendt, J. E. (2000), *Das Jazzbuch*, 9th Ed., Fischer Taschenbuch Verlag, Frankfurt a. M.

Blair, M. E. (1990), *The influence of context upon the conditioning of product attitudes with music (advertisement music)*, Ph.D., University of South Carolina

Brassington, F. & Pettitt, S. (1997), *Principles of marketing*, Pitman Publishing, London

Bro, P. A. (1993), *Development of the American-made saxophone: A study of saxophones made by Buescher, Conn, Holton, Martin, and H. N. White*, Northwestern University

Buchner, G. (1986), *Musik A-Z: Klassik, Jazz, Rock, Pop; Musikgeschichte, Instrumentenkunde, berühmte Komponisten und Interpreten*, 2nd Ed., Franz Schneider Verlag, Munich

Chisnall, P. (1997), *Marketing research*, 5th Ed., McGraw-Hill Marketing Series, London

Ciolina, E. & Ciolina, E. (1993), *Werbefiguren und Comicfiguren*, Battenberg, Augsburg

185

Dahlberg, J. S. (1999), *A content analysis and comparison of message attributes of commercials found during daytime, daytime fringe, and primetime television*, Ph.D., State University of New York at Buffalo

Deutsch, D. (Ed.) (1999), *The psychology of music*, 2nd Ed., Academic Press, San Diego

Dieterle, G. S. (1992), *Verhaltenswirksame Bildmotive in der Werbung: theoretische Grundlagen – praktische* Anwendung, Physica-Verlag, Heidelberg

Dietz, W. (2001), *Automobilmarketing: erfolgreiche Strategien, praxisorientierte Konzepte, effektive Instrumente*, 4th Ed., Verlag Moderne Industrie, Landsberg/Lech

Dowling, W. J. & Harwood, D. L. (1986), *Music cognition*, Academic Press, Orlando

Dullat, G. (1995), *Saxophone*, 2nd Ed., Nauheim/Groß-Gerau

Genin, L. V. (2001), *'Virtual Personal Shopper': Gateway to customer satisfaction and intention to buy in online shopping*, DBA, Golden Gate University

Habla, B. (1990), *Besetzung und Instrumentation des Blasorchesters I*, Hans Schneider, Tutzing

Harris, R. J. (1999), *A cognitive psychology of mass communication,* 3rd Ed., Lawrence Erlbaum Associates, Mahwah (USA)

Hung, K. (1996), *An empirical investigation of the impact of music on brand perception in television commercials*, Ph.D., York University, Canada

Juchem, D. (1996), *Saxophone facts. Grundlagen & Spezialeffekte für alle Saxophone*, Schott Musik International, Mainz

Kasprik, R. (1993), *Erinnerungsstarke Werbung durch die Verwendung von unstimmigen Bildern?*, Harri Deutsch, Thun/Frankfurt a. M.

Koeppler, K. (2000), *Strategien erfolgreicher Kommunikation: Lehr- und Handbuch*, Oldenbourg Wirtschaftsverlag, Munich

Kool, J. (1931), *Das Saxophon*, Faks.-Ausg. Weber, Leipzig

Kotler, P. & Armstrong, G. & Saunders, J. (1999), *Principles of marketing*, 2nd European Ed., Prentice Hall Europe, London, New York et al.

Lacher, K. T. (1991), *A study of the hedonic responses involved in the consumption of music*, Ph.D., Florida State University

Lois, G. and Bill Pitts (1993), *Die zündende Idee: mit Frechheit werben (und verkaufen!)*, Campus Verlag, Frankfurt a. M., New York

Meffert, H. (2000), *Grundlagen marktorientierter Unternehmensführung. Konzepte – Instrumente – Praxisbeispiele.* 9th Ed., Gabler Verlag, Wiesbaden

Messaris, P. (1997), *Visual persuasion: The role of images in advertising*, Sage Publications, Thousand Oaks (USA)

Meyer, L. (1956), *Emotion and meaning in music*, University of Chicago Press, Chicago

Ogilvy, D. (1964), *Confessions of an advertising man*, Atheneum, New York

Ogilvy, D. (1984), *Ogilvy über Werbung*, Econ Verlag, Düsseldorf and Vienna

Oller, J. W. & Giardetti J. R. (1999), *Images that work: creating successful messages in marketing and high stakes communication*, Greenwood Publishing Group, Westport (USA)

Philipps, T. (1998), *Musik der Bilder. Von der Frühzeit bis zur Gegenwart*, Verlag Prestel, Munich et al.

Rehorn, J. (1988), *Werbetests*, Verlag Luchterhand, Neuwied

Rötter, G. (1987), *Die Beeinflußbarkeit emotionalen Erlebens von Musik durch analytisches Hören – psychologische und physiologische Betrachtungen*, Peter Lang Verlag, Frankfurt a. M.

Schmidt, S. J. & Spieß, B. (Eds.) (1995), *Werbung, Medien und Kultur*, Westdeutscher Verlag, Opladen

Schmittel, W. (1978), *process visual*, ABC Edition, Zurich

Schwaiger, M. (1997), *Multivariate Werbewirkungskontrolle: Konzepte zur Auswertung von Werbetests*, Gabler Verlag, Wiesbaden

Sin, L. Y. (1992), *Mood and advertising persuasion: A model integrating mood management and mood disruption mechanisms*, Ph.D., University of British Columbia (Canada)

Springer, C. M. (1992), *Society's soundtrack: Musical persuasion in television advertising*, Ph.D., Northwestern University

Stewart, D. W. & Furse, D. H. (1987), *Effective television advertising: A study of 1000 commercials*, 2nd Print, Lexington Books, Lexington

Strauss, S. G. (1998), *Language and culture of the television ad: A look at TV commercials from Japan, Korea, and the United States*, Ph.D., University of California at Los Angeles

Stromeyer, M. (1992), *Die Anwendung der 'Funktionalen Musik' im Marketing. Wirkungsweise und Einsatz von Hintergrundmusik in Discountern, Warenhäusern, Boutiquen, Restaurants, Hotels, Banken und bei Zahnärzten*, 5th Ed., Stromeyer, Pfyn

Tarasti, E. (2002), *Signs of music: A guide to musical semiotics*, Mouton de Gruyter, Berlin and New York

Tauchnitz, J. (1990), *Werbung mit Musik*, Physica-Verlag, Heidelberg

Theberge, P. (1993), *Consumers of technology: Musical instrument innovations and the musicians' market*, Ph.D., Concordia University (Canada)

Timmerman, J. E. (1981), *The effects of temperature, music, and density on the perception of crowding and shopping behavior of consumers in a retail environment*, DBA, Memphis State University

Vaccaro, V. L. (2001), *In-store music's influence on consumer responses: The development and test of a music-retail environmental model*, Ph.D., City University of New York

Ventzke, K. & Raumberger, C. & Hilkenbach, D. (1994), *Die Saxophone: Beiträge zu ihrer Bau-Charakteristik, Funktion und Geschichte*, 3rd Ed., Verlag Erwin Bochinsky, Frankfurt a. M.

Vinh, A.-L. (1994), *Die Wirkungen von Musik in der Fernsehwerbung*, Dissertation No. 1562, Hochschule St. Gallen, Rosch-Buch, Hallstadt

Vogl, M. (1993), *Instrumentenpräferenz und Persönlichkeitsentwicklung: eine musik- und entwicklungspsychologische Forschungsarbeit zum Phänomen der Instrumentenpräferenz bei Musikern und Musikerinnen,* Peter Lang Verlag, Frankfurt a. M.

Watson, S. A. (1992), *The effects of music in television commercials,* Ph.D., University of Wollongong (Australia)

Wöhe, G. (2000), *Einführung in die allgemeine Betriebswirtschaftslehre,* 20th Ed., Verlag Franz Vahlen, Munich

Wüsthoff, K. (1999), *Die Rolle der Musik in der Film-, Funk- und Fernseh-Werbung,* 2nd Ed., Merseburger, Kassel

Yoon, S.-G. (1993), *The role of music in television commercials: The effects of familiarity with and feelings toward background music on attention, attitude, and evaluation of the brand,* Ph.D., University of Georgia

Articles and book excerpts

Abeles, H. & Chung, J. W. (1996), *Responses to music,* in: Hodges, D. (Ed.), *Handbook of music psychology,* 2nd Ed., IMR press, San Antonio, pp. 285-342

Ashton, D. (1998), *In the twentieth century,* in: Ingham, R. (Ed.) *The Cambridge Companion to the Saxophone,* Cambridge University Press, Cambridge, p. 21

Bartlett, D. (1996), *Physiological responses to music and sound stimuli,* in: Hodges, D. (Ed.), *Handbook of music psychology,* 2nd Ed., IMR press, San Antonio, pp. 343-386

Cohen, A. (2001), *Music as a source of emotion in film,* in: Juslin, P. & Sloboda, J. (Eds.), *Music and emotion,* Oxford University Press, Oxford, pp. 249-274

Cook, N. & Dibben, N. (2001), *Musicological approaches to emotion,* in: Juslin, P. & Sloboda, J. (Eds.), *Music and emotion,* Oxford University Press, Oxford, pp. 45-70

Cross, M. (1996), *Reading television texts: The postmodern language of advertising*, in: Cross, M. (Ed.), *Advertising and culture. Theoretical perspectives*, Praeger, Westport, pp. 1-10

Dowling, W. J. (1999), *The development of music perception and cognition*, in: Deutsch, D. (Ed.), *The psychology of music*, 2nd Ed., Academic Press, San Diego, pp. 603-625

Dryer-Beers, T. (1998), *Influential soloists*, in: Ingham, R. (Ed.) *The Cambridge Companion to the Saxophone*, Cambridge University Press, Cambridge, pp. 42-44

Gabrielsson, A. (1999), *The performance of music*, in: Deutsch, D. (Ed.), *The psychology of music*, 2nd Ed., Academic Press, San Diego, pp. 501-602

Hodges, D. & Haack, P. (1996), *The influence of music on human behavior*, in: Hodges, D. (Ed.), *Handbook of music psychology*, 2nd Ed., IMR press, San Antonio, pp. 469-556

Ingham, R. (1998), *Invention and development*, in: Ingham, R. (Ed.) *The Cambridge Companion to the Saxophone*, Cambridge University Press, Cambridge, p. 125

Julien, J. R. (1985), *The use of folklore and popular music in radio advertising*, in: Horn, D. (Ed.), *Popular Music Perspectives 2: Papers from the Second International Conference on Popular Music Studies*, Reggio Emilia (Italy), September 19-24, 1983, IASPM, Gothenburg, pp. 417-427

Juslin, P. & Sloboda, J. (2001), *Music and emotion: Introduction*, in: Juslin, P. & Sloboda, J. (Eds.), *Music and emotion*, Oxford University Press, Oxford, pp. 3-22

Klempe, H. (1994), *Music, text and image in commercials for Coca-Cola*, in: Corner, J. & Hawthorn, J. (Eds.), *Communication studies*, 4th Ed., Arnold, London, pp. 245-254

Leppälä, K. (1999), *Kulturelles Wissen in der Werbung,* in: Bungarten, T. (Ed.), *Sprache und Kultur in der interkulturellen Marketingkommunikation*, 2nd Ed., Attikon Verlag, Tostedt, pp. 126-131

Lewin, G. (1998), *Invention and development*, in: Ingham, R. (Ed.) *The Cambridge Companion to the Saxophone*, Cambridge University Press, Cambridge, pp. 114-115

Liley, T. (1998), *Invention and development*, in: Ingham, R. (Ed.) *The Cambridge Companion to the Saxophone*, Cambridge University Press, Cambridge, pp. 1-18

Meyer, L. (2001), *Music and emotion: Distinctions and uncertainties*, in: Juslin, P. & Sloboda, J. (Eds.), *Music and emotion*, Oxford University Press, Oxford, pp. 341-360

No author identified (1994a), *Jahrbuch der Werbung 1994 (The Advertiser's Annual for Germany, Austria and Switzerland1994)*, Eds.: Schalk, W., Thoma, H., Vol. 31, Econ Verlag, Düsseldorf et al., p. 458

No author identified (1996), *Jahrbuch der Werbung 1996 (The Advertiser's Annual for Germany, Austria and Switzerland 1996)*, Eds.: Schalk, W., Thoma, H., Strahlendorf, P., Vol. 33, Econ Verlag, Düsseldorf et al., pp. 342-343

No author identified (1998), *Jahrbuch der Werbung 1998 (The Advertiser's Annual for Germany, Austria and Switzerland 1998)*, Eds.: Schalk, W., Thoma, H., Strahlendorf, P., Vol. 35, Econ Verlag, Düsseldorf et al., pp. 224-225, 635

No author identified (2000), *Jahrbuch der Werbung 2000 (Advertising Annual for German Speaking Regions 2000)*, Eds.: Schalk, W., Strahlendorf, P., Thoma, H., Vol. 37, Econ Ullstein List Verlag, Munich et al., p. 171

Puto, C. & Hoyer, R. (1990), *Transformational advertising: Current state of the art*, in: Agres, S. & Edell, J. & Dubitsky, T. (Eds.), *Emotion in advertising. Theoretical and practical explorations*, Quorum Books, New York, pp. 69-80

Puto, C. & Wells, W. (1984), *Informational and transformational advertising: Differential effects of time*, in: Kinnear, T.C. (Ed.), *Advances in consumer research*, Vol. 11, Association for Consumer Research, Provo, pp. 638-643

Scherer, K. & Zentner, M. (2001), *Emotional effect of music: production rules*, in: Juslin, P. & Sloboda, J. (Eds.), *Music and emotion*, Oxford University Press, Oxford, pp. 361-392

Schmidt, H.-C. (1992), *Von high-tech Zigeunern und stummen Nudeln: Fußnoten zum Ton und zur Musik in der Werbung,* in: Schoenebeck, M. von & Brandhorst, J. & Gerke, H. J. (Eds.), *Politik und gesellschaftlicher Wertewandel im Spiegel populärer Musik,* Essen, pp. 102-108

Schmidt, H.-C. (1997), *Die Murattis und die Luckies geben eine Party: Zur Rolle der Musik in der Filmwerbungs-Geschichte,* in: Liedtke, U. (Ed.), *'Jeder nach seiner Fasson':* Musikalische Neuansätze heute, Pfau Verlag, Saarbrücken, pp. 194-309

Sloboda, J. (1991), *Empirical studies of emotional response to music,* in: Riess Jones, M. & Holleran, S. (Eds.), *Cognitive bases of musical communication,* American Psychological Association, Washington, pp. 33-46

Sloboda, J. & Juslin, P. (2001), *Music and emotion: Commentary,* in: Juslin, P. & Sloboda, J. (Eds.), *Music and emotion,* Oxford University Press, Oxford, pp. 453-462

Sloboda, J. & O'Neill, S. (2001), *Emotions in everyday listening to music,* in: Juslin, P. & Sloboda, J. (Eds.), *Music and emotion,* Oxford University Press, Oxford, pp. 415-429

Stout, P. A. & Leckenby, J. D. (1988), *Let the music play: Music as a nonverbal element in television commercials,* in: Hecker, S. & Stewart, D. W. (Eds.), *Nonverbal communication in advertising,* Lexington Books, Lexington, pp. 207-223

Vornhusen, L. (2000), *Zahlen, Daten und Fakten zum Werbejahr 2000,* in: Schalk, W. & Strahlendorf, P. & Thoma, H. (Eds.), *Jahrbuch der Werbung 2000,* Vol. 37, Econ Ullstein List Verlag, Munich et al., pp. 55-65

Wright-Isak, C & Farber, R. & Horner, L. (1997), *Comprehensive measurement of advertising effectiveness: Notes from the marketplace,* in: Wells, W. D. (Ed.) *Measuring Advertising Effectiveness,* Lawrence Erlbaum Associates, Inc., Mahwah (USA), pp. 2-12

Journals and Newspapers

Adelson, A. (1998), *Companies are increasingly seeking to identify their products with music, both old and new*, in: **The New York Times**, 27 August 1998, Col. 5, p. 3

Al-Olayan, F. & Karande, K. (2000), *A content analysis of magazine advertisements from the United State and the Arab world*, in: **Journal of Advertising**, Vol. 29, No. 3, pp. 69-82

Babin, L. A. & Burns, A. C. (1997), *Effects of print ad pictures and copy containing instructions to imagine on mental imagery that mediates attitudes*, in: **Journal of Advertising**, Vol. 26, No. 3, pp. 33-44

Behne, K.-E. (1999), *Zu einer Theorie der Wirkungslosigkeit von (Hintergrund) Musik*, in: **Jahrbuch der Dt. Gesellschaft für Musikpsychologie**, Vol. 14, pp. 7-23

Bensmann, D. (1995), *Zur Ausbildung von Konzertsaxophonisten*, in: **rohrblatt**, Vol. 10, No. 1, pp. 27-28

Boltz, M. G. & Schulkind, M. & Kantra, S. (1991), *Effects of background music on the remembering of filmed events*, in: **Memory and Cognition**, Vol. 19, pp. 595-606

Bruner, G. C. (1990), *Music, mood, and marketing*, in: **Journal of Marketing**, Vol. 54, October, pp. 94-104

Bullerjahn, C. & Morr, S. & Paland, M. (1994), *Musik in der Werbung. Kultur- oder Manipulationsfaktor?*, in: **Musik und Unterricht**, Vol. 5, No. 29, pp. 9-15

Carlton, R. (1995), *The public marketing of music*, in: **International Review of the Aesthetics and Sociology of Music**, Vol. 26, Issue 1, pp. 123-132

Cheng, H. & Schweitzer, J. C. (1996), *Cultural values reflected in Chinese and U.S. television commercials*, in: **Journal of Advertising Research**, Vol. 36, No. 3, pp. 27-46

Bruner, G.C. (1990), *Music, mood, and marketing*, in: **Journal of Marketing**, Vol. 54, October, pp. 94-104

Bullerjahn, C. & Morr, S. & Paland, M. (1994), *Musik in der Werbung. Kultur- oder Manipulationsfaktor?*, in: **Musik und Unterricht**, Vol. 5, No. 29, pp. 9-15

Carlton, R. (1995), *The public marketing of music*, in: **International Review of the Aesthetics and Sociology of Music**, Vol. 26, Issue 1, pp. 123-132

Cook, N. (1994), *Music and meaning in the commercials*, in: **Popular Music**, Vol. 13, No. 1, pp. 27-40

Cunningham, J. G. & Sterling, R. S. (1988), *Developmental change in the understanding of affective meaning of music*, in: **Motivation & Emotion**, Vol. 12, pp. 399-413

Demkowych, C. (1986), *Music on the upswing in advertising*, in: **Advertising Age**, Vol. 57, p. S-5

Dolgin, K. G. & Adelson, E. H. (1990), *Age changes in the ability to interpret affect in sung and instrumentally-presented melodies*, in: **Psychology of Music**, Vol. 18, pp. 87-98

Edell, J. A. & Staelin, R. (1983), *The information processing of pictures in print advertisements*, in: **Journal of Consumer Research**, Vol. 10, June, pp. 45-61

Elliott, S. (1992), *Advertising: Alternative music is piquing interest as a marketing tool*, in: **New York Times Abstracts**, 21 August 1992, p. 15, Col. 1

Englis, B. G. & Solomon, M. R. & Olofsson, A. (1993), *Consumption imagery in music television: a bi-cultural perspective*, in: **Journal of Advertising,** Vol. 22, No. 4 (Winter), pp. 21-34

Finn, A. (1988), *Print ad recognition readership scores: An information processing perspective*, in: **Journal of Marketing Research**, Vol. 25, May, pp. 168-177

Friedrich, B. (1994), *Das Saxophon als Hauptfach im Hochschulstudium. Eine Analyse von Anspruch und Zielformulierung*, in: **rohrblatt**, Vol. 9, No. 2, p. 51

Gagnard, A. & Morris, J. R. (1988), *CLIO commercials from 1975-1985: Analysis of 151 executional variables*, in: **Journalism Quarterly**, Vol. 65, No. 4, pp. 859-869

Galizio, M. & Hendrick, C. (1972), *Effect of musical accompaniment on attitude: the guitar as a prop for persuasion*, in: **Journal of Applied Social Psychology**, Vol. 2, No. 4, pp. 350-359

Gerardi, G. M. & Gerken, L. (1995), *The development of affective responses to modality and melodic contour*, in: **Music Perception**, Vol. 12, pp. 279-290

Finn, A. (1988), *Print ad recognition readership scores: An information processing perspective*, in: **Journal of Marketing Research**, Vol. 25, May, pp. 168-177

Gladstone, V. (1998), *Advertisers play a new tune: jazz*, in: **The New York Times**, 6 December 1998, p. 34

Görlich, R. (2003), *Bläser in der NDW: Tue auch was du nicht kannst – zum Beispiel Saxophon spielen*, in: **Clarino.print**, Vol. 2, pp. 44-46

Gorn, G. J. (1982), *The effects of music in advertising on choice behavior: A classical conditioning approach*, in: **Journal of Marketing**, Vol. 46, Winter, pp. 94-101

Gorn, G. & Goldberg, M. & Basu, K. (1993), *Mood, awareness, and product evaluation*, in: **Journal of Consumer Psychology**, Vol. 2, No. 3, pp. 237-256

Haberkamp, T. (1993), *Zur Ausbildung professioneller Saxophonisten. Versuch einer Skizzierung unter Einbeziehung musikhistorischer Hintergründe*, in: **rohrblatt**, Vol. 8, No. 1, pp. 23-27

Habla, B. (1996), *Das heutige Image des Saxophons unter besonderer Berücksichtigung bildlicher Darstellungen in der Werbung*, in: **Clarino**, Vol. 2, pp. 13-19

Habla, B. (2001), *Darstellungen von Saxophonen in der Werbung. Eine Dia-Show anhand von Werbebildern mit Saxophonen als Accessoire*, in: **Arbeitsberichte – Mitteilungen. Pannonische Forschungssstelle Oberschützen**, No. 12, September 2001, Pannonische Forschungsstelle des Instituts 12 (Oberschützen) (vorm. Expositur) der Universität für Musik und darstellende Kunst Graz, Austria, pp. 153-188

Haley, R. & Richardson, J. & Baldwin, B. (1984), *The effects of nonverbal communications in television advertising*, in: **Journal of Advertising Research**, Vol. 24, No. 4 (August/September), pp. 11-18

Hentz, S. (1991), *Ein Klang für jede Gelegenheit, 150 Jahre Saxophon*, in: **Neue Zeitschrift für Musik**, Vol. 152, No. 7-8, pp. 53-57

Herbert, J. (1993), *Der amerikanische Präsident als Saxophontrendsetter*, in: **rohrblatt**, Vol. 8, No. 1, p. 39

Hilkenbach, D. (1993), *Internationale Saxophon-Studientage in Ochsenhausen*, in: **rohrblatt**, Vol. 8, No. 4, pp. 180-181

Haley, R. & Richardson, J. & Baldwin, B. (1984), *The effects of nonverbal communications in television advertising*, in: **Journal of Advertising Research**, Vol. 24, No. 4 (August/September), pp. 11-18

Holbrook, M. B. & Schindler, R. M. (1989), *Some exploratory findings on the development of musical taste*, in: **Journal of Consumer Research**, Vol. 16, June, pp. 119-124

Holmer, A. K. & Nienhaus, W. (1994), *'Viel Lärm um nichts?' Musik in der Rundfunkwerbung*, in: **Musik und Unterricht**, Vol. 5, No. 29, pp. 22-29

Houston, M. J. & Childers, T. L. & Heckler, S. E. (1987), *Picture-word consistency and the elaborative processing of advertisements*, in: **Journal of Marketing Research**, Vol. 24, November, pp. 359-369

Hung, K. (2000), *Narrative music in congruent and incongruent TV advertising*, in: **Journal of Advertising**, Vol. 29, No. 1, pp. 25-34

Hung, K. (2001), *Framing meaning perceptions with music: The case of teaser ads*, in: **Journal of Advertising**, Vol. 30, No. 3 (Fall), pp. 39-49

Huron, D. (1989), *Music in advertising: An analytic paradigm*, in: **Musical Quarterly**, Vol. 73, No. 4 (Fall), pp. 557-574

Jauk, W. (1994), *Die Veränderung des emotionalen Empfindens von Musik durch audiovisuelle Präsentation*, in: **Jahrbuch der Dt. Gesellschaft für Musikpsychologie**, Vol. 11, pp. 29-51

Kastner, M. & Crowder, R. (1990), *Perception of major/minor: IV. Emotional connotations in young children*, in: **Music Perception**, Vol. 8, pp. 189-202

Kellaris, J. J. & Cox, A. D. & Cox, D. (1993), *The effect of background music on ad processing: A contingency explanation*, in: **Journal of Marketing**, Vol. 57, October, pp. 114-125

Kellaris, J. J. & Cox, A. D. (1989), *The effects of background music in advertising: A reassessment*, in: **Journal of Consumer Research**, Vol. 16, June, pp. 113-118

Kleinen, G. (1994), *Musikalischer Ausdruck und ästhetische Wertung als interkulturelle Qualität und Differenz*, in: **Jahrbuch der Dt. Gesellschaft für Musikpsychologie**, Vol. 11, pp. 76-101

Klimek, O. (1998), *Ein ungewöhnlicher Klangkörper*, in: **rohrblatt**, Vol. 13, No. 4, p. 174

Krüger, I. (1994), *Von Katzen und Klarinetten*, in: **rohrblatt**, Vol. 9, No. 2, pp. 64-73

Laws, D. (1994), *Selling your skills. Marketing music in the 90's*, in: **The Woodwind Quarterly**, Part I, Issue 4, February, pp. 90-106, Part II, Issue 5, May, pp. 30-47

Lehmann, A. (1993), *Habituelle und situative Rezeptionsweisen beim Musikhören im interkulturellen Vergleich*, in: **Jahrbuch der Dt. Gesellschaft für Musikpsychologie**, Vol. 10, pp. 38-55

Lin, C. A. (2001), *Cultural values reflected in Chinese and American television advertising*, in: **Journal of Advertising**, Vol. 30, No. 4, pp. 83-94

Macinnis, D. J. & Park, C. W. (1991), *The differential role of characteristics of music on high- and low-involvement consumers' processing of ads*, in: **Journal of Consumer Research**, Vol. 18, September, pp. 161-173

Madsen, C. K. (1997), *Emotional response to music*, in: **Psychomusicology**, Vol. 16, No. 1 & 2 (Spring/Fall), pp. 59-67

Marks, J. (1998), *Shake, rattle, and please buy my product*, in: **U.S. News & World Report**, Vol. 124, No. 20, p. 51

Marshall, S. & Cohen, A. J. (1988), *Effects of musical soundtracks on attitudes to geometric figures*, in: **Music Perception**, Vol. 6, pp. 95-112

McQuarrie, E. F. & Mick, D. G. (1999), *Visual rhetoric in advertising: Text-interpretive, experimental, and reader-response analyses*, in: **Journal of Consumer Research**, Vol. 26, June, pp. 37-54

Meyers-Levy, J. & Peracchio, L. A. (1995), *Understanding the effects of color: How the correspondence between available and required resources affects attitudes*, in: **Journal of Consumer Research**, Vol. 22, September, pp. 121-138

Michaelson, S. (1986), *Matching the musical message*, in: **Marketing & Media Decisions**, Vol. 21, p. 133

Milliman, R. E. (1982), *Using background music to affect the behavior of supermarket shoppers*, in: **Journal of Marketing**, Vol. 46, Summer, pp. 86-91

Mitchell, A. A. (1986), *The effect of verbal and visual components of advertisements on brand attitudes and attitude toward the advertisement*, in: **Journal of Consumer Research**, Vol. 13, June, pp. 12-24

Mizerski, R. & Pucely, M. & Perrewe, P. & Baldwin, L. (1988), *An experimental evaluation of music involvement measures and their relationship with consumer purchasing behavior*, in: **Popular Music and Society**, Vol. 12, No. 3, pp. 79-96

Murray, N. M. & Murray, S. B. (1996), *Music and lyrics in commercials: A cross-cultural comparison between commercials run in the Dominican Republic and in the United States*, in: **Journal of Advertising**, Vol. 25, No. 2 (Summer), pp. 51-64

Naccarato, J. L. & Neuendorf, K. A. (1998), *Content analysis as a predictive methodology: Recall, readership, and evaluation of business-to-business print advertising*, in: **Journal of Advertising Research**, Vol. 38, No. 3, pp. 19-33

No author identified (1989), *Fewer ad jingles are heard as Madison Ave. shifts beat*, in: **The New York Times**, Monday, 19 June 1989, p. First Business Page and D7

No author identified (1994b), *Musik und Werbung*, in: **Musik und Unterricht**, Vol. 5, No. 29, pp. 5-8

Olney, T. J. & Holbrook, M. B. & Batra, R. (1991), *Consumer responses to advertising: The effects of ad content, emotions, and attitude toward the ad on viewing time*, in: **Journal of Consumer Research**, Vol. 17, March, pp. 440-453

Olsen, G. D. (1995), *Creating the contrast: the influence of silence and background music on recall and attribute importance*, in: **Journal of Advertising**, Vol. 24, No. 4 (Winter), pp. 29-45

Palmer, C. (1997), *Music performance*, in: **Annual Review of Psychology**, Vol. 48, pp. 115-138

Park, C. W. & Young, S. M. (1986), *Consumer response to television commercials: The impact of involvement and background music on brand attitude formation*, in: **Journal of Marketing Research**, Vol. 23, February, pp. 11-24

Parrot, A. C. (1982), *Effects of paintings and music, both alone and in combination, on emotional judgments*, in: **Perceptual and Motor Skills**, Vol. 54, pp. 635-641

Qeenan, R. (1993), *Classical gas*, in: **Forbes**, Vol. 152, No. 10, p. 214

Roehm, M. (2001), *Instrumental vs. vocal versions of popular music in advertising*, in: **Journal of Advertising Research**, Vol. 41, No. 3 (May/June), pp. 49-58

Rösing, H. (1975), *Funktion und Bedeutung von Musik in der Werbung*, in: **Archiv für Musikwissenschaft**, Vol. 32, No. 2, pp. 139-160

Rötter, G. & Plößner, C. (1994), *Über die Wirkung von Kaufhausmusik*, in: **Jahrbuch der Dt. Gesellschaft für Musikpsychologie**, Vol. 11, pp. 154-164

Ronen, S. & Shenkar, O. (1985), *Clustering countries and attitudinal dimensions. A review and synthesis*, in: **Academy of Management Review**, Vol. 10, No. 3, pp. 435-454

Rosenfeld, A. H. (1985), *Music, the beautiful disturber; whether it's Bach, Beatles, 'The Boss', blues or ballads, chances are that music speaks to your emotions, and it's no accident*, in: **Psychology Today**, Vol. 19, p. 48

Rumpf, W. (1997), *Eric Clapton Autoflotte, Carlos Santana Käse-Samba und der Turnschuh von Iggy Pop: Popschnipsel als Werbetrailer*, in: **Bremer Jahrbuch der Musikkultur**, Vol. 3, pp. 184-197

Schulte-Döinghaus, U. (2001), *Was soll das heißen?*, in: **Die Marke. Wesen – Wirkung – Wandel.** Ein gemeinsames Supplement zum Deutschen Marketingtag 2001 von w&v (werben und verkaufen), Süddeutsche Zeitung, media & marketing und Der Kontakter, pp. 8-12

Scott, L. M. (1990), *Understanding jingles and needledrop: A rhetorical approach to music in advertising*, in: **Journal of Consumer Research**, Vol. 17, September, pp. 223-236

Scott, L. M. (1994), *Images in advertising: The need for a theory of visual rhetoric*, in: **Journal of Consumer Research**, Vol. 21, September, pp. 252-273

Sewall, M. A. & Sarel, D. (1986), *Characteristics of radio commercials and their recall effectiveness*, in: **Journal of Marketing**, Vol. 50, January, pp. 52-60

Simpson, R. H. & Quinn, M. & Ausubel, D. P. (1956), *Synesthesia in children: Association of colors with pure tone frequencies*, in: **Journal of Genetic Psychology**, Vol. 89, pp. 95-103

Smith, P. C. & Curnow, R. (1966), *Arousal hypotheses and the effects of music on purchasing behaviour*, in: **Journal of Applied Psychology**, Vol. 50, No. 3, pp. 255-256

Standley, J. M. (1986), *Music research in medical/dental treatment: Meta-analysis and clinical applications*, **Journal of Music Therapy**, Vol. 23, No. 2, pp. 56-122

Standley, J. M. (1996), *A meta-analysis on the effects of music as reinforcement for education/therapy objectives*, in: **Journal of Research in Music Education**, Vol. 44, No. 2, pp. 105-133

Stewart, D. W. & Farmer, K. M. & Stannard, C. I. (1990), *Music as a recognition cue in advertising tracking studies*, in: **Journal of Advertising Research**, Vol. 30, No. 4 (August/September), pp. 39-48

Taylor, T. D. (2000), *World music in television ads*, in: **American Music**, Vol. 18, Summer, pp. 162-192

Toivonen, M. (1993), *TV-mainosten miehet ja naiset: Mainosmusiikin käyttö sosiaalisen viestinnän välineenä*, in: **Etnomusikologian vuosikirjä**, Vol. 5, pp. 43-70

Toncar, M. & Munch, J. (2001), *Consumer responses to tropes in print advertising*, in: **Journal of Advertising**, Vol. 30, No. 1, pp. 55-64

Uhrbrock, R. (1961), *Music on the job: Its influence on worker morale and production*, in: **Personnel Psychology**, Vol. 14, pp. 9-38

Unnava, H. R. & Burnkrant, R. E. (1991), *An imagery-processing view of the role of pictures in print advertisements*, in: **Journal of Marketing Research**, Vol. 28, May, pp. 226-231

Välinoro, A. (1993), *Miten margariini soi? Mainosmusiikin vaikutusten, rakenteen ja merkityksenantokäytäntöjen tarkastelua*, in: **Etnomusikologian vuosikirjä**, Vol. 5, pp. 71-97

Yalch, R. (1991), *Memory in a jingle jungle: Music as a mnemonic device in communicating advertising slogans*, in: **Journal of Applied Psychology**, Vol. 76, No. 2, pp. 268-275

Yalch, R. & Spangenberg, E. (1990), *Effects of store music on shopping behavior*, in: **Journal of Consumer Marketing**, Vol. 7, No. 2 (Spring), pp. 55-63

Yalch, R. & Spangenberg, E. (1993), *Using store music for retail zoning: A field experiment*, in: **Advances in Consumer Research**, Vol. 20, pp. 632-636

Yang, D. J. & Warner, J. (1993), *Marketing: Hear the Muzak, buy the ketchup – The elevator-music folks' new push: Customized in-store ads*, in: **Business Week**, Vol. 3325, p. 70

Internet

- **Alsop, R.** (1985): *Ad agencies jazz up jingles by playing on 1960s nostalgia*, retrieved online in http://global.factiva.com/en/arch/display/.asp, 27 October 2002 (article printed in **The Wall Street Journal**, 18 April 1985)

- **Belton, R. J.** (2001): *Words of art*, retrieved online in http://www.arts.ouc.bc.ca/fiar/glossary/gloshome.html, 13 September 2001

- **Dümling, A. & Girth, P.** (2003): *"Entartete Musik". Eine kommentierte Rekonstruktion zur Düsseldorfer Ausstellung von 1938*, retrieved online in http://www.duemling.de/EM-Info.htm, 8 June 2003

- **Hübner, A.** (2003), *Der filmische Code/Umberto Eco*, retrieved online in: http://www.rossleben2001.werner-knoben.de/doku/kurs76web/node16.html, 3 June 2003

- **Kochnitzky, L.** (2001): *Historical excerpts from ADOLPHE SAX AND HIS SAXOPHONE*, cited and retrieved online in http://www.saxgourmet.com/adolph-sax.html, 13 August 2001

- No author identified (2001): *America's shrine to music museum*, retrieved online in http://www.usd.edu/smm/clinton.html, 5 October 2001

- No author identified (2001): *A teacher's guide to the holocaust. 'Degenerate' Music*, retrieved online in http://fcit.coedu.usf.edu/holocaust/arts/musDegen.htm, 15 July 2001

- No author identified (2001), *Biography*, retrieved online in http://www.candydulfer.nl/history/content.html, 4 November 2001

- No author identified (2001): *Biographie Carolin Hild*, retrieved online in http://www.ca-roh.de/inhalt.htm, 19 September 2001

- No author identified (2001), *ERBARMEN – wenn die Werbung das Saxophon entdeckt*, retrieved online in http://www.saxophoniker.de/erbarmen.html, 13 April 2001

- No author identified (2001), retrieved online in http://www.blasmusik-nrw.de/index.htm, 26 October 2001

- No author identified (2001), retrieved online in http://www.koestritzer.de, 17 October 2001

- No author identified (2001), retrieved online in http://www.liferadio.at, 8 September 2001

- No author identified (2001), retrieved online in http://www.osnabrueck.de, 10 May 2001

- No author identified (2001), retrieved online in http://www.saxgourmet.com, 7 October 2001
- No author identified (2002), retrieved online in http://www.saxophoniker.de, 9 November 2002
- No author identified (2002), retrieved online in http://www.kit-info.org, 9 November 2002
- No author identified (2003), retrieved online in: http://www.teamup.de/EcoOnline/Bibliografie.html, 3 June 2003
- Not author identified (2003), retrieved online in: http://pespmc1.vub.ac.be/SEMIOTER.html, 8 June 2003

Expert Interviews

Billek, Thomas (2001), Marketing-Vision, Ges. f. Marketing-Management und Absatzförderung mbH, Wetzlar (Germany), Telephone interview, 8 October 2001

Bungert, Holger (2001), Gesellschafter und Mitglied der Geschäftsleitung (Shareholder and Member of the Board of Executives) of DIE CREW, Werbeagentur GmbH, Stuttgart (Germany), Telephone interview, 19 October 2001

Eberle, Heiner (2001), Consultant at OgilvyOne worldwide GmbH, Frankfurt a. M. (Germany), Telephone interview, 10 October 2001

Krüger, Friedrich Wilhelm (2001), Marketingleiter (Marketing Manager) of Brauerei Felsenkeller Herford (Germany), Telephone interview, 11 October 2001

Slaby, Norbert (2001), Grafiker (Designer) at PAC Promotion Werbeagentur GmbH, Vellmar (Germany), Telephone interview, 8 October 2001

Staufacher, Katja (2001), JWT+Hostettler+Fabrikant, Werbeagentur AG, Zurich (Switzerland), Telephone interview, 9 October 2001

Wiesoleck, Günter (2001), Begros Gmbh, Bedarfsgüter-Großhandelsgesellschaft für Wohnung und Heim mbH, Oberhausen (Germany), Telephone interview, 10 October 2001

Zimmer, Holger (2001), U5 Gmbh, Düsseldorf (Germany), Telephone interview, 18 October 2001

Others

- **ADAC Motorwelt** (1990), Heft 7/1990
- **ADAC Motorwelt** (1991), Heft 4/1991
- **Alba Moda** (1999), Katalog Herbst/Winter 1999/2000
- **Bielefeld Veranstaltungen 2001**, brochure published by Bielefeld Marketing
- **Brigitte** (1996), Salzburg Exclusiv Katalog Herbst/Winter 1996
- **Burgenland plus** (1994), December 1994
- **Cine** (2002), November issue, no author identified, p. 6
- **Citroën Saxo Catalogue** M 5300101
- **Clarino** 10 (2000), p.5
- **Clarino** 11 (2000), p. 21 and cover page at the back
- **Clarino** 5 (2001), p. 39
- **Clarino** 10 (2002), pp. 15 and 57
- Collection B. Habla (2001)
- Daube Wohnwelt, Brochure October 2002
- **Der Abi Spiegel** (1994), Geschwister-Scholl-Schule Melsungen
- **Die ganze Woche** (1999), No. 28/1999, article *Saxy Candy bläst den Jungle Beat* by R. Colerus
- **Dorn, W.** (1995), *Musikforum.Viktring*, Klagenfurt
- Fax by *Citroën*, received by Melanie Vockeroth on 12.10.2001
- Fernseh- und Radiowoche (1992)
- Festival leaflet *3. Deutsches Bundesmusikfest 2001*, published by Bundes-vereinigung Deutscher Blas- und Volksmusikverbände e.V.
- Festival leaflet *Osnabrücker Maiwoche 2001*, published by Osnabrück Marketing und Tourismus GmbH
- **Festschrift** (2000), *75 Jahre MGV Niedergude 1925 vom 14.07. bis 17.07.2000*
- **Finke Catalogue** (2001), Autumn 2001
- **HBZ** (1997), 17. September 1997
- **HNA** Melsunger Allgemeine (2001a), 2 July 2001
- **HNA** Melsunger Allgemeine (2001b), 9 July 2001

- **HNA** Melsunger Allgemeine (2001c), 19 September 2001
- **HNA** Melsunger Allgemeine (2001d), 01 October 2001
- **Jahrbuch der Werbung 1991**, Vol. 28, Econ Verlag, Düsseldorf et al.
- **Jahrbuch der Werbung 1994**, Vol. 31, Econ Verlag, Düsseldorf et al.
- **Jahrbuch der Werbung 1998**, Vol. 35, Econ Verlag, Düsseldorf et al.
- **Jahrbuch der Werbung 2000**, Vol. 37, Econ Ullstein List Verlag, Munich et al.
- **Jahrbuch der Werbung 2001**, Vol. 38, Econ Ullstein List Verlag, Munich et al.
- **Katalog** (2003) Comfort Schuh GmbH
- **Kleine Zeitung** (1995a), 4 September 1995
- **Kleine Zeitung** (1995b), 4 October 1995
- **Kleine Zeitung** (1995c), 24 November 1995
- **Kleine Zeitung** (1998), 2 May 1998
- **Kleine Zeitung** (2000), 15 September 2000
- **Kortina** Catalogue (2002)
- Leaflet *Ried im Innkreis* (undated)
- **Lipscomb, S.** (1999), Cross-modal integration: Synchronization of auditory and visual components in simple and complex media. Collected papers of the 137th Meeting of the Acoustical Society of America and the 2nd Convention of the European Acoustics Association (CD-ROM, 4 pp), New York
- London Philharmonic Orchestra Yearbook 1997-1998
- **Lustiges Taschenbuch** LTB 276 by Walt Disney
- **Magazin Österreich** (1994), No. 5/1994 IB Burgenland, p. 30
- **Meet DFDS Seaways** (2002), Journal August/September 2002
- **Metro**, London, issue unknown
- **Miele** (2002), brochure
- **Möbelhaus Putz** Leaflet (1993)
- **News** (1992), No. 4, 5 November 1992
- **News** (1995), No. 25
- **News** (1997), issue unknown
- **Otto Katalog** (2002) Herbst/Winter 2000/2001
- Packaging **DooWap**
- Packaging **Haribo**
- Packaging **Mozartkugeln**
- **Peek & Cloppenburg** (2002) brochure, Germany
- Programmheft *Die Grazbürsten 1995/1996. In Ehren versaut!*
- **Rohrblatt** 8 (1993), No. 1, pp. 25 and 27
- **Rohrblatt** 9 (1994), No. 4, p. 74
- **Rohrblatt** 10 (1995), No. 1, cover page at the back
- Sales folder *Weinedition Jazz*, Weingärtnergenossenschaft Untertürkheim eG (undated)

- Sales folder *Sparkassenversicherung* (undated)
- **Sparkasse Osnabrück** Leaflet (2001), cover page
- **SportBlick** (1990), *SportBlick. Erstes Burgenländisches Sportmagazin*, No. 1, 14 August 1990
- **Stern** (1999), No. 36, 2 September 1999
- **Süddeutsche Zeitung** (2001), No. 241, 19 October 2001
- **TV Movie** (2002), Vol. 21
- University of Applied Sciences Osnabrück (2001), *Studienangebote. Profil*
- Verkerke Greeting Card #38389
- **Wohnen** (1999), Die aktuellen Trends, Herbst 1999

Appendices

Appendix 1: Categorisation of Advertisements Featuring a Saxophone

The categorisation shown on the following two pages was developed by using all advertisements and sources that were accessible to the authors. It is by no means a complete selection of all advertisements using the saxophone of the three countries under consideration in the relevant timescale, but it is a representative selection, from which the role of the saxophone in advertising can be examined and understood. Divisions and subdivisions of products and services are indicated by different shades of grew.

Products Furniture & Household	Food & Drink Food: Sweets	Fashion Both Genders	Vehicles Motorbikes	Other Products Sound Systems etc.
Bader Katalog 2002	Haribo	H&M	BMW	Casio
Blue World by Möbel Hesse	Lieken Urkorn	For Men	Cars	Sanyo
Brigitte Katalog	Drinks	Alba Moda (Leather jacket)	Audi Zentrum Kassel	Sony
Daube Wohnwelt	Alcoholic Drinks	Bueckle	BMW	Cosmetics
Finke, Neubert, Möbelstadt				Haarmann & Reimer (Cosmetics)
Sommerland	Wine	C & A New Legend	Chevrolet	
	Weingärtnergenossenschaft			
Gröbl Möbel	Untertürkheim	Peek & Cloppenburg	Citroen Saxo	Tabac Original
Känguruh	Beer	Street One and Cecil	Fiat Stilo	Stationery
Kortina-Küchen	Budweiser	Top Herrenmode Balaskovics	Ford Fiesta Blues	Rotring
Lutz	DAB	For Women	Volkswagen	Books
Magazin Möbel-Leuchten-Accessoires	Gräfinger	C & A New Legend	Volvo	Die Vogelhochzeit
Möbel Bolte Armchair	Heineken Germany	Katalog Firma Turbo-Schuh		Traumhochzeiten
Möbel Bolte Celebration	Heineken Switzerland	Schöps		Cigarettes
Möbelhaus Putz	Herforder Pils	Stefanel		Camel
Wennos - Kollektion Jazz	Köstritzer	Universal		Gauloises
Household Appliances	Trumer Pils	Shoes		HB
Elektra Bregenz (Microwave)	Villacher	Stiefelkönig		Memphis
Neff	Spirits	Comfort Schuh GmbH		Musical Accessories
Miele Staubsauger Jazz	Southern Comfort			Druck und Verlag Obermayer GmbH
Furnishings	Soft Drinks			Fox Holz
Holzring Parkettfußboden	Lipton			Kölbl
Teppichboden	Rosenberg Mineralbrunnen			sdsysterms
Wiesner-Hager Objekteinrichtung				Industry
Wohntrends				Elektronische Beschichtungssysteme
				Toys
				Barbie

Services		Media	Others	
Events and Event Locations	Travel — Tourism and Places	Print	Shops and Businesses	Politics
3 Deutsches Bundesmusikfest	Arosa Bergbahnen, Switzerland	Deutschland Aktuell	Augenoptik Bock	Bill Clinton
Alando Palais Osnabrück	DFDS Seaways	Hannover live	B. Braun Melsungen AG	Green Party, Greece
Blasorchester Brunslar	Jamaika	Kleine Zeitung - Flohmarkt	Bank Austria	King Bhumibol, Thailand
Die lange Nacht der Musik, München	Travel catalogue USA and Canada	Kurier Immobilien-Anzeigen	Bayerischer Hof	Other Celebrities/Comics
Eifeler Musiktage	Jugendhotel Bitburg	Mannheimer Morgen	Bigband der Bundeswehr	Lisa Simpson
Ein Fest mit Most und Jazz	KLM - Journeys to the USA	Neue Kronen Zeitung	buch.de	Pink Panther
Esslinger Kultursommer	Kreuzfahrt	News	Capitol - Cinema	Saxophone Smurf
Forum am Schlosspark, Ludwigsburg	Prize Competition	Small ads (lonely hearts ad)	Dracula Cocktail Bar	Scrooge McDuck
Grünnger Bad, Magdeburg	Ried im Innkreis	Zeitungsgruppe WAZ	Dresdner Bank	
Havana Night	Travel agency Bel Mondo	Broadcast	FH Osnabrück	
Hessentag in Lich			IBM	
Honky-Tonk Kneipenfestival Kassel	Voyages, Voyages (Travel show on TV)	Antenne Bayern	Invesco	
Jazz im Citypark, Graz	Public Transport	DeutschlandRadio Berlin	Jazz-Biergarten	
Jazz-Festival, Homberg	Rhein-Main-Verkehrsverbund	Life Radio, Austria	Kaufhof	
Jazz-Session in der Kulturfabrik	Deutsche Bahn	Radio Brandenburg	Musikhaus Kassel	
K.it. Kinder Info-Tage, Hannover			Nürnberger Versicherung	
Klassik & Jazz / Sparkasse Osnabrück			Postbank	
Münster Live			Raiffeisen-Club	
Musik Nacht Adventskirche Kassel			Saxgourmet	
Musikkunstwochen Arosa			Sparkasse (various times)	
Olympic Wintergames			Sparkassenversicherung	
Osnabrück Live! Die zweite (2001)			Zabos	
Osnabrücker Jazzfestival 2001				
Osnabrücker Maiwoche 2001				
Österreichischer Nationalzirkus				
Sommer-Samstags-Konzerte Melsungen				
Swing Society Bremen e. V				
Varieté Star-Club Kassel				
Vienna Art Orchestra concert				
Zirkus Meer				

Appendix 2: List of Interview Partners

This list includes only the interview partners, with whom a telephone interview took place. The interviews are listed in the order of appearance in the main text of this publication.

1. **Figure 19**: Furniture advertisement, *Finke. Das Erlebnis-Einrichten GmbH & Co. KG*, recent campaign
Paderborner Str. 97
33104 Paderborn
Germany
Phone: +49 5251 302110
Fax: +49 5251 302167
Contact: Ms Gerke and Ms Buchberger (Direct line +49 5251 302 ext. 173), in-house advertising department

Advertising Agency: Begros GmbH
Bedarfsgüter-Großhandelsgesellschaft für Wohnung und Heim mbH
Graf-Zeppelin-Str. 5
46149 Oberhausen
Germany
Phone: +49 208 99 493-0
Fax: +49 208 99 493 – 999
Internet: http://www.begros.de
Email: info@begros.de
Contact: Ms Aholt, Mr Günter Wiesoleck

2. **Figure 31**: Beer advertisement, *Brauerei Felsenkeller Herford* (Herforder Pils), recent campaign
Postfach 1351
32003 Herford
Germany
Phone: +49 5221 965-285
Fax: +49 5221 965-202
Internet: http://www.herforder-pils.de
Email: info@herforder.de
Contact: Marketingleiter (Marketing Manager) Mr Krüger

3. **Figure 32**: Beer advertisement, *Heineken*, previous campaign
Advertising Agency: JWT+Hostettler+Fabrikant
Werbeagentur AG, BSW
Hardstraße 219, Postfach
8037 Zurich
Switzerland
Phone: +41 1 27 771-11
Fax: +41 1 27 771-12
Internet: http://www.jwthf.ch
E-Mail: jwtzurich@jwthf.ch or info@jwthf.ch
Contact: Ms Katja Staufacher

4. **Figure 34**: Weingärtnergenossenschaft Stuttgart-Untertürkheim, *Weinedition Jazz*
Advertising Agency: Die Crew Werbeagentur GmbH
Maybachstraße 8, Am Killesberg
70469 Stuttgart
Phone: +49 711 13545-0
Fax: +49 711 13545-90
Internet: www.diecrew.de
Email: bungert@diecrew.de
Contact: Mr Holger Bungert (Consulting and Concept)

5. **Figure 50**: Motorbike advertisement, *BMW*, previous campaign
Advertising Agency: U5 GmbH
Unternehmen für integrierte Kommunikation
Heerdter Sandberg 30
40549 Düsseldorf
Phone: +49 211 55 894-0
Fax: +49 211 55 80625
Contact: Mr Holger Zimmer

6. **Figure 81**: Insurance company, *Sparkassenversicherung*, previous campaign
Advertising Agency: Marketing-Vision
Ges. f. Marketing-Management und Absatzförderung mbH
Im Amtmann 11-15
35578 Wetzlar
Germany
Phone: +49 6441 9789-0

Internet: http://www.marketing-vision.de
Email: info@marketing-vision.de
Contact: Mr Billeck

7. **Figure 82**: Recruiting Advertisement for *IBM*, previous campaign
Advertising Agency: OgilvyOne worldwide GmbH
Geleitsstraße 14
60599 Frankfurt am Main
Phone: +49 69 60 915-0
Fax: +49 69 618031
Internet: http://www.ogilvyone.de
Contact: Mr Heiner Eberle (Consultant)

8. **Figure 102**: Medical care/cultural advertisement, *B. Braun Melsungen AG*,
previous campaign
Advertising Agency: PAC Promotion Werbeagentur GmbH (Personally)
Brüder-Grimm-Str. 30
34246 Vellmar
Germany
Phone: +49 561 98282-16
Email: n.slaby@pac-werbeagentur.de
Internet: http://www.pac-werbeagentur.de
Contact: Mr Norbert Slaby (Designer)

Appendix 3: Interviewing Guide (Original Version in German)

The following interviewing guide is the general guide, which was used as a general framework for all the interviews. Topics of special interest regarding the relevant advertisements are not included here. These were added during the preparation of the individual interview.

Interviewing Guide

1. Begrüßung und kurze Vorstellung meiner Person

2. Grund des Anrufes: auf Saxophon in der Werbung als Thema einer wissenschaftlichen Arbeit zu sprechen kommen

3. Frage, ob Mitschnitt des Gespräches erlaubt

4. Sagen, auf welche Werbung ich mich beziehe und woher ich sie kenne (in der Lage sein zu erklären, wie ich auf den Ansprechpartner gekommen bin)

5. Frage nach dem „Warum das Saxophon?" Was ist besonders daran?

6. Aufgabe des Saxophons im Speziellen, was soll es bewirken/ ausdrücken/verkörpern?

7. Ziele der Kampagne

8. Zielgruppe(n)? Warum das Saxophon für diese Zielgruppe(n)?

9. In welchen Medien wurde diese Idee genutzt?

10. Nach Zielerfüllung fragen; wurde überprüft?

11. Image-Analyse

12. Andere Werbungen mit dem Saxophon?

13. Oder mit anderen Instrumenten?

14. Bedanken für das Gespräch und Verabschiedung

Appendix 4: Interviewing Guide (English Translation)

1. Greeting and short introduction of myself

2. Reason for the phone call: to talk about the saxophone in advertising, as topic of publication

3. Request for permission to record the interview

4. Explain which specific advertisement I am talking about, and where it was found (be in a position to explain how I established the contact)

5. Raise the questions "Why the saxophone?" "What is special about it?"

6. Discuss task or role of the saxophone in particular - what is it intended to affect, communicate or embody?

7. Objectives of the campaign

8. Identification of target audience; why the saxophone for this audience?

9. In which publications or media was the advertisement printed? Only print?

10. Ask if effectiveness of the campaign was checked

11. Image analysis

12. Other advertisements with a saxophone?

13. Or with other instruments?

14. Express thanks for information and take leave

MARKT-MANAGEMENT

Herausgegeben von Prof. Dr. Axel Eggert,
Prof. Dr. Wolfgang Müller und Prof. Dr. Konrad Zerr

Band 1 Michael Langer: Service Quality in Tourism. 1997.

Band 2 Katja Bergmann: Angewandtes Kundenbindungs-Management. 1998.

Band 3 Axel Eggert: Kulanzmanagement in der Kfz-Industrie. 2002.

Band 4 Konrad Zerr / Brigitte Gaiser / Dominik Decker: Die Rolle des Marketing bei der Entwicklung und Vermarktung von Dienstleistungen. Ergebnisse einer empirischen Studie zur Untersuchung von Erfolgsfaktoren für Dienstleistungsinnovationen. 2003.

Band 5 Axel Eggert / Melanie Vockeroth: The Saxophone in Advertising. 2003.